998 WORLD PRESS PHOTO

Thames and Hudson

LOUIS LEMAIRE

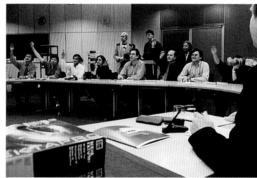

It took the jury of the
41st World Press Photo
Contest six days of
intensive deliberation
to arrive at the results
published in this book.
They had to judge
36,041 entries
submitted by 3,627
photographers from
115 countries.

World Press Photo

World Press Photo is an independent nonprofit organization, founded in The Netherlands in 1955. Its main aim is to support and promote internationally the work of professional press photographers. Over the years, World Press Photo has evolved into an independent platform for photojournalism and the free exchange of information. The organization operates under the patronage of H.R.H. Prince Bernhard of The Netherlands.

In order to realize its objectives, World Press Photo organizes the world's largest and most prestigious annual press photography contest. The prizewinning photographs are assembled into a traveling exhibition, which is visited by over a million people in more than 35 countries every year. This yearbook presenting all prizewinning entries is published annually in six languages. Reflecting the best in the photojournalism of a particular year, the book is both a catalogue for the exhibition and an interesting document in its own right. A six-monthly World Press Photo newsletter deals with current issues in the field.

Besides managing the extensive exhibition program, the organization closely monitors developments in photojournalism. Educational projects play an increasing role in World Press Photo's annual calendar. Five times a year seminars open to individual photographers, photo agencies and picture editors are organized in developing countries. The annual Joop Swart Masterclass, held in The Netherlands, is aimed at talented photographers at the start of their careers. They receive practical instruction and are shown how they can enhance their professionalism by some of the most accomplished people in photojournalism.

World Press Photo is sponsored world-wide by Canon, KLM Royal Dutch Airlines and Kodak Professional, a division of Eastman Kodak Company.

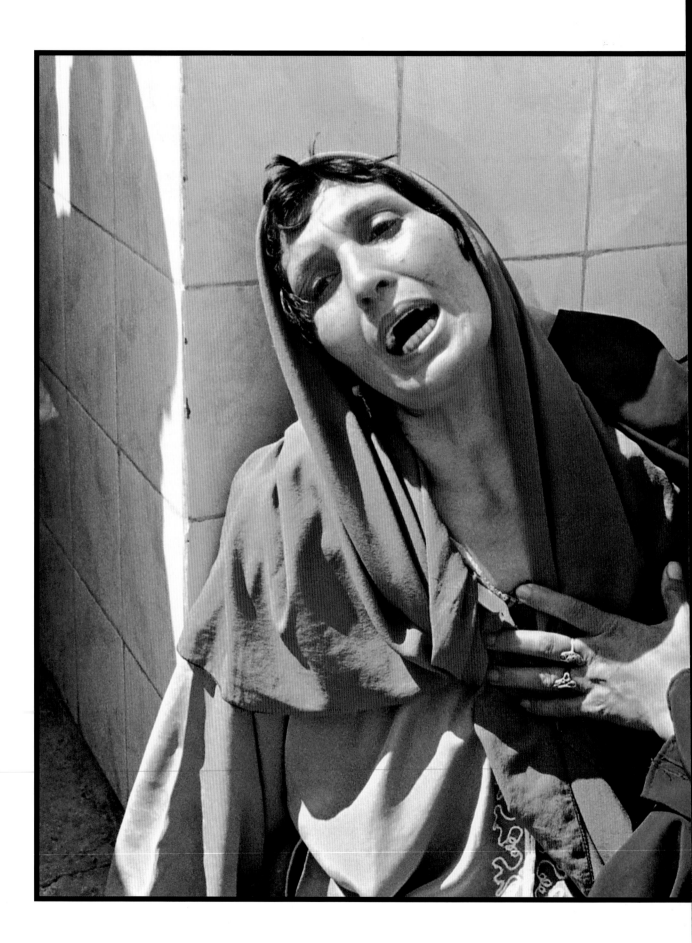

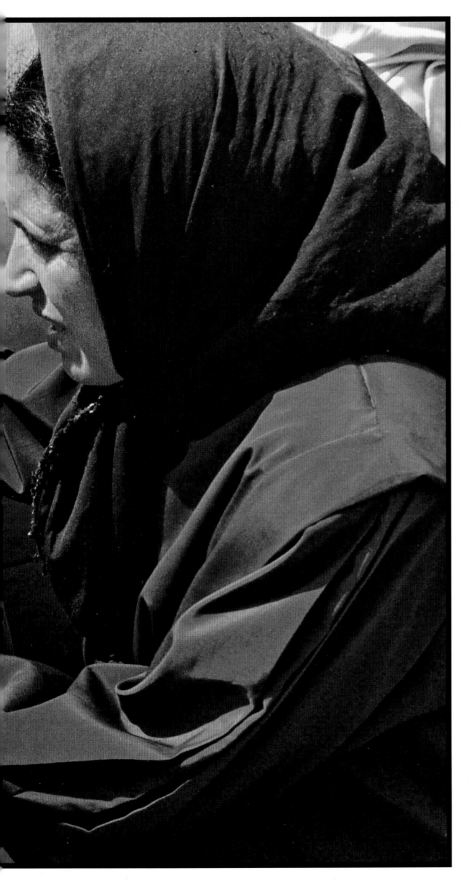

World Press Photo of the Year

· Hocine
Algeria, Agence France Presse

A woman cries outside the Zmirli Hospital, where the dead and wounded had been taken after a massacre in Bentalha, Algeria, on September 23. *See also interview on page 7.*

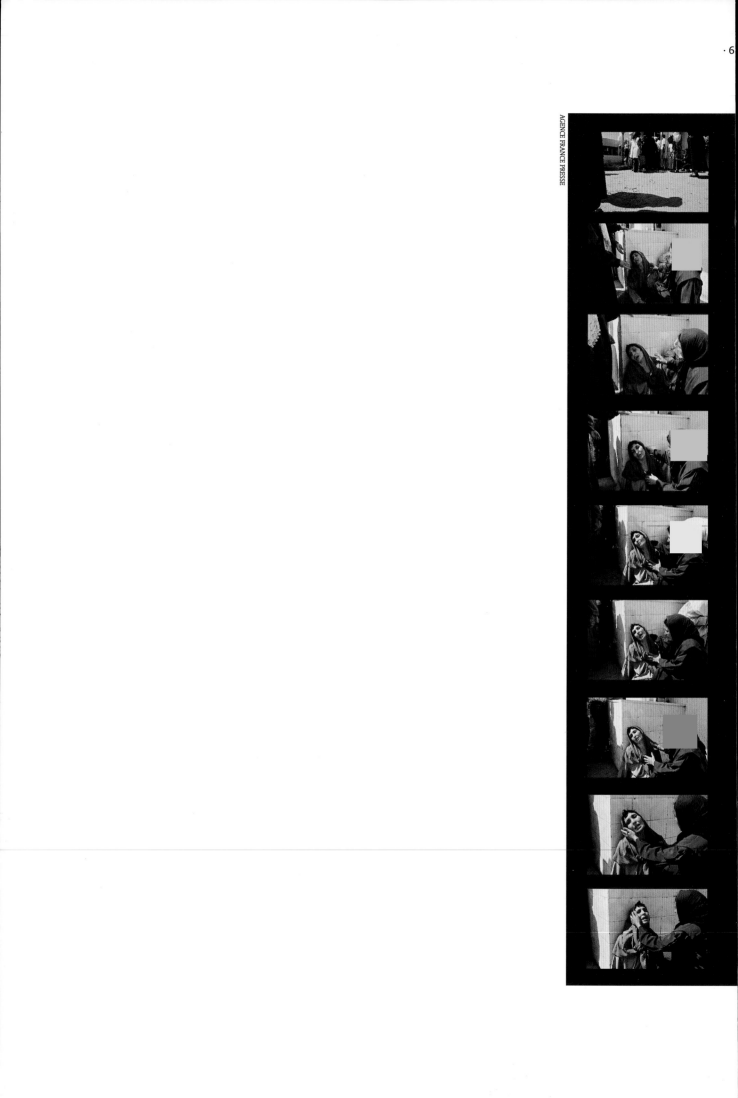

Hocine

Hocine, the author of the World Press Photo of the Year 1997, answered some questions about his work.

Can you explain how you came to be at the hospital where you took the winning picture?

I took one photograph in Bentalha, the site of the massacre. When I found out that the dead and wounded were being taken to the nearest hospital, the Zmirli Hospital, I followed them there. I was absolutely determined to photograph the survivors of the horrible slaughter in Bentalha.

What happened while you were at the hospital?

There was a huge crowd waiting outside the hospital gate. Access was strictly forbidden. The security guards told me that this was because the nursing staff had to be able to attend to the wounded unhampered. The spectacle before my eyes was apocalyptic — the crowd consisted mostly of screaming women. Many people were waiting for news and pleading for a list of survivors. Others just wanted to know if their family or neighbors were dead or alive.

As I waited at the main entrance to the hospital in the hope of being allowed inside, the shrill cries of a woman in a group standing some 20 meters away from me caught my attention. There was a moment of real panic. Then I saw the woman slide down against the wall with her head back, as if she was about to faint. I ran towards the group to get as close to her as possible. It was then, just before 12.30pm on September 23rd, that I photographed the anonymous woman who later became known as "the Madonna of Bentalha". As I took her picture — five or six frames in all — amidst many other crying women, my only concern was to produce a photographic document about the pain of the Algerian mothers in the face of the massacres we are living through.

The press had been forbidden to take photographs, and one of the hospital's security guards, trying to do his job, called out to me to stop shooting. I waited for another hour, still hoping against hope to be allowed to enter the hospital, but in the end I had to face the fact that they were not going to open the gate.

What made you want to be a photographer in the first place?

I took up photography as a hobby in 1970. I owe my first glimpse of the wonderful world of photography to an older relative, Cherif, who was then an architecture student at the Fine Arts College in Algiers and a real photography fanatic. He gave me books and magazines with work by great photographers such as Brassaï, Cartier-Bresson, Boubat and so on. He wanted me to see their work as examples of ways in which to document the human condition. This is how I started portraying my fellow countrymen in their everyday lives. I photographed the Kasbah, the port and fishermen of Algiers, children in working-class neighborhoods and tramps, with particular emphasis on people living in harsh conditions. Through hard work and perseverance I became an assistant teacher of photography at the same college in Algiers where Cherif, whom I like to consider my teacher, studied in the 1970s.

How did you fare as a professional photographer?

I started my career as a photojournalist with Reuters in 1989, and joined Agence France Presse in January 1993. Like other agency photographers I was assigned to cover the news in different places, mostly in Somalia, Rwanda and Zaire. I later concentrated entirely on photographing the political and social events of my own country, which are part of my life every day. I wish the tragic events which tear Algeria apart would end once and for all, so that I can view my country in a different light.

Has your work changed as a result of the political developments in Algeria?

Of course the situation has had a certain influence on the way I operate as a photojournalist. I am constantly documenting what I see around me. In spite of the restrictions and the danger, I have always been able to carry on working just like any other photographer. I have never received any threats, and I have no particular protection.

How did you react when you heard you had won World Press Photo's top award?

When I heard the news I felt immense joy, also for my Algerian colleagues. I see it as recognition from my peers. It was made possible thanks to the support of the AFP office in Algiers and the AFP Paris Photo Desk. I would also like to take this opportunity to thank my parents and my friends for their support.

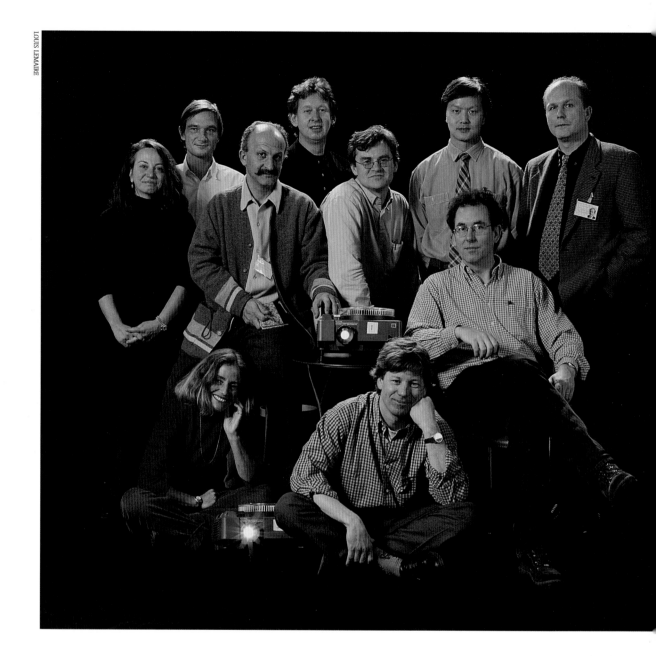

LOUIS LEMAIRE

THIS YEAR'S JURY
BACK ROW, FROM LEFT TO RIGHT:
Michele McNally, USA
Mark Grosset, France
Reza, Iran
Adriaan Monshouwer (Secretary)
Carl de Keyzer, Belgium
Andrew Wong, Hong Kong
Tomasz Tomaszewski, Poland
FOREGROUND, FROM LEFT TO RIGHT:
Ana Cecilia Gonzales-Vigil, Peru
Werry Crone, The Netherlands
Neil Burgess, UK (Chairman)

Foreword

Being invited for the second time by World Press Photo to be the Chairman of the Jury was a great honour, but also a task I viewed as somewhat onerous. This year 36,041 photographs were entered by 3,627 photographers from 115 countries, and the prospect of spending six days looking at them locked up in a darkened room with a bunch of editors and photographers did not initially fill me with relish. However, as the time drew nearer, I began to find myself looking forward to it. Ultimately, the opportunity of immersing oneself without distractions in a year's worth of the world's best photojournalism is such a unique and stimulating experience that no professional could resist it. Described at one point as "the UN of the photographic world", the jury came from nine different countries and cultures. But they had one common passion: photography. We can only hope that the book produced through our deliberations is worthy of our colleagues in one of the world's most difficult and extraordinary professions.

1997 was a difficult year for journalism, and for photojournalism in particular. Our profession has always had to deal with individuals and organizations — from pop stars to political parties — who wish to "manage" the news. More than ever before, the press came under pressure in 1997 from advertisers, spin doctors, press secretaries and public relations agents, all of whom try to control access to the news and to the way it is presented. It is becoming increasingly difficult for journalists to do their jobs and report what they see, what they think and what they believe, from an independent perspective, without interference. We need a free press and I believe that that is what the public wants. Apart from the photographers and journalists themselves, editors and publishers must also stand firm against the tendency to manage our media.

In 1997 one particular event had a devastating effect on public perception of the photojournalist: the tragic death of Princess Diana. Many individuals and even the media themselves lost no time in putting the blame on photographers. Although it soon became clear that the paparazzi pursuing Diana's car were not directly involved in the crash which killed her, a great slur was inflicted upon our profession. Photographers were spat at, attacked and abused wherever they went. The level of hypocrisy from people in the public eye who sought to control the news, from publishers and of course from the public was astonishing. The issue of privacy is an important one, but so is the freedom of the press. We need to bring this debate forward, unfettered by the emotional response to Diana's death.

Before the World Press Photo judging started, I attempted to discover what had happened to the pictures taken by the photographers who pursued Diana on that fateful night. After much telephoning I discovered that they were all still held by the police. The question whether they should be published is a controversial one, but one that should be answered by the photographers, their agencies and their publishers — not by the police or by politicians. The spectre of censorship is never far away.

For photographers working in Algeria the debates and problems discussed above must seem rather academic. For Hocine, the author of this year's World Press Photo, being a photojournalist means putting his life in danger on a daily basis. In the last five years tens of thousands of people have been murdered in Algeria, often in the most brutal and senseless way. Included in that figure are many of our colleagues — journalists who tried to tell the public what is going on.

Hocine's picture of a woman grieving for her murdered family brings to the world an understanding of the horrors being perpetrated in Algeria. It is one of very few messages to emerge from that troubled country. One reason why the jury chose it is for its symbolic value as a rare signal of the tragedy being played out there. After all, efforts by the UN and the EU to discover the truth have been blocked.

The winning photograph has been praised as a masterful, painterly image of great skill and vision. But it becomes even more important if we see it as a tool which can help prize the truth from the tragedy that is Algeria today — a truth which many would prefer to keep hidden.

Neil B

NEIL BURGESS
Chairman of the 1998 Jury
London, February 1998

Spot News

· Wendy Sue Lamm
USA, Agence France Presse

1ST PRIZE SINGLES

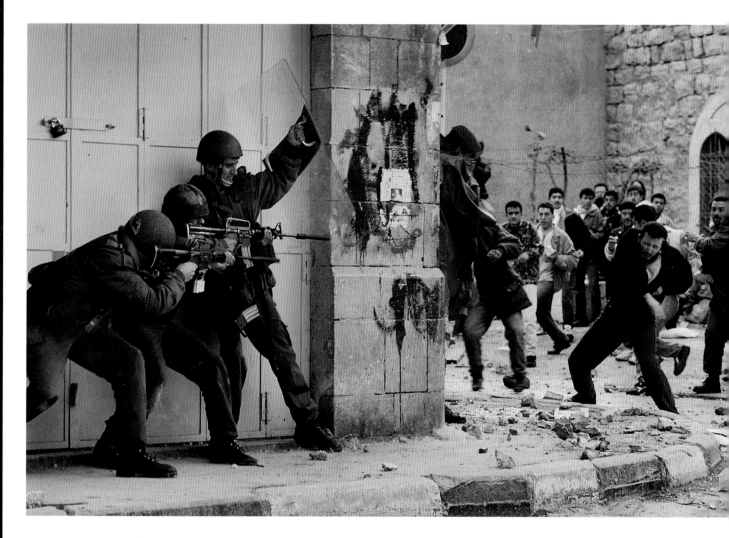

As he hurls a stone at Israeli soldiers, a Palestinian is shot in Hebron. Israel's decision in March to build a new Jewish quarter in East Jerusalem sparked off riots in Bethlehem and Hebron and caused a dramatic deterioration in relations between Israel and the Arab world. The Arab League called for a renewed boycott of the Jewish state.

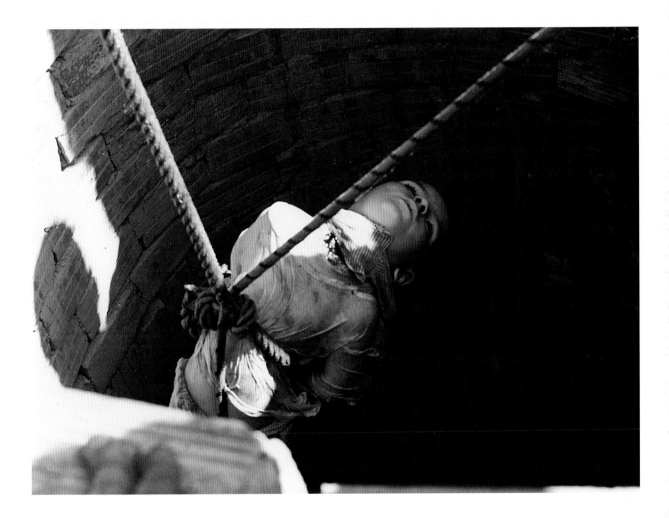

· **Anonymous**
Algeria, Sipa Presse for Paris Match, France /
Time Magazine, USA

2ND PRIZE SINGLES

Following a pledge by the president that terrorism's final hour had struck and demonstrations which brought tens of thousands out onto the streets, more than 100 people were found murdered in Algeria. In Frais-Vallon in the hills of the capital Algiers seven women and children — members of two families who had been kidnapped — were pulled from the village well on August 26. Their throats had been slashed and some of them had been decapitated.

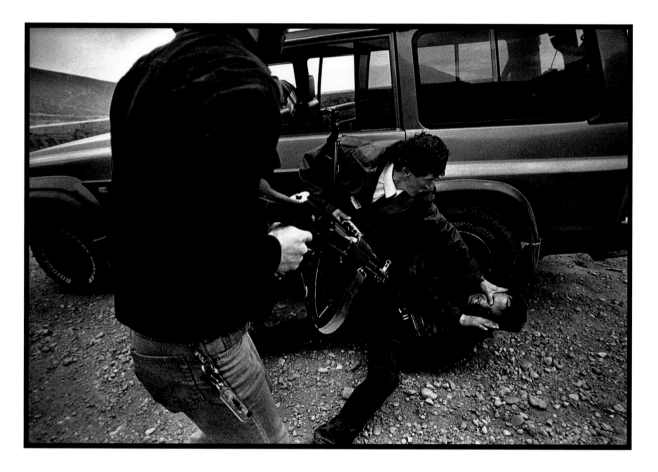

· Massimo Sciacca
Italy

3RD PRIZE SINGLES

In the Albanian village of Prenjias, close to
the Macedonian border, an alleged highway
robber is forced to the ground and arrested
by police. Lawlessness reigned in the small
Balkan country when the hugely popular
'pyramid' investment funds collapsed.
Many lost not only their savings, but their
mortgaged homes and land as well.

· Santiago Lyon
USA, The Associated Press

1ST PRIZE STORIES

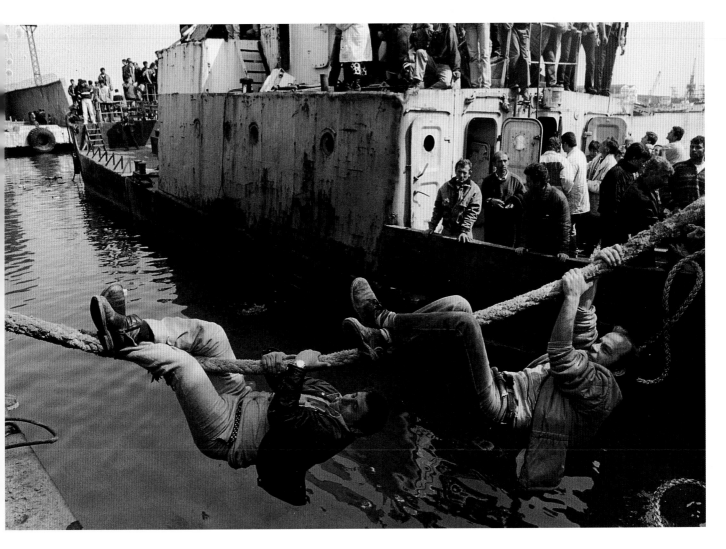

When over half of Albania's population lost their high-risk investments at the beginning of the year, they turned their rage against the authorities. Particularly in the south, rebellious mobs attacked army barracks, police stations and shops to procure arms and other goods. Here two men attempt to flee the anarchy by boarding a boat for Italy *(story continues)*.

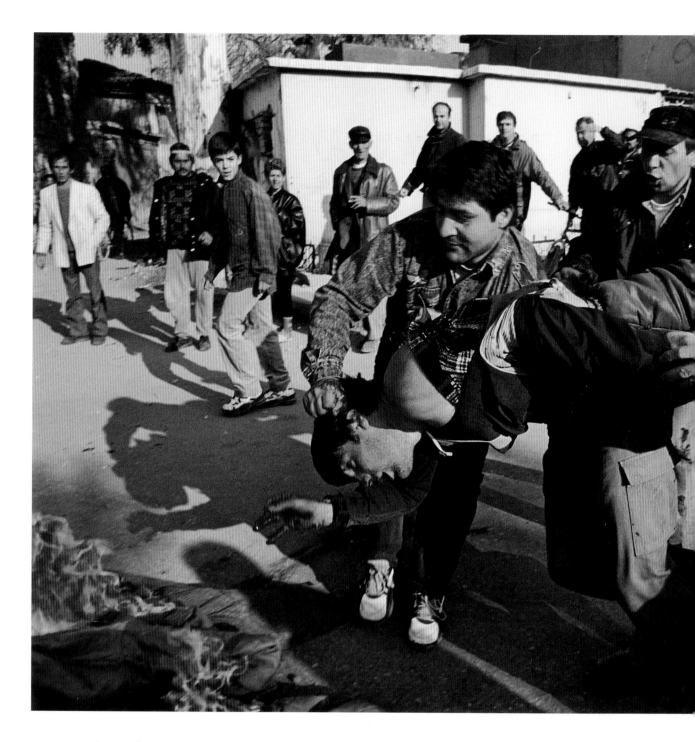

(continued) At one point every civilian in Albania appeared to possess some kind of weapon. Individuals representing the government were often at the receiving end of their aggression. Above: Two policemen, one in plain clothes and one in riot gear, attempt to push an anti-government demonstrator into a street fire. Facing page, from top: A demonstrator aims a blow at a police officer. People trying to flee the country are terrorized by a gunman firing over their heads. A hooded rebel points a gun at Adem Hasa, the head of the presidential bodyguard.

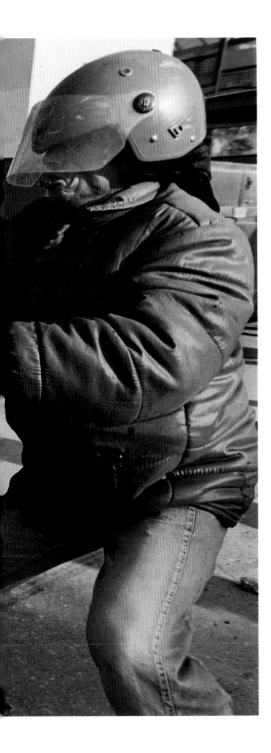

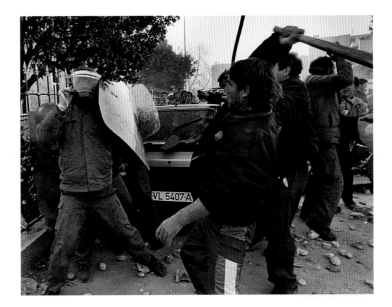

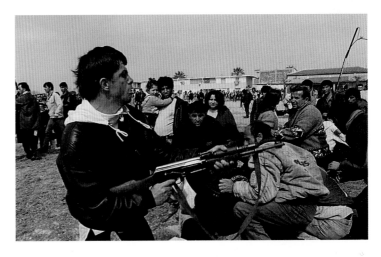

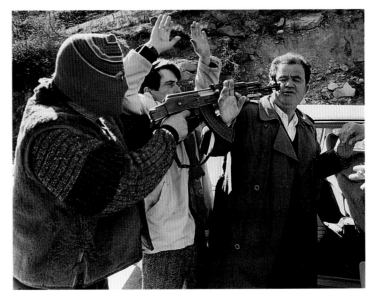

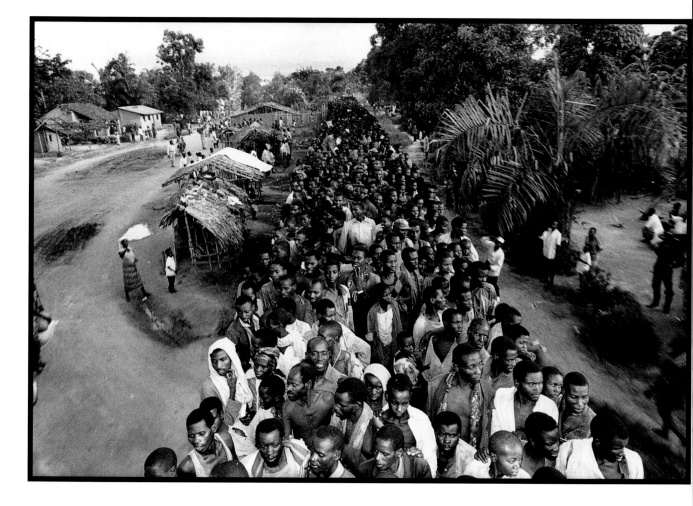

· Kadir van Lohuizen
The Netherlands, Agence Vu, France for Vrij Nederland

2ND PRIZE STORIES

As this open-topped train, loaded way beyond capacity, made its
way from Biaro refugee camp to Kisangani in Zaire, alarm
signals went unheeded and many people were crushed to death.
From Kisangani the refugees were to be airlifted back to Rwanda
by the United Nations *(story continues)*.

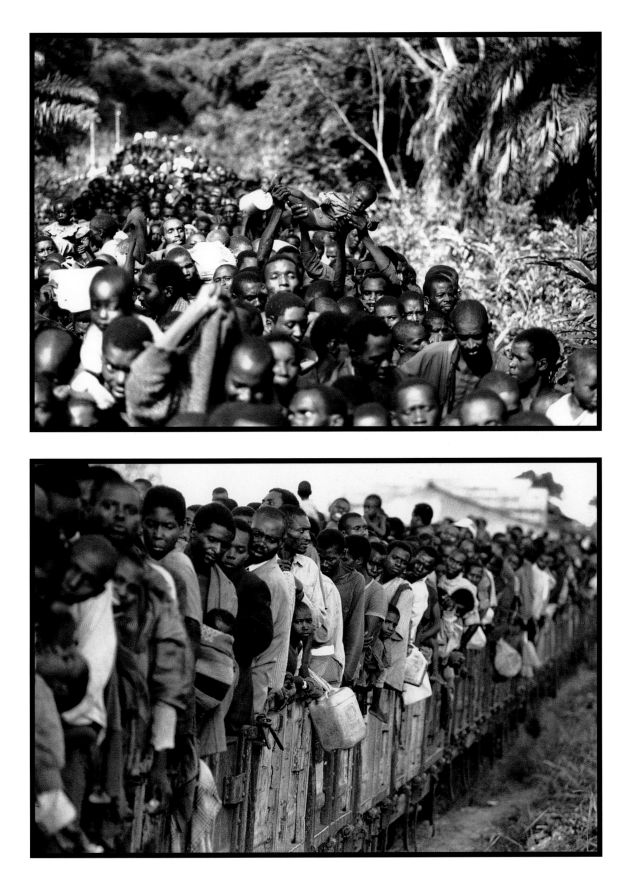

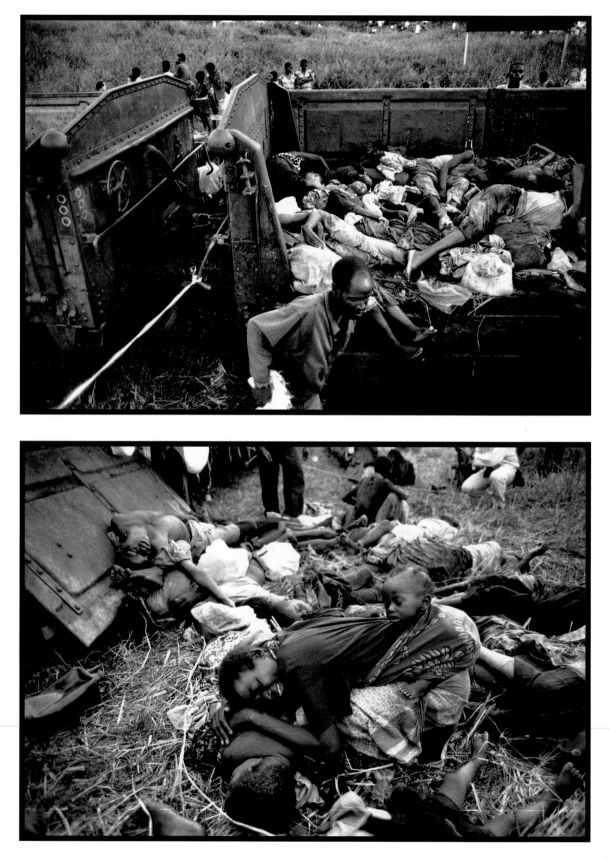

(continued) When the train arrived in Kisangani about
100 people had died in the crush.

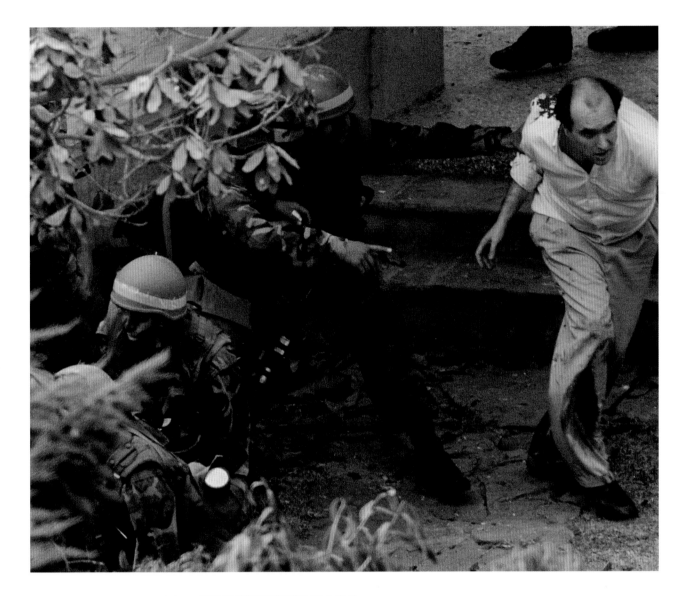

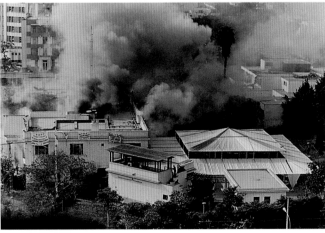

· Silvia Izquierdo
Peru, Reuters

3RD PRIZE STORIES

On December 17, 1996, members of the Tupac
Amaru Revolutionary Movement (MRTA)
dressed as waiters occupied the Japanese
ambassador's residence in Lima, the capital of
Peru, where a reception was in progress.
Most of the hostages they took were released
in January, but further negotiations dragged
on for months. Finally, on April 22, a minutely
planned commando operation was carried out
in which all 14 rebels and two commandos
were killed. One hostage also perished;
the remaining 71 were freed. Above: Soldiers
help Francisco Tudela, Peru's foreign minister,
to safety shortly after the first explosion
signaled the start of the rescue operation
(story continues).

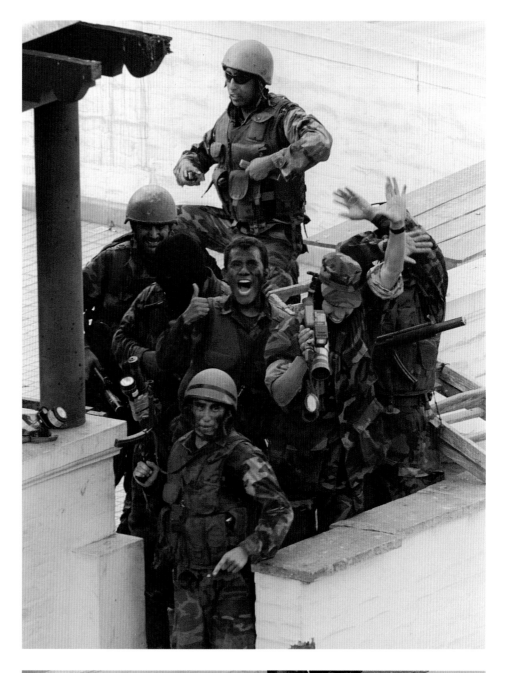

(continued) Below right: Commando Captain Raúl Jimenez is evacuated by his comrades over the roof of the Japanese ambassador's residence. He suffered injuries by grenade shrapnel to his throat and died shortly afterwards. Right: Members of the Chavin de Huantar commando unit celebrate the recapture of the building and the rescue of 71 of the 72 hostages.

People in the News

· Joachim Ladefoged
Denmark, Politiken

3RD PRIZE SINGLES *(following pages)*
1ST PRIZE STORIES

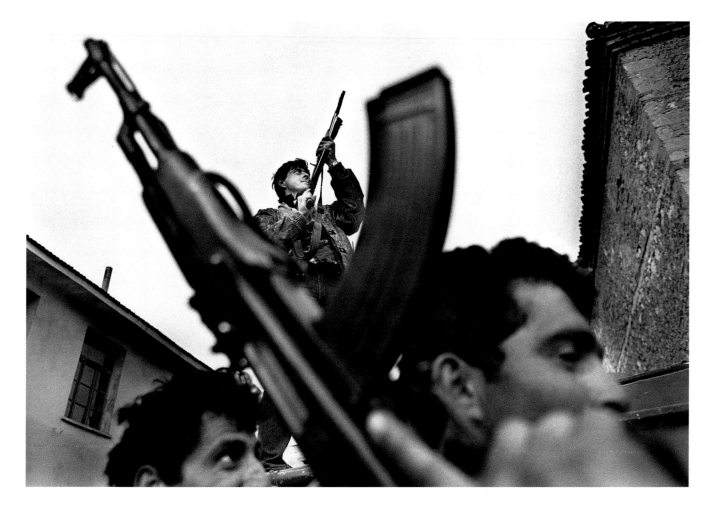

Already Europe's poorest country, Albania was afflicted by economic and political turmoil at the beginning of 1997. For weeks outbreaks of armed violence were the order of the day, particularly in the south. In January the police had been thrown out of the town of Vlore, but by April they gradually resumed their patrols. Following pages: Faslli Veisllari was hit by a stray bullet in the town of Berat, where the violence claimed more than 200 lives *(story continues).*

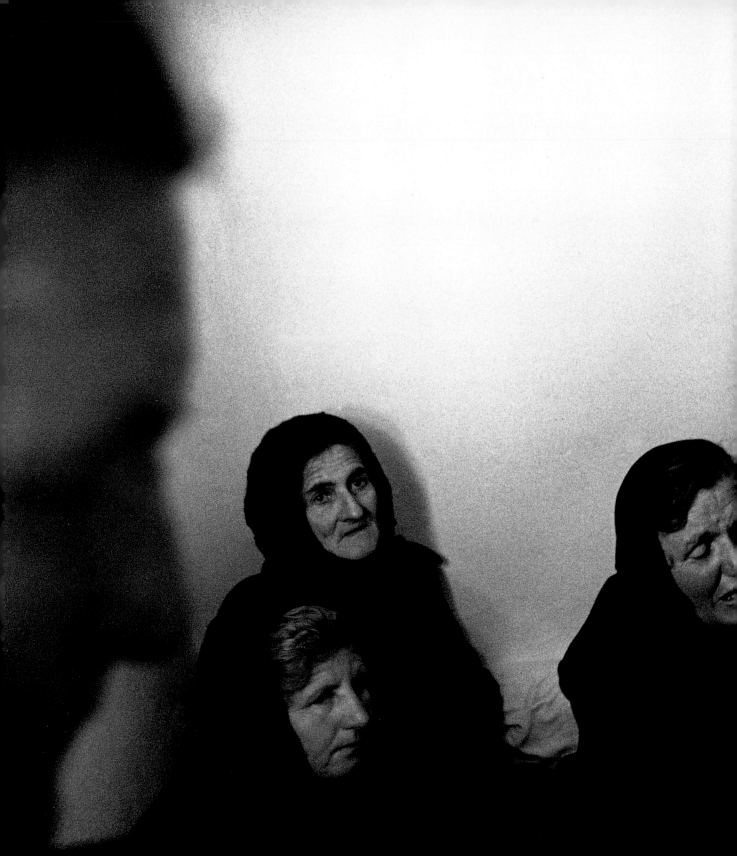

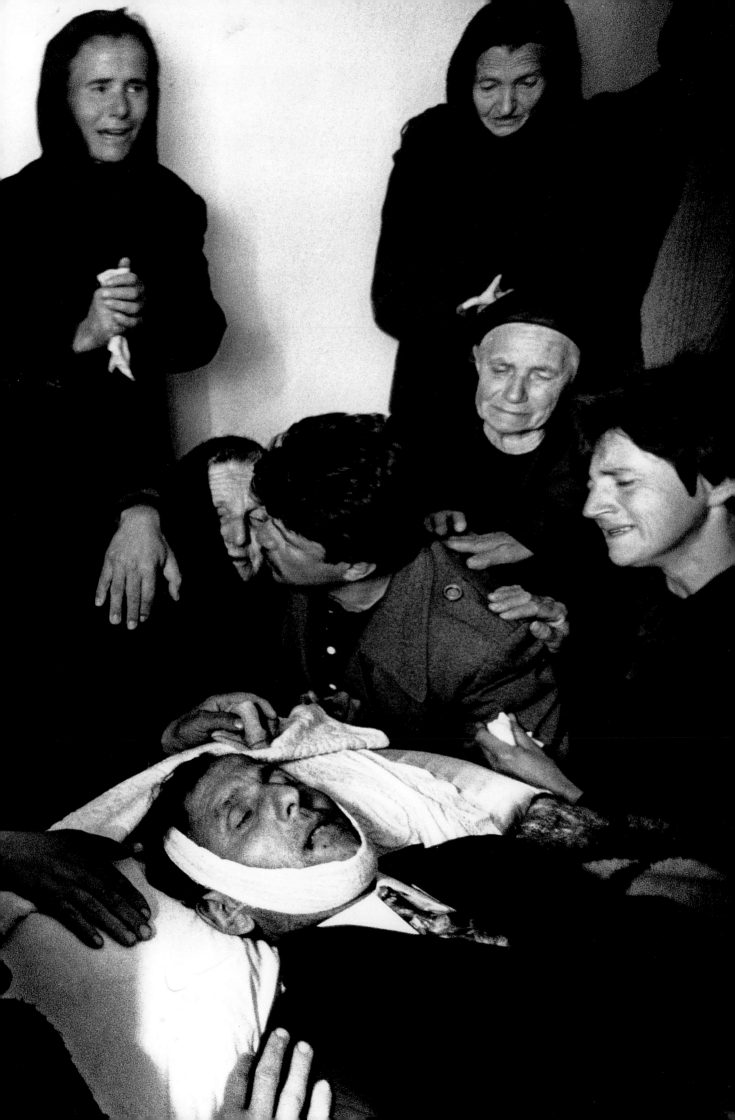

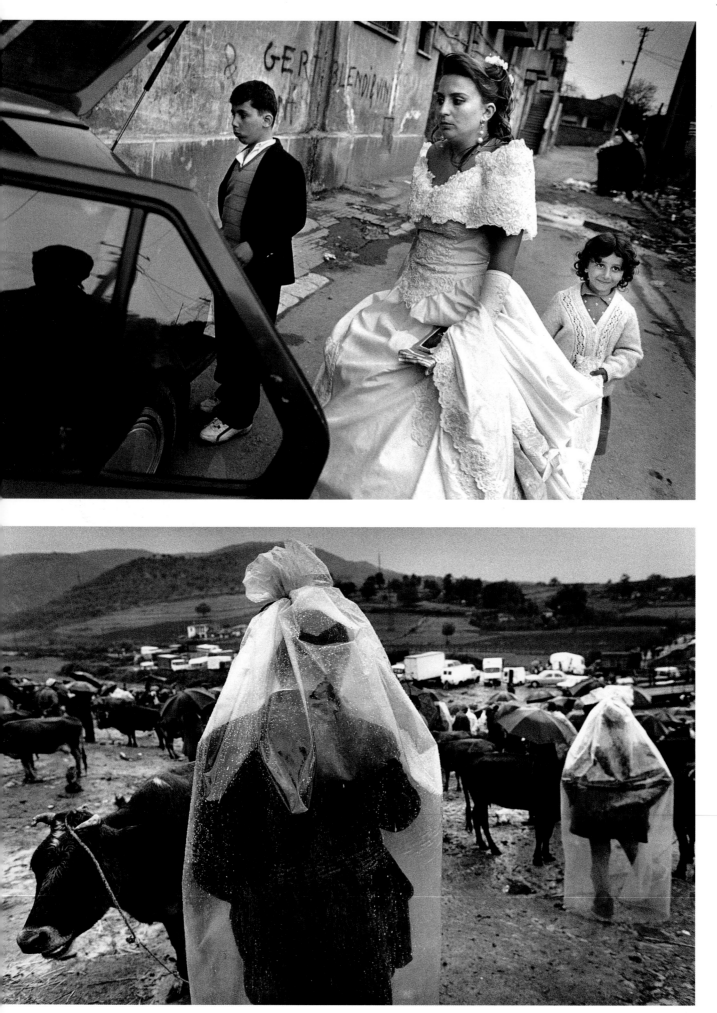

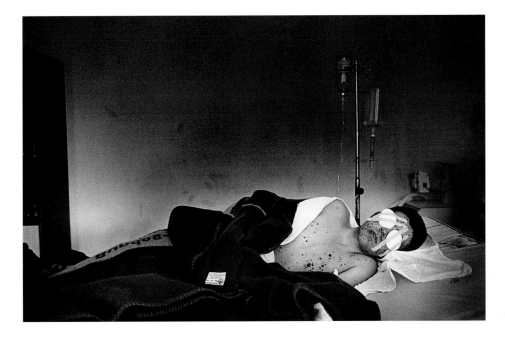

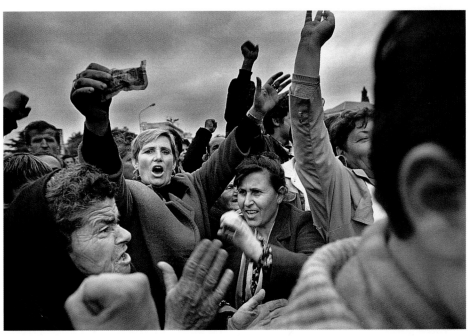

(continued) Facing page: A bride and groom on their way home from their wedding and a cattle market show a more peaceful face of Albania. This page from top: This boy lost both his eyes while playing with live ammunition. An anti-government demonstration in the town of Vier. Twelve-year-old Ilir Gera lives in a poor quarter of the Albanian capital Tirana. His father is in prison convicted for murder *(story continues)*.

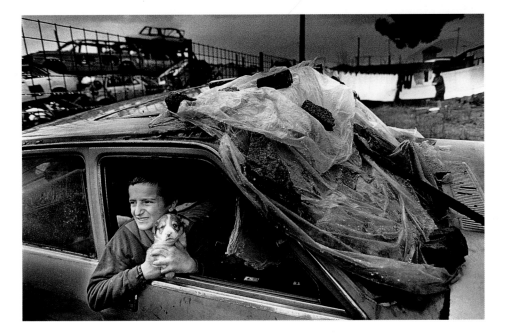

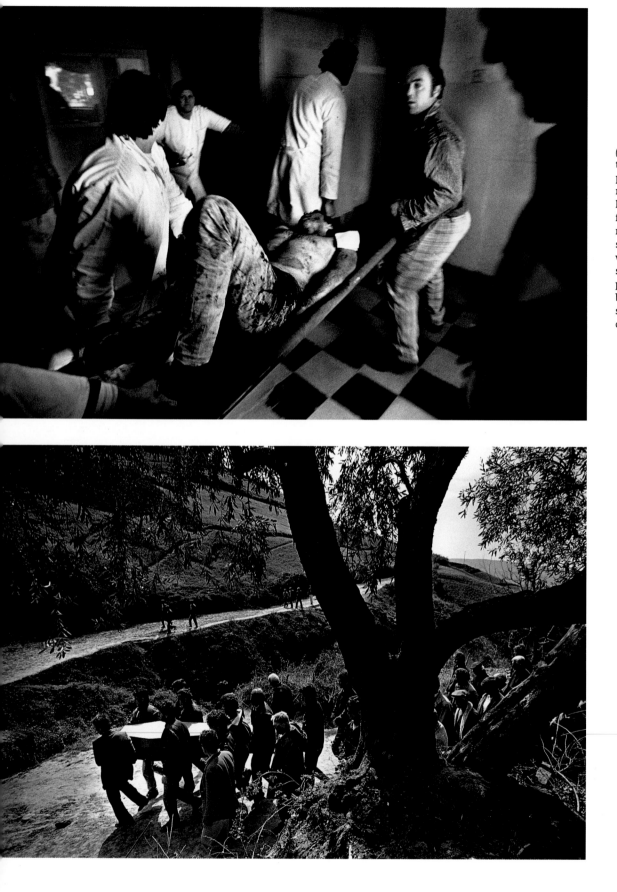

(continued) Shot within two days in March, these pictures show an injured rebel's arrival at the hospital in Vlore and the funeral of one of the many casualties of the short-lived Albanian civil war. As negotiations to send a multinational peacekeeping force were being concluded, the situation started to calm down.

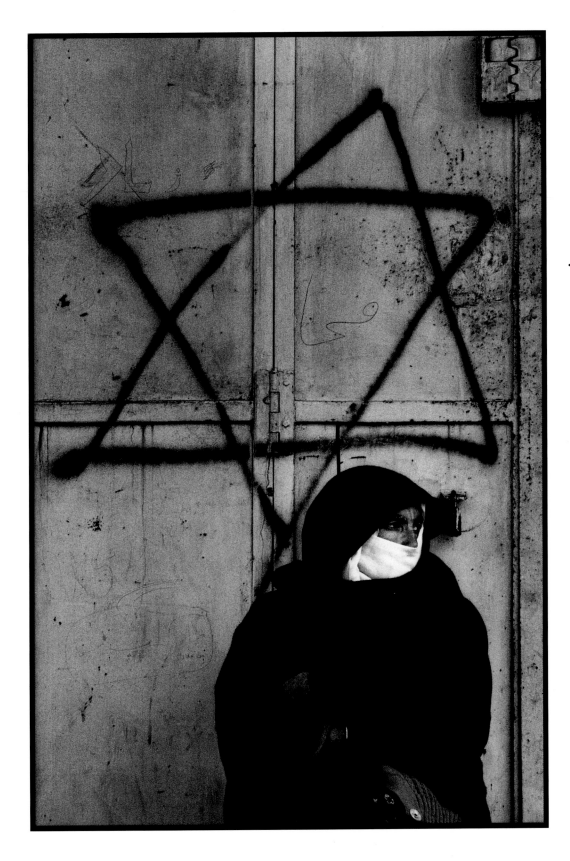

· Judah Passow
USA, Network Photographers,
United Kingdom

2ND **P**RIZE **S**INGLES
(following pages)
2ND **P**RIZE **S**TORIES

A wide-ranging photo
essay marking the tenth
anniversary of the be-
ginning of the *intifada*,
the Palestinian uprising
against Israel's occupa-
tion of the West Bank
and Gaza. This woman
was pictured in Hebron's
Central Market at the
time when Israel handed
most of the town back to
the Palestinians.
Following pages: Israeli
soldiers come to the aid
of an injured Palestinian
outside the Tomb of the
Patriarchs in Hebron
(story continues).

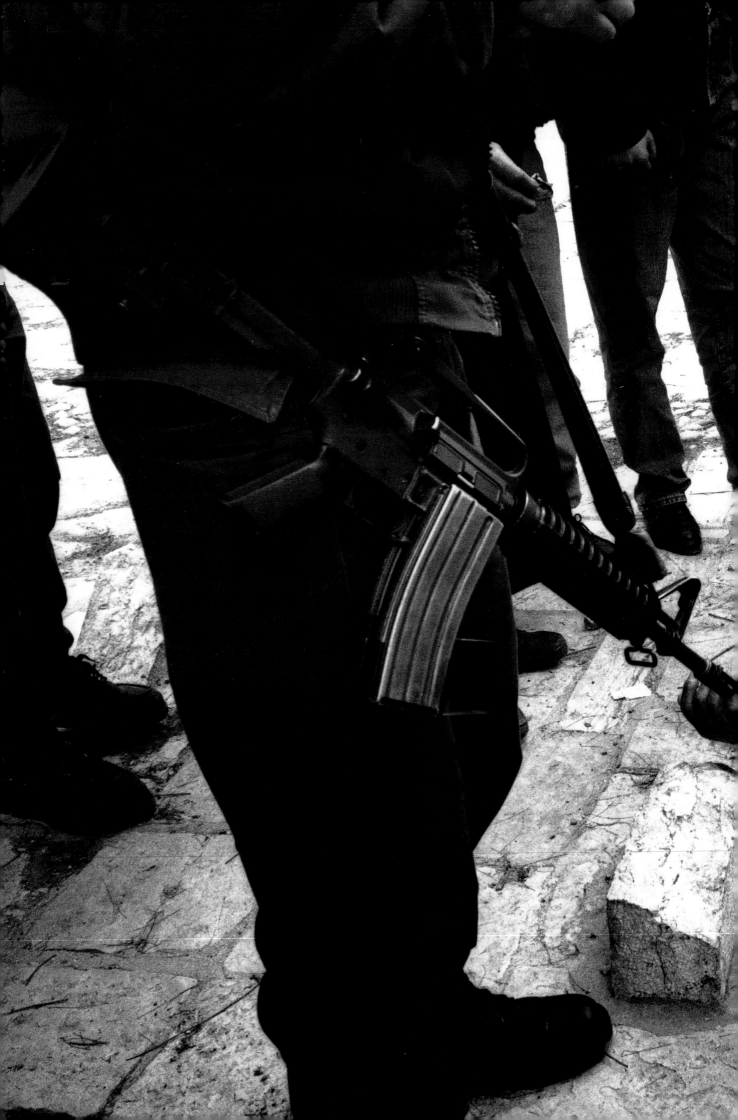

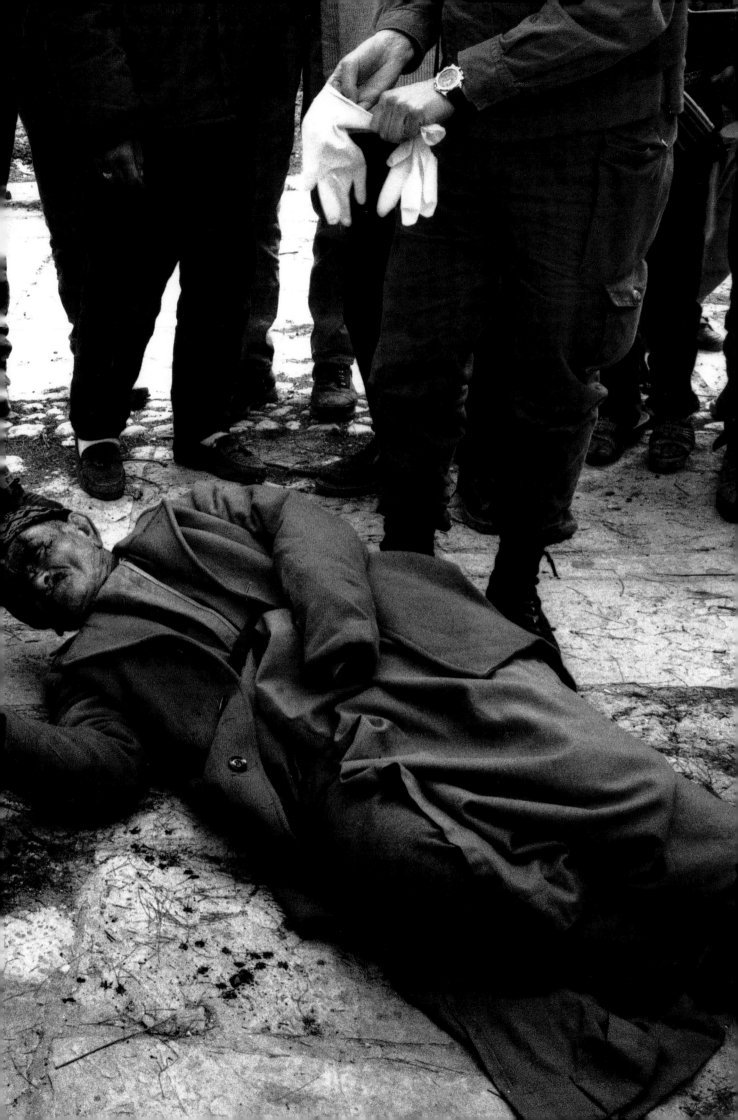

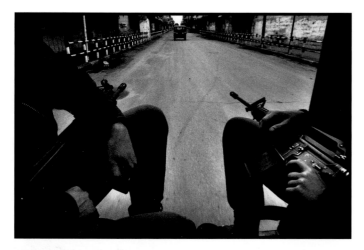

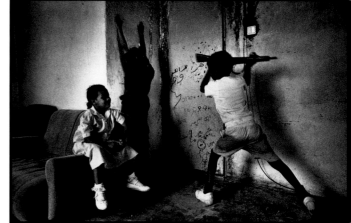

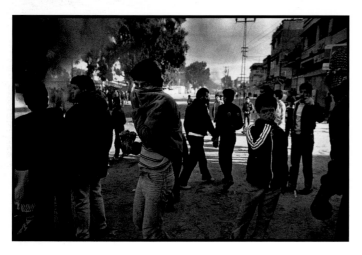

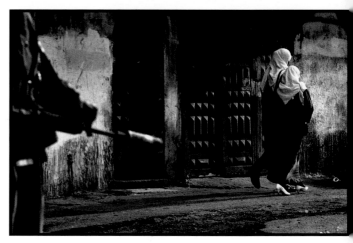

(continued) Armed Israeli patrols are a common sight in the streets of Gaza. Above left: Palestinian teenagers confront the Israeli army. Top right: For these children in the West Bank village of Fahme intifada has become a game. Facing page: With most of Hebron now under the control of the Palestinian Authority, there are three Israeli soldiers for every one of the town's 400 Jewish inhabitants.

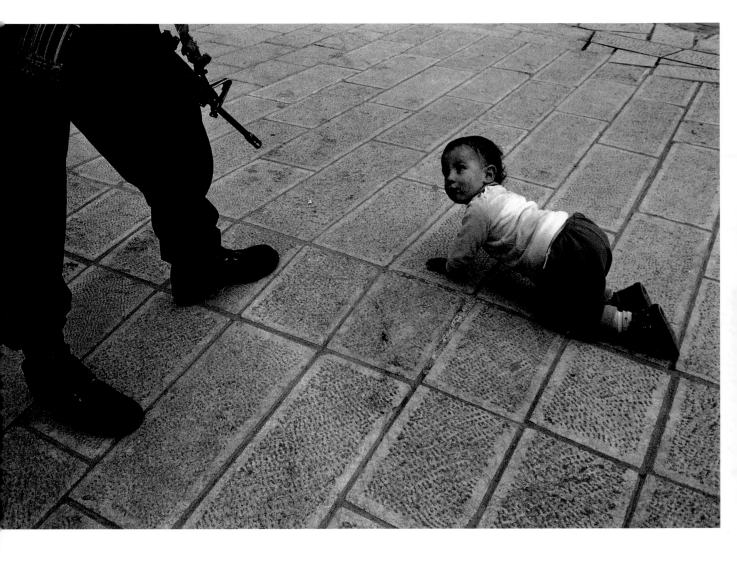

· David Modell
United Kingdom, Independent Photographers Group

3RD PRIZE STORIES

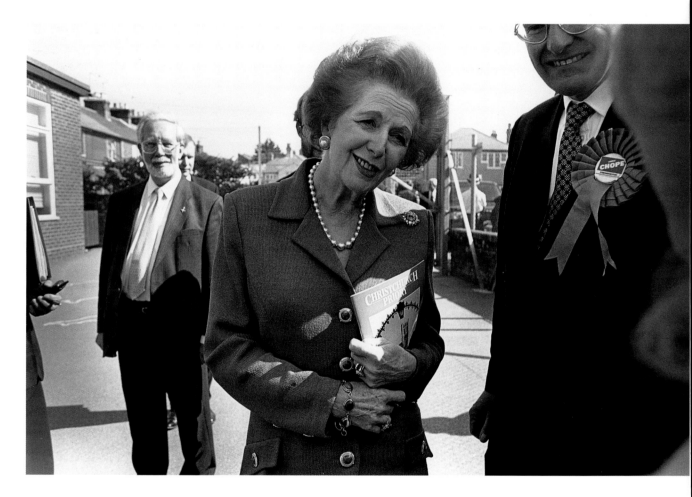

The British general election on May 1 spelled
the worst-ever defeat for the Conservative
Party. With only 31 percent of the vote, Prime
Minister John Major (shown on the following
pages waving to a supporter in Bournemouth)
had little choice but to resign. Above: Lady
Thatcher, Britain's first woman Prime Minister,
on the campaign trail at a school in
Christchurch. Facing page, top: Former
Conservative minister Neil Hamilton refused
to resign in the face of corruption charges. He
was one of the many Tories who lost their
seats. Bottom: Delegates at a Conservative
Party conference. *(story continues)*.

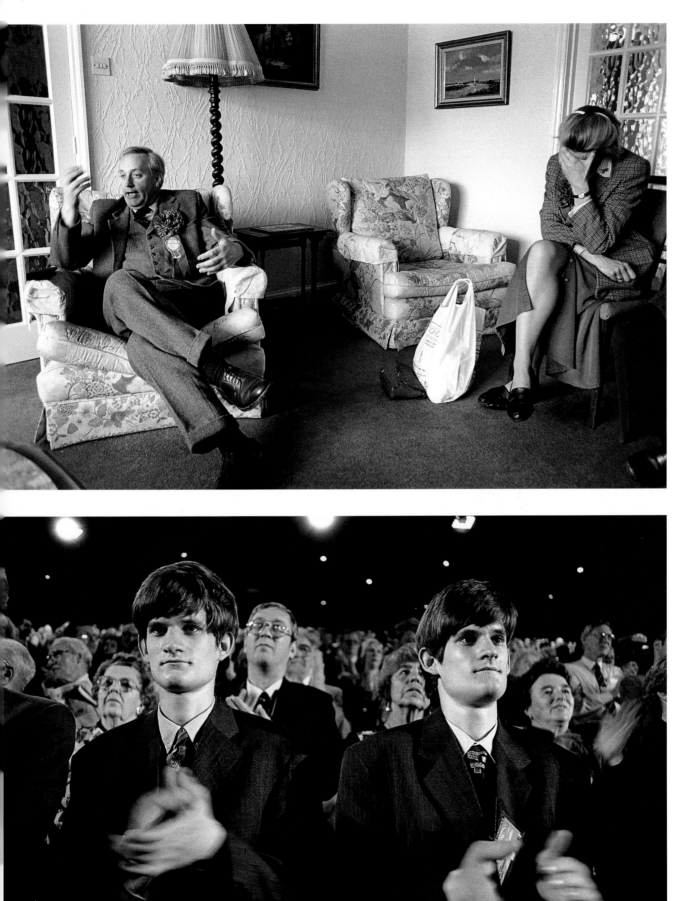

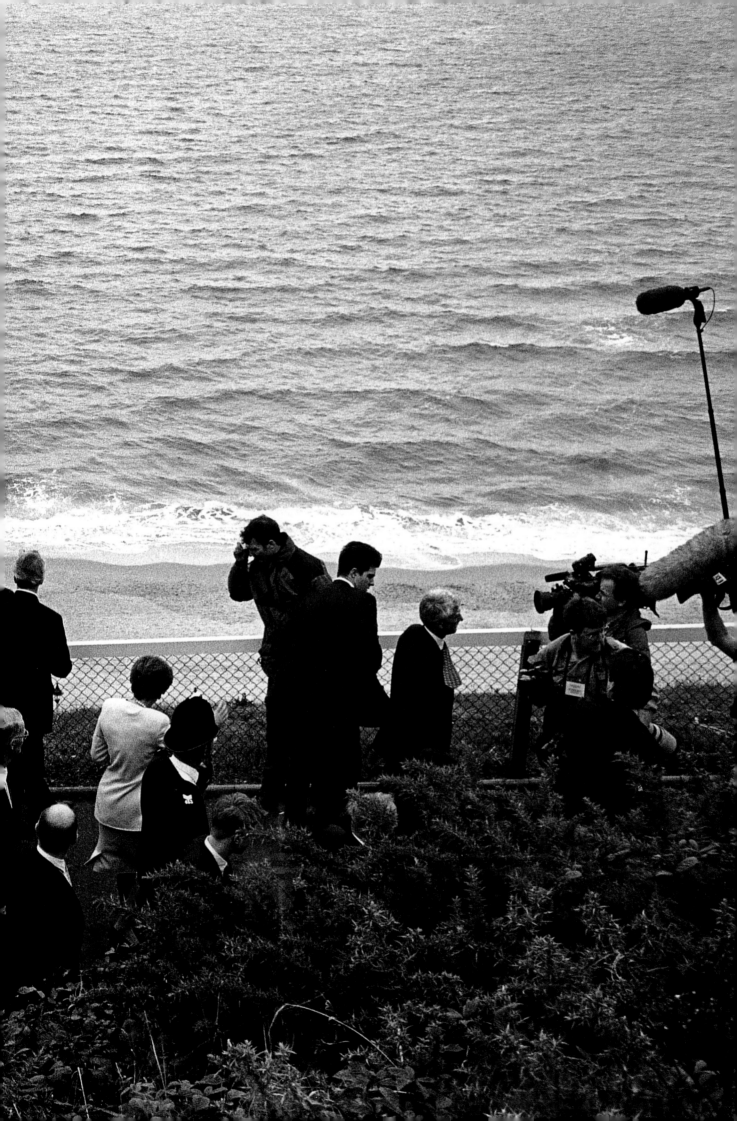

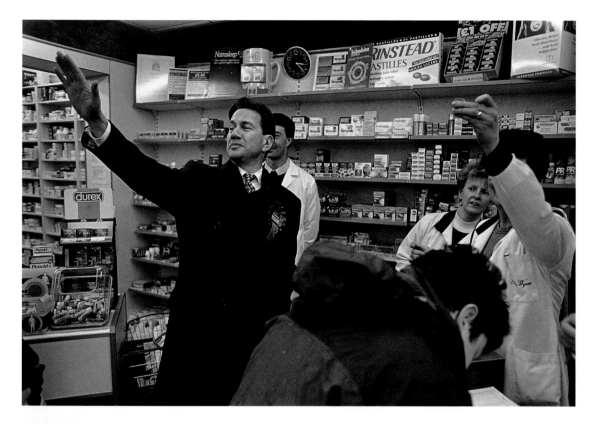

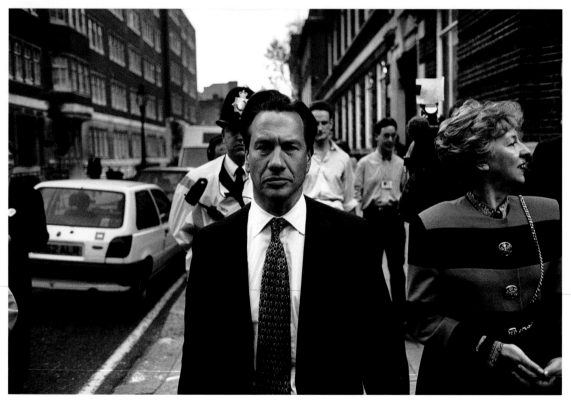

(continued) Before — and after. Left: In February Defense Secretary Michael Portillo campaigned for his party in a by-election on Merseyside. Below, he leaves Conservative Central Office after learning that he has lost his own seat in the general election.

Sports

· Jed Jacobsohn
USA, Allsport USA

1ST PRIZE SINGLES

Mike Tyson confirmed his reputation as the *enfant terrible* of boxing when he bit off a chunk of the ear of his opponent, Evander Holyfield. The incident occurred in the third round of a world heavyweight title fight held in Las Vegas on June 28. Tyson was disqualified, fined and suspended indefinitely. He also had to pay back his US$30 million fee. The damage to Holyfield's ear was surgically repaired.

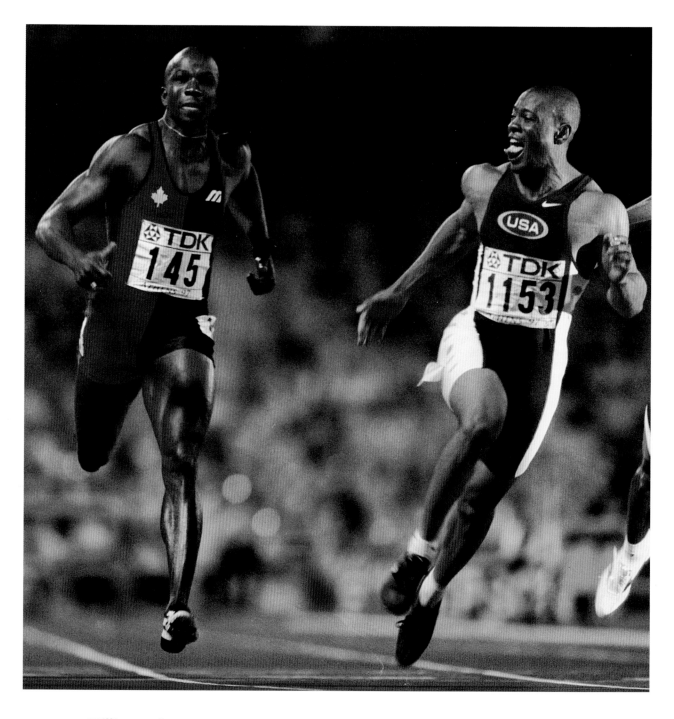

· **William Frakes**
USA, Sports Illustrated

2ND PRIZE SINGLES

The 100 meters is a key distance in any athletics
tournament. The World Championships held in
August in Athens, Greece, were no exception.
Much taunting and challenging between two of the
title candidates, Canadian world record holder
Donovan Bailey (left) and 23-year-old US athlete
Maurice Greene, preceded the race. Greene stuck his
tongue out at his opponent as he crossed the
finishing line first in 9.86 seconds.

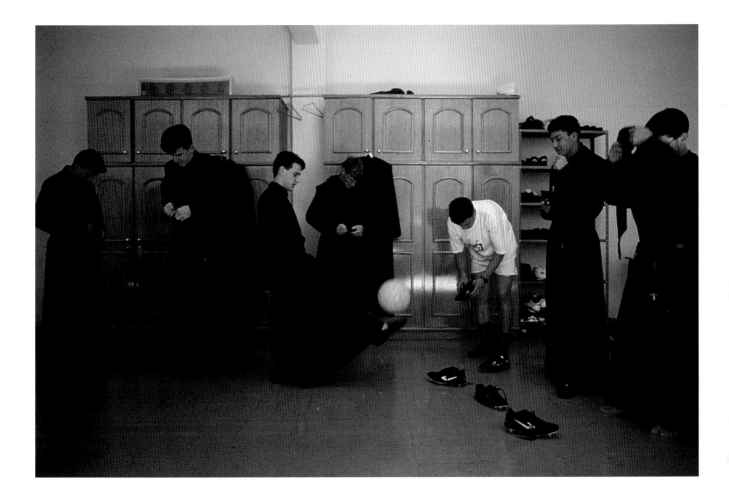

· Christopher Pillitz
Brazil, Network Photographers,
United Kingdom for Stern, Germany

3RD PRIZE SINGLES

Priests at the Santo Agostino
seminary 200 kilometers west of
Rio de Janeiro prepare for a game
of football. The picture is part of a
story on football being played in
sometimes surprising locations all
over Brazil: in slums and on
beaches, on top of skyscrapers
and on oil platforms.

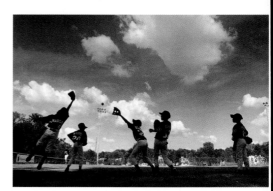

· Eric Mencher
USA, The Philadelphia Inquirer

1ST Prize Stories

For ten scorching days the Anderson Monarchs, a Little
League baseball team of African American 10- and 11-year-
olds from South Philadelphia, toured the eastern United
States. In an attempt to recreate the atmosphere of the
Negro Leagues' barnstorming tours of the 1930s and '40s,
they traveled over 3,000 kilometers in a cramped old bus.

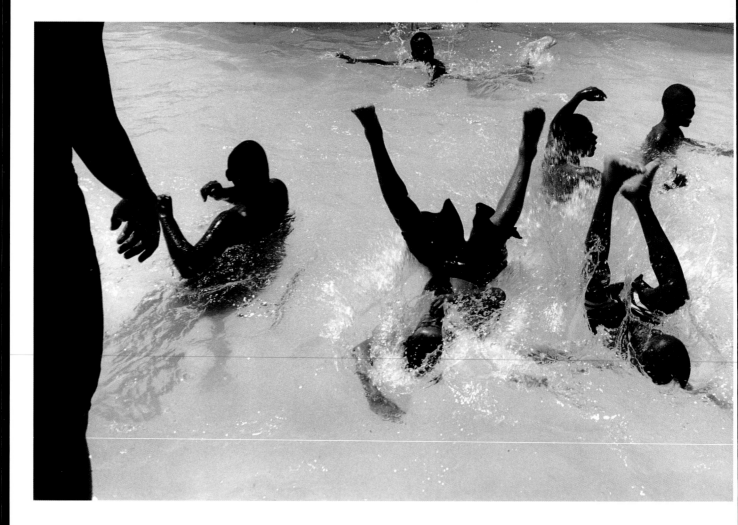

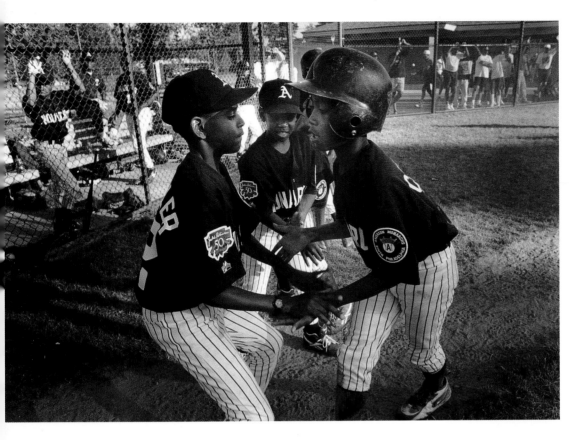

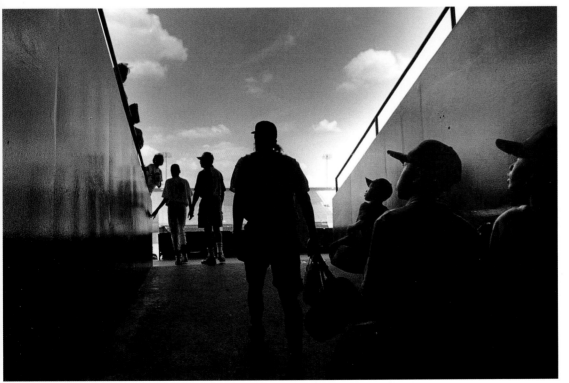

Between games and long
bus rides (following
pages) the boys frolicked
in motel pools and visited
Minor League ball parks.

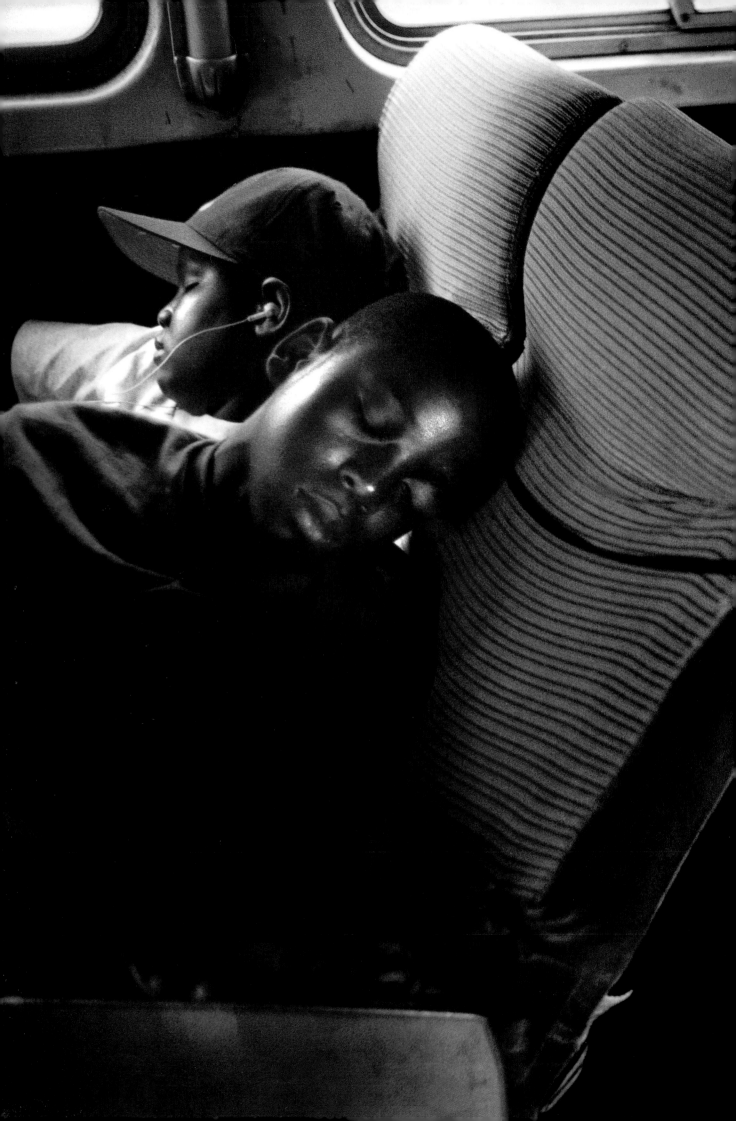

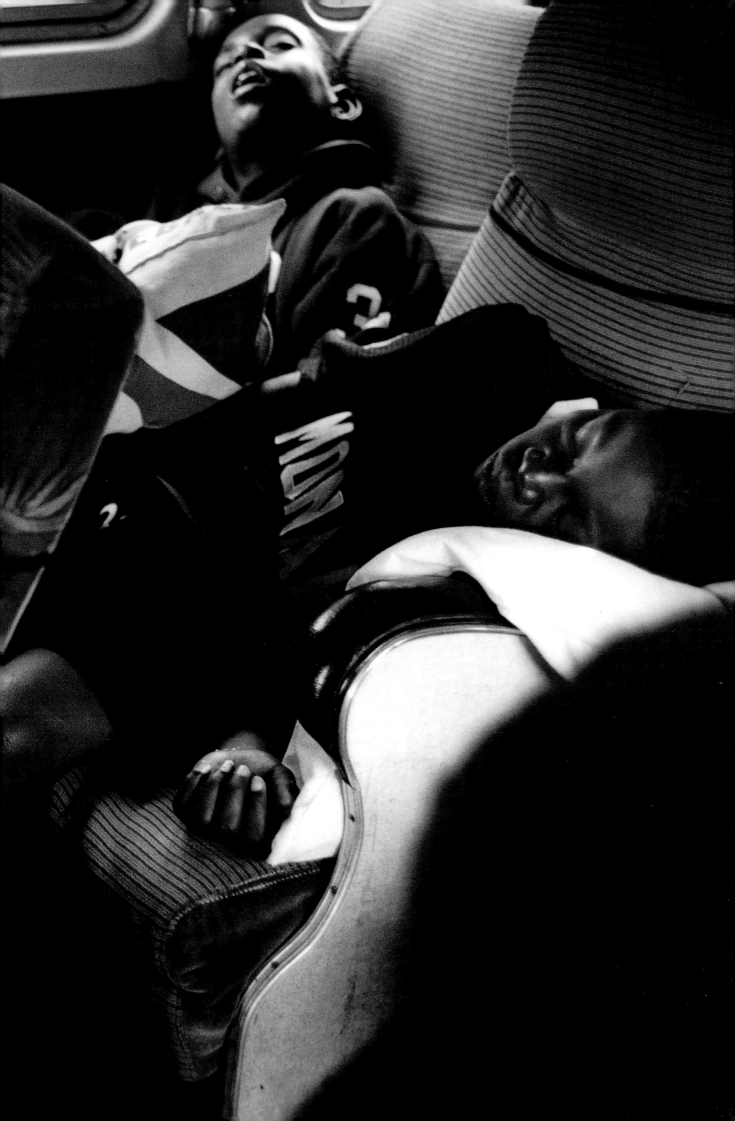

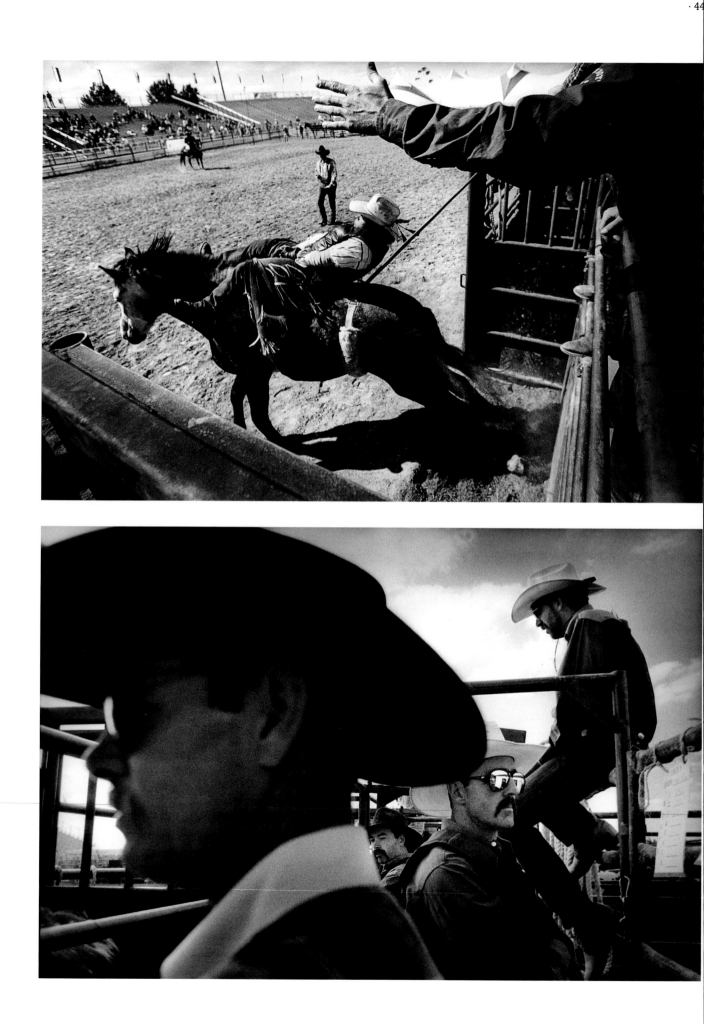

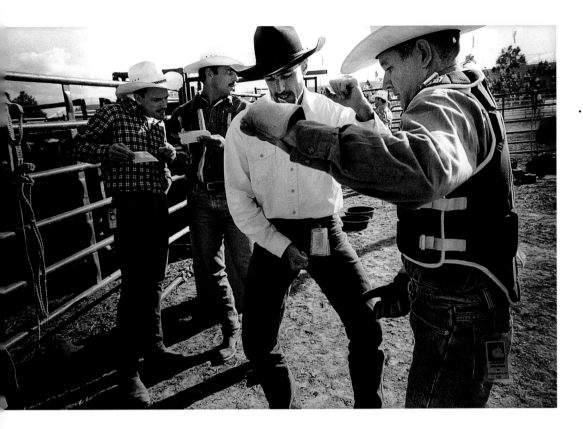

· Aristide
Economopoulos
USA, The Jasper Herald

2ND PRIZE STORIES

Gay rodeos enjoy increas-
ing popularity in North
America. They are action-
packed events attracting
crowds interested in both
the social and sporting
aspects. Shot outside
Washington DC, this story
shows bronco practice
before the start of the
competition and cowboys
awaiting their turn, a
discussion about riding
techniques and a warm
greeting between friends.

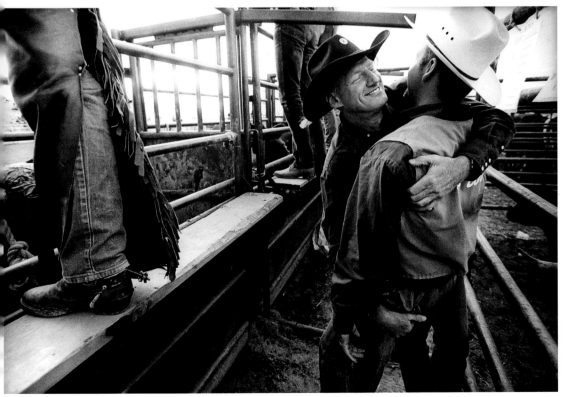

· Dudley M. Brooks
USA, The Washington Post

3RD PRIZE STORIES

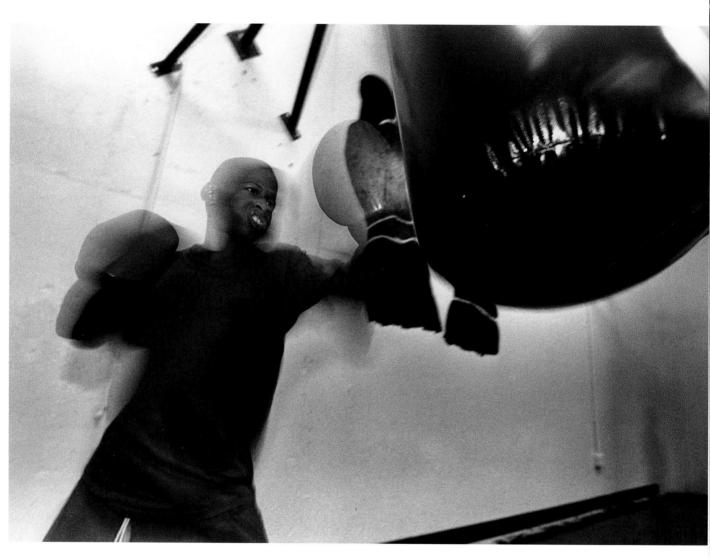

The steadfast support of his
father Henry and mother May
enabled 12-year-old Deion
Robinson to take part in the Silver
Gloves boxing competition in
Lennexa, Kansas. Cheered on by
his family, Deion made it through
the preliminary rounds, but he
was beaten in the semifinals.
Above, he is training on a heavy
punching bag at the rear of a local
restaurant. The facing page shows
him in other training situations,
being coached by his father (top)
and a coach who accompanied his
team to Lennexa *(story continues)*.

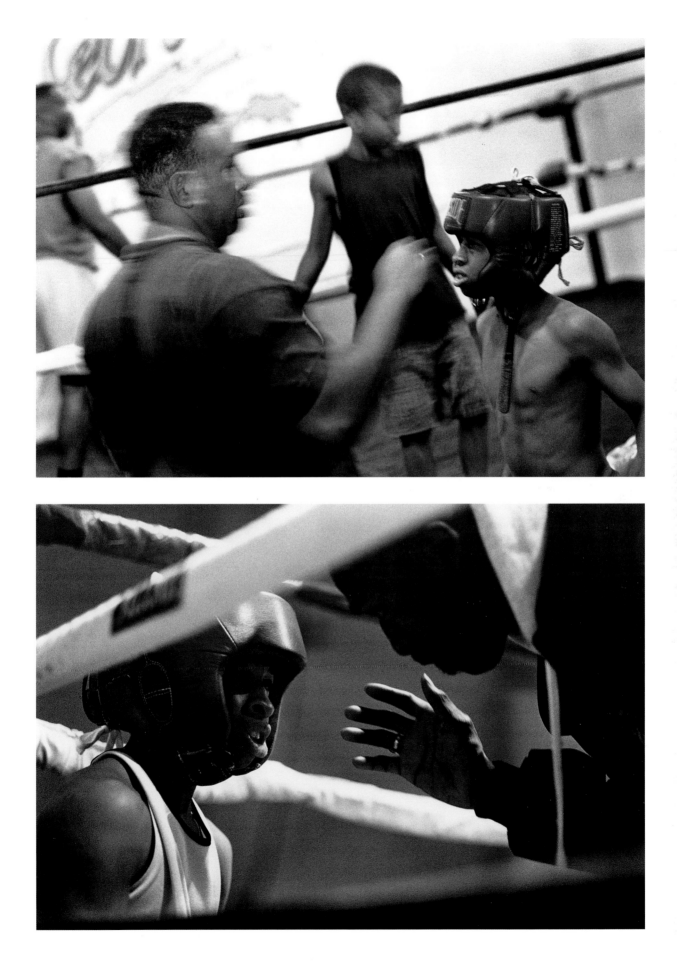

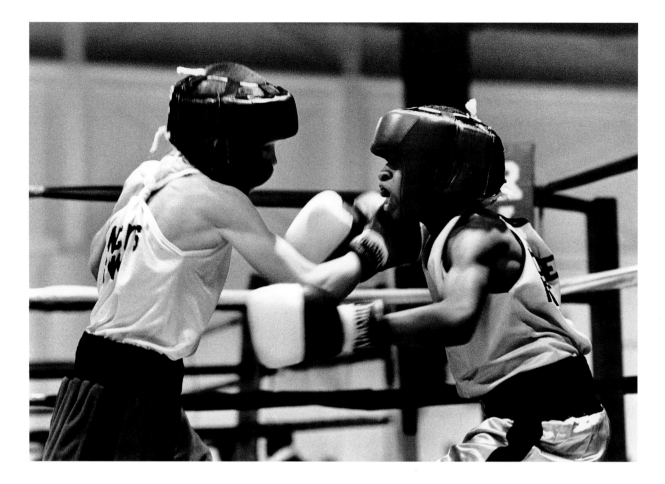

(continued) With the semi-final in full swing, the boys trade blow for blow. Deion was narrowly beaten in the last of three rounds. After the game he dropped his fighting face and sought solace in his mother's arms.

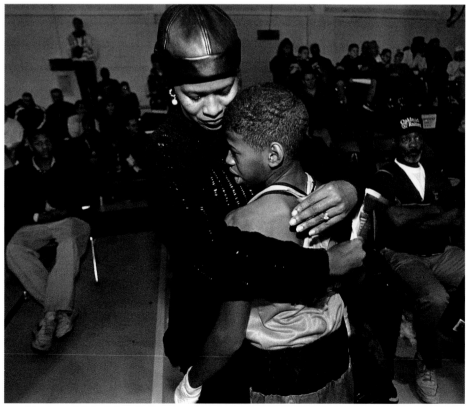

· Craig Golding
Australia, Sydney Morning Herald

HONORABLE MENTION STORIES

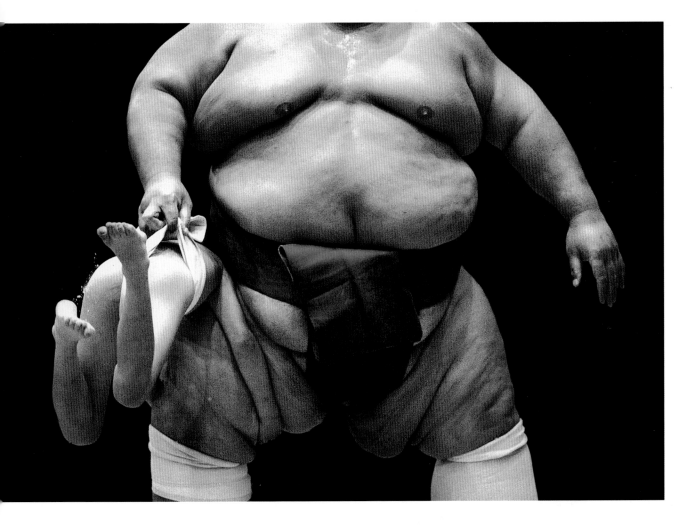

In mid-June, 36 of the world's top 40 sumo wrestlers gathered in Sydney to compete in the Australian Grand Sumo Tournament. On the second night Takanohana emerged the winner after defeating the only other wrestler boasting the rank of *yokozuna* (champion of champions), the Hawaiian Akebono. Above, a sumo wrestler lifts up a small boy as part of the entertainment before the matches *(story continues)*.

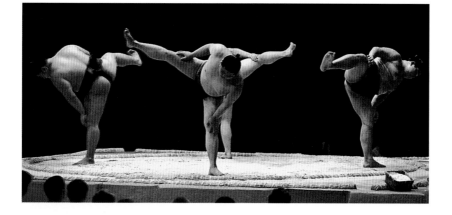

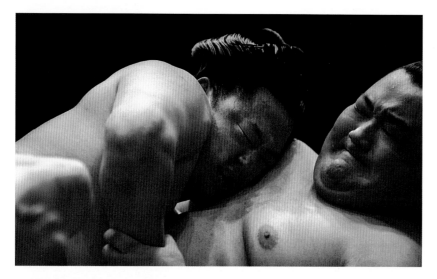

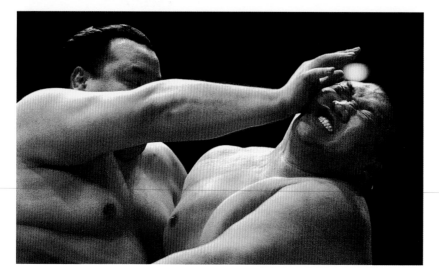

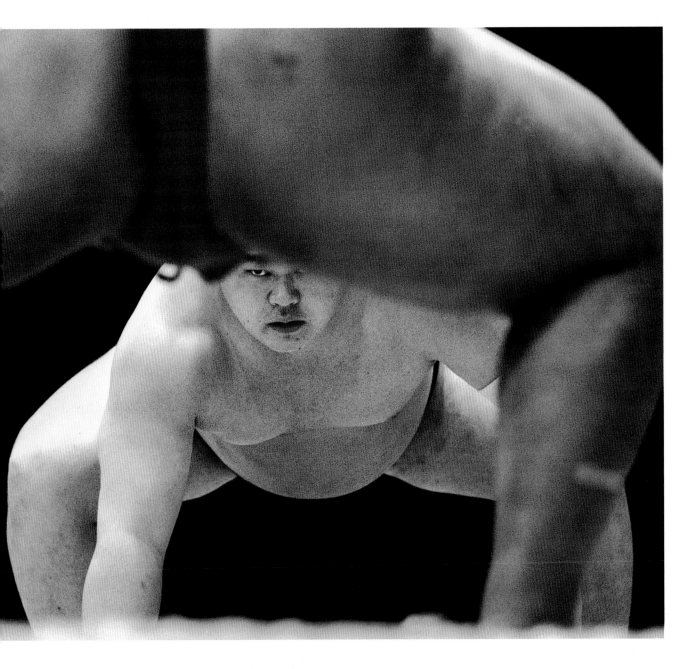

(continued) Sumo wrestlers glare at each other moments before they charge. Facing page: After the initial ceremonials the fight is on.

Portraits

· Michael S. Wirtz
USA, The Philadelphia Inquirer

1ST PRIZE SINGLES

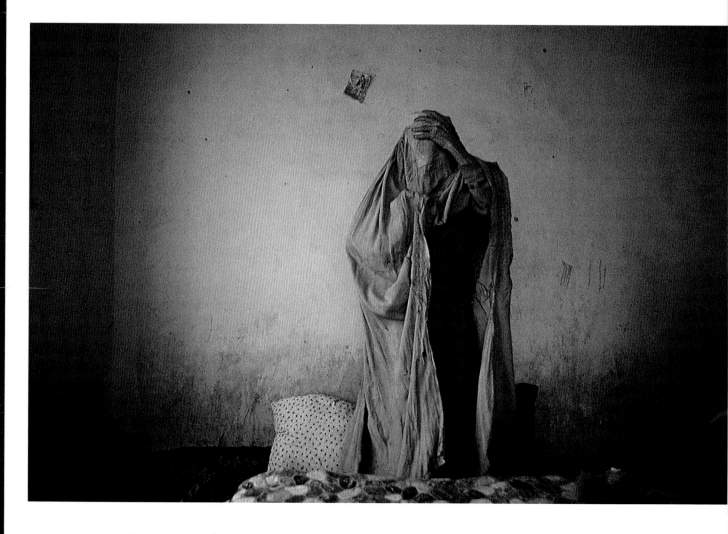

Dress conventions for
women in Afghanistan
were profoundly affected
by the government take-
over of 1996. When the
strict Islamic Taliban
movement came to
power all women were
required to cloak them-
selves in the *burka*,
which covers even the
eyes. This woman is
preparing to leave her
home in Kabul, the
Afghan capital.

· Peter Dammann
Germany, Mare Magazine

2ND PRIZE SINGLES

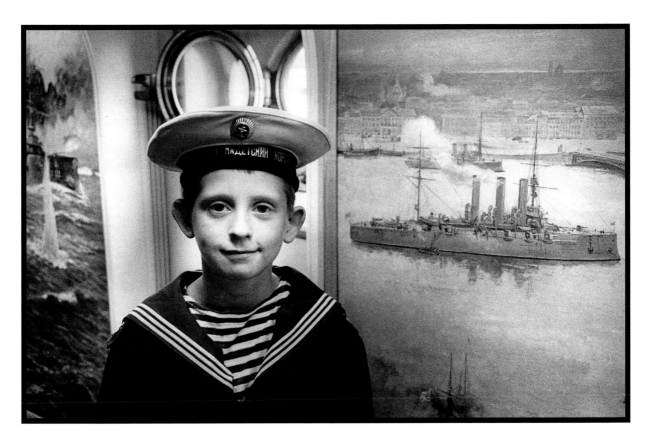

Sergei Kamynin is a cadet at St. Petersburg's new naval
academy on the island of Kronstadt, where time-honored
methods are used to drum traditional skills and values
into him and his fellow students. He is pictured aboard the
cruiser Aurora, which played a key role in the October
Revolution of 1917.

· Carol Guzy
USA, The Washington Post

3RD PRIZE SINGLES

Muhammad Ali (56) has
come a long way since he
established his reputation
as the promising young
boxer Cassius Clay. He is
shown reminiscing amidst
boxing memorabilia in the
barn of his farm in Berrien
Springs, Michigan, where
he once trained for his big
fights. Though stricken
with Parkinson's disease,
he is actively involved with
various humanitarian
causes.

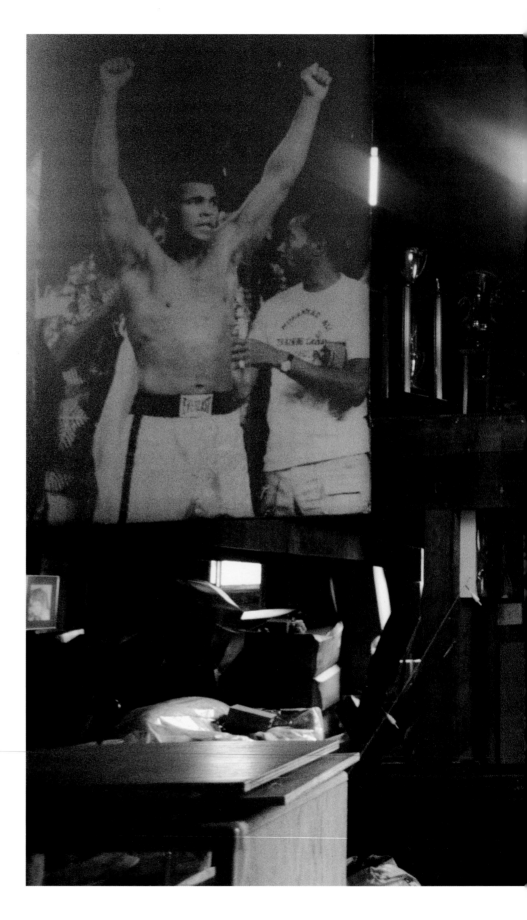

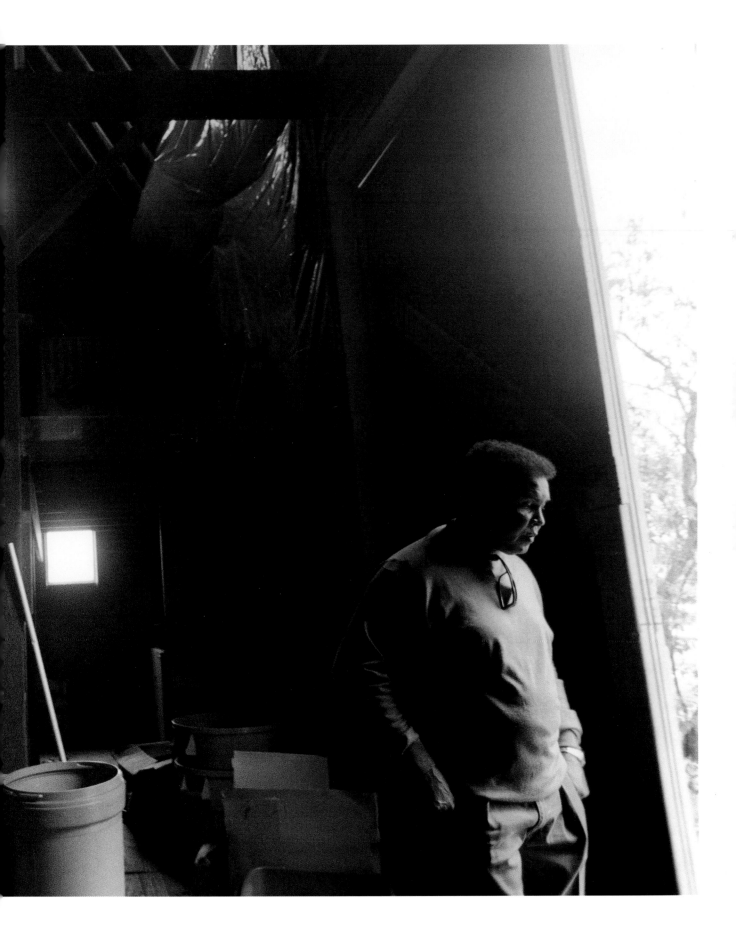

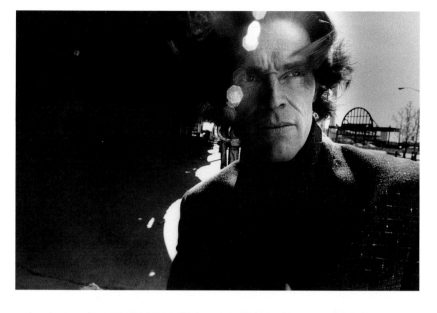

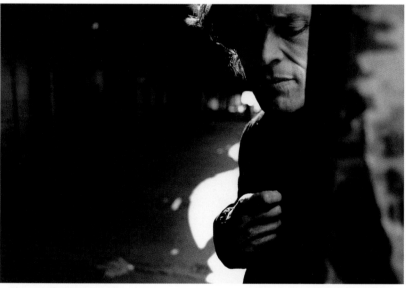

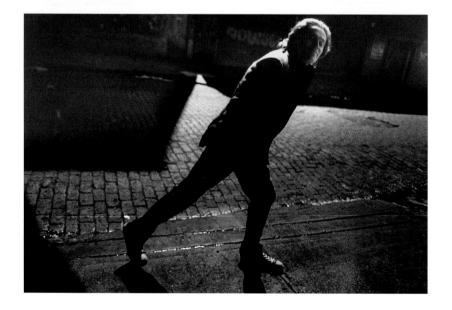

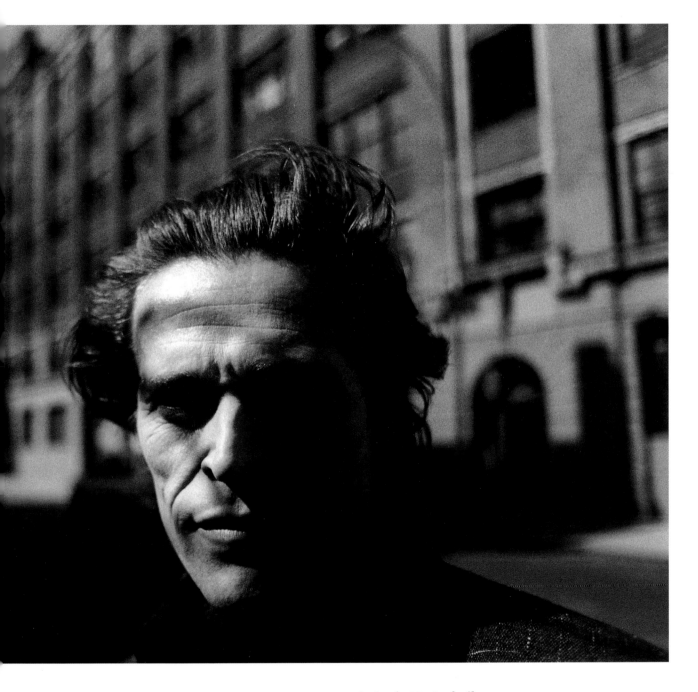

· Antonin Kratochvil
Czech Republic, Saba Photo for Detour Magazine, USA

1ST PRIZE STORIES

Sweet Willem is the title the photographer gave to these portraits of US actor Willem Dafoe. Having grown up in a large family in the American Midwest, Dafoe started his movie career in the notorious loss-maker *Heaven's Gate*. In 1986 he received an Oscar nomination as best supporting actor for the Vietnam film *Platoon*. His recent roles in *The English Patient* and *Speed 2: Cruise Control* illustrate the versatility of his talent.

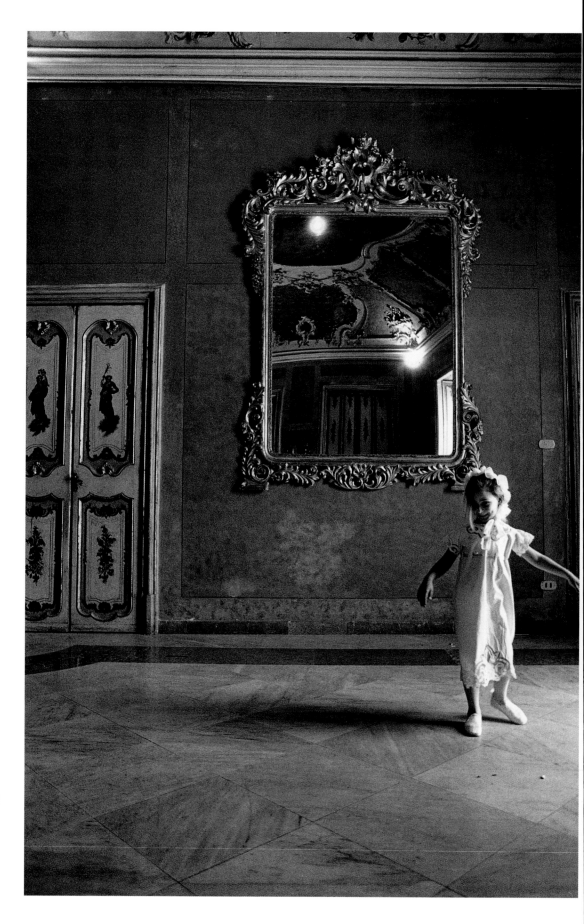

· **Shobha**
Italy, Agenzia Contrasto

2ND PRIZE STORIES

A Sicilian herself, the photographer was allowed access to the splendid residences and private lives of Sicily's aristocracy, a world at once austere and surreal. Although modern times have changed the lives of especially the young, these "heirs of the Gattopardo" — a reference to Tomasi di Lampedusa's famous book — continue to indulge their aristocratic tastes. Right: The daughter of a noblewoman at the Palazzo Asmundo.

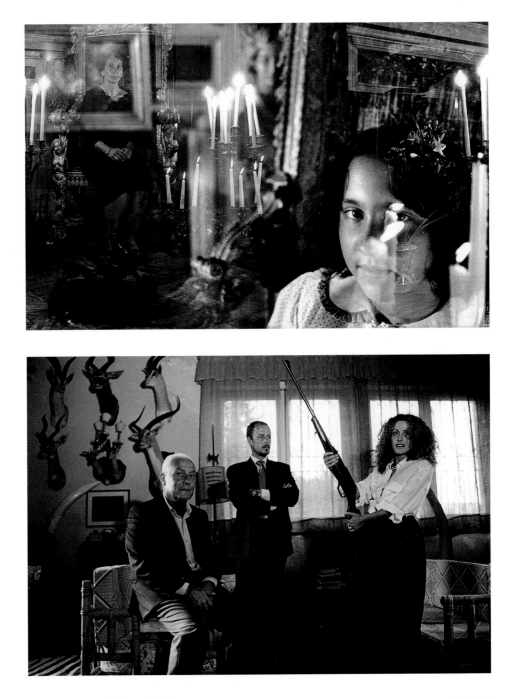

From top: Donna Paramita Moncada dei Principi di Paternó poses with her daughter at the Palazzo Butera. At the Castello Paternó, the ancestral residence, Duke Enrico of Carcaci is portrayed with his son Gino and Donna Chicca. Three generations of the Arezzo family relax around the pool of their country house. Following pages: Marchioness Anna Monroy di Spedalotto makes a stylish appearance outside the Villa Spedalotto.

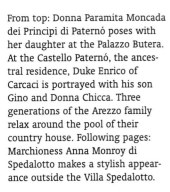

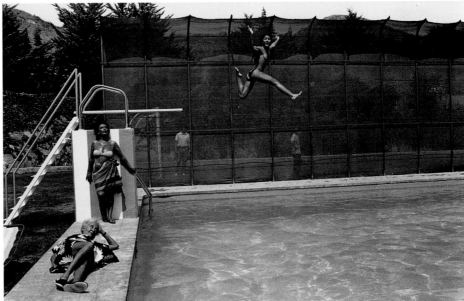

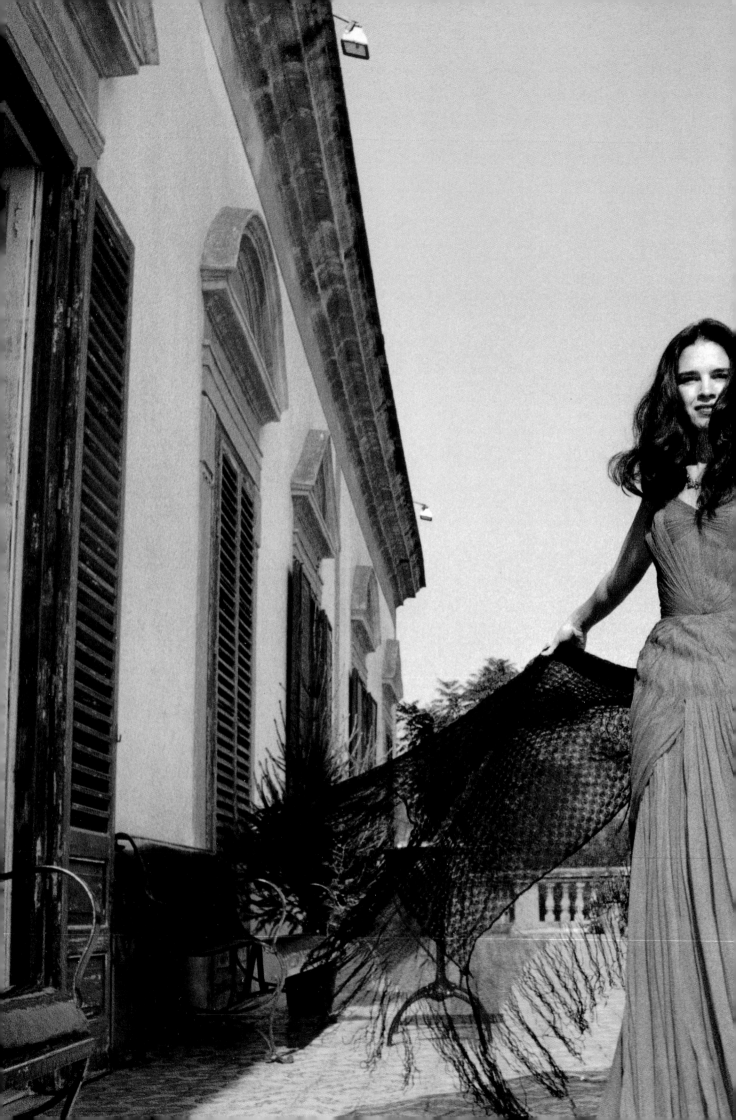

· **Tom Stoddart**
*United Kingdom, Independent
Photographers Group*

3RD PRIZE STORIES

The UK's general election,
appropriately held on
Europe's Labour Day,
brought a landslide victory
for Tony Blair's New Labour.
With 45 percent of the vote
the party scored its largest
victory since 1945.
Introducing a style of
government he promised
would be modern and
dynamic, Blair waived
traditional protocol and
insisted that first names be
used in his new cabinet.
This picture story of Blair's
election campaign shows
him keeping in touch with
his HQ by mobile phone,
sharing a drink with
members of the Trimdon
Pigeon Fanciers Club and
enjoying a rare quiet
moment with his wife
Cherie *(story continues)*.

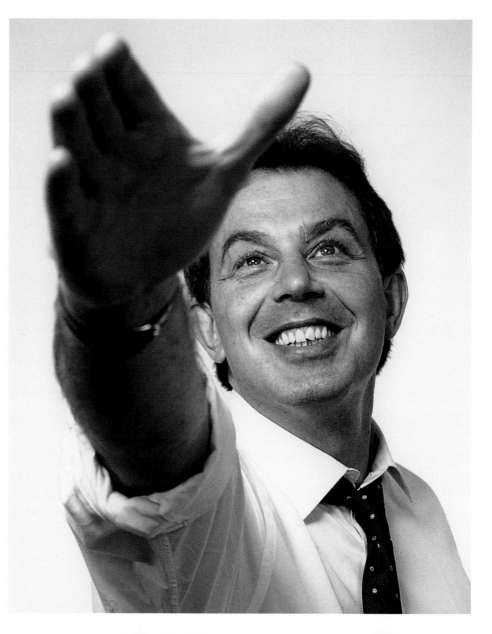

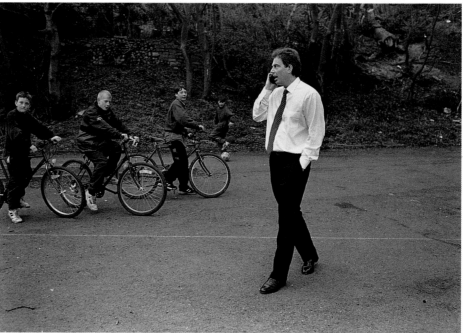

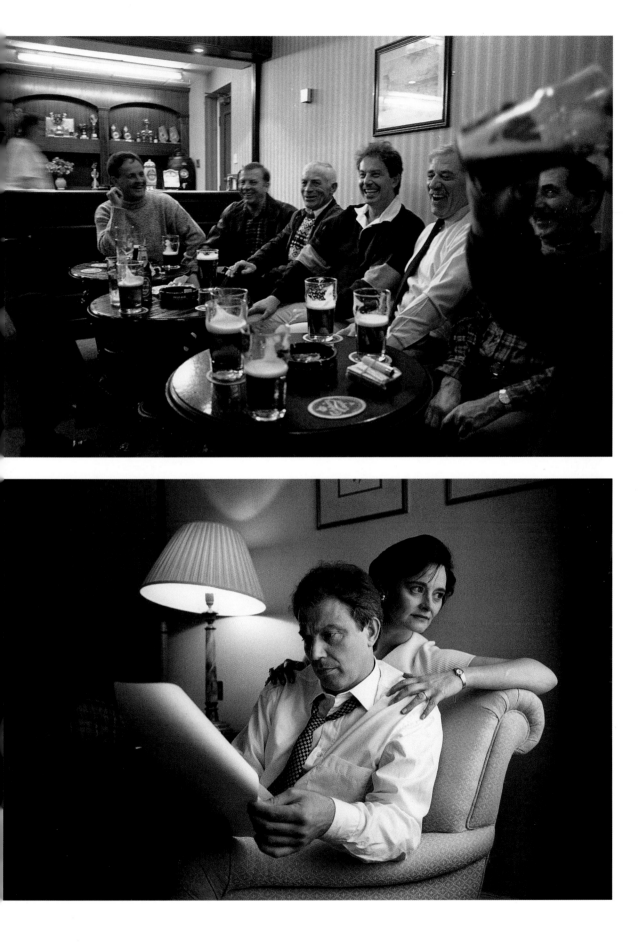

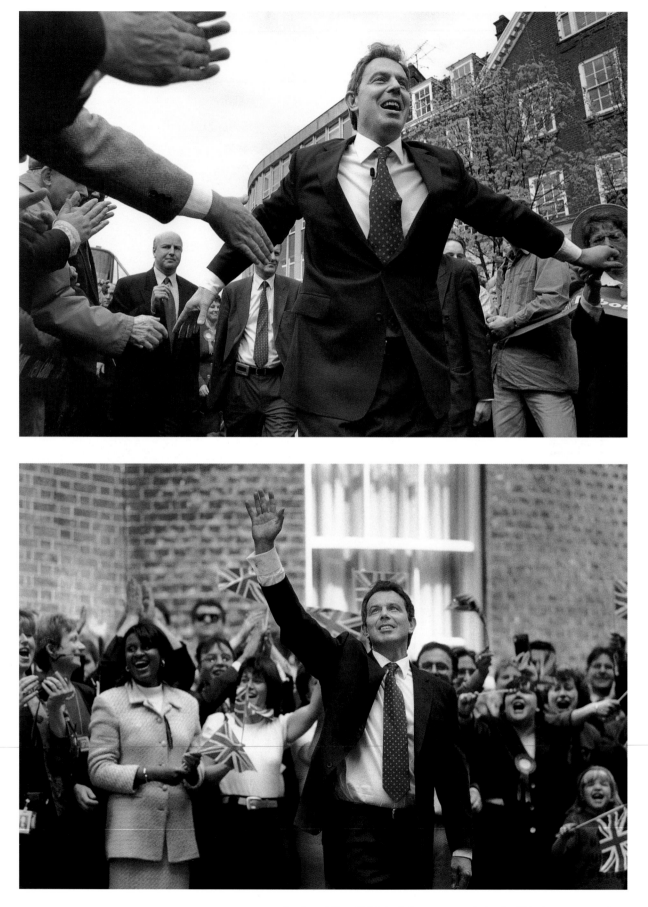

(continued) Tony Blair's body language speaks for itself during a stop on the campaign trail and upon his arrival at Downing Street, the British Prime Minister's official residence.

Science and Technology

· Stephen Ferry
USA, Gamma Liaison for Life Magazine

1ST PRIZE SINGLES

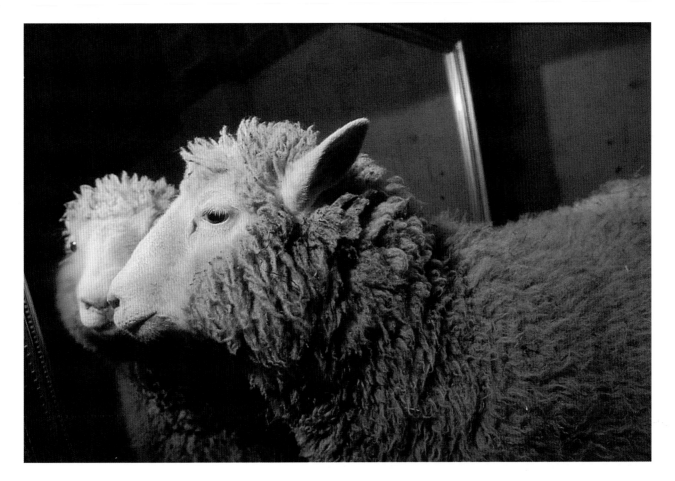

Dolly the sheep became the world's most controversial animal. Scientific history was written at the Roslin Institute in Scotland, which announced on February 22 that it had produced the first cloned mammal. Biologists took one mammary cell from an adult ewe and inserted it into a sheep's ovum, which divided and developed to become Dolly, carrier of an exact replica of her mother's DNA. The news sparked heated discussions about the ethics of cloning.

· Oliver Meckes and Nicole Ottawa
Germany, Eye of Science for Geo Magazine

3RD PRIZE SINGLES

Adult and juvenile specimens of *Phthirus pubis*
(pubic lice) hang on to two human hairs.
They transfer to a new "host" during coitus or
when people share the same bed. Without a host,
they die within 12 hours. The authors of this picture
use a complex procedure involving magnification
and digitization. They also cover their subjects with
a thin layer of gold to make them reflect light.

· George Steinmetz
USA, National Geographic Magazine

1ST **P**RIZE **S**TORIES

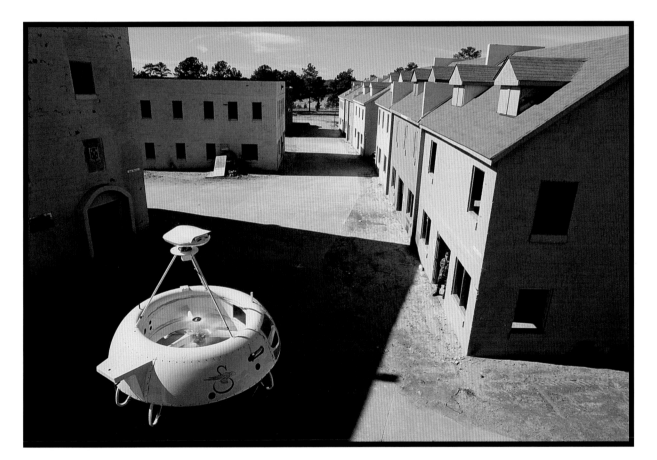

Visualizing the evolution of robotics, this story was shot in locations all over the US and in Osaka, Japan. Above, a robotic helicopter called Cypher shows off its surveillance technique in a mock town in Fort Benning, Georgia. Guided by a mouse on a computer screen, it can locate and track people and carry a 50-pound load for up to 48 kilometers. Cypher was designed to assist ground troops on dangerous missions *(story continues)*.

(continued) Below: Sarcoman is a remotely controlled entertainment robot of the master-slave variety. The sensor suit worn by the engineer across the table enables the latter to measure and relay his movements. Bottom: *Tentomushi* or ladybug robots are powered by high-voltage, flexible solar cells. Their "eyes" steer them towards bright light. Facing page: IT is the most human of robots. Simple sensors which react to light, sound and movement enable it to mimic emotions.

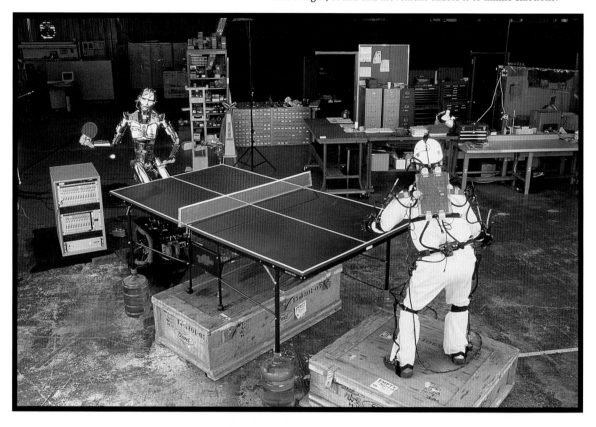

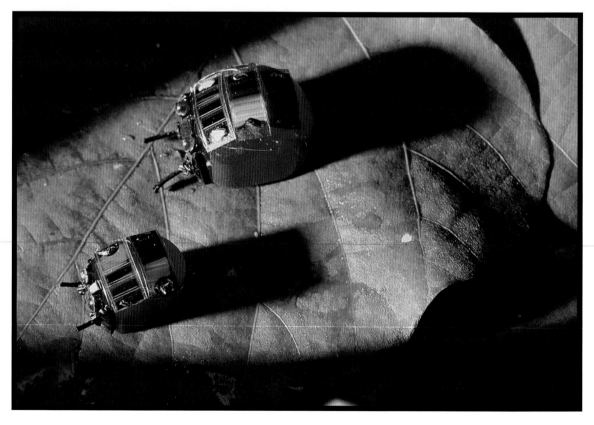

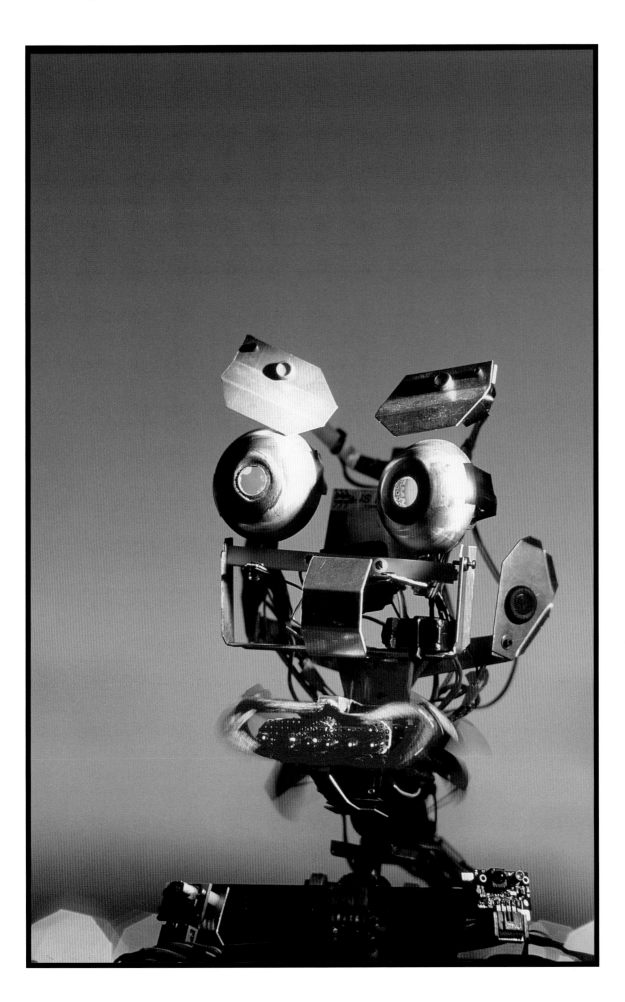

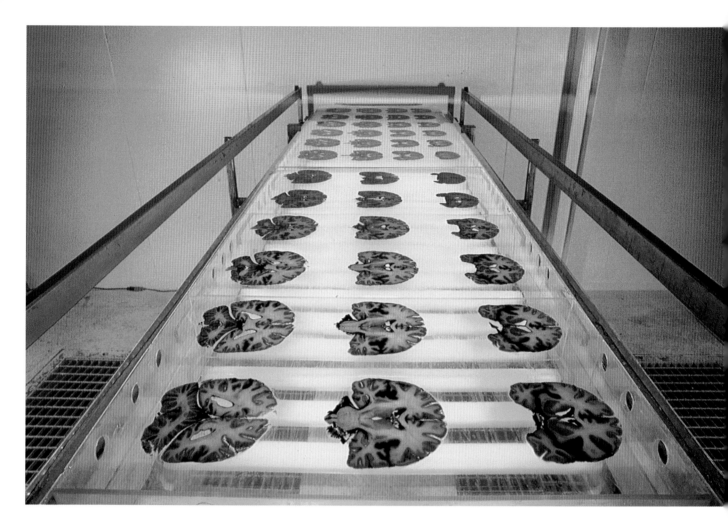

· Marc Steinmetz
Germany, +49 photo for Focus

2ND PRIZE SINGLES *(following pages)*
2ND PRIZE STORIES

German anatomist Professor Gunther von Hagens (facing page)
has developed a method of preserving human bodies or parts of
them, a process he calls "plastination". Initially designed to create
detailed anatomical preparations for educational and medical
purposes, the products of plastination are now also exhibited in
highly controversial shows (following pages). At the private insti-
tute which he founded to be free from restrictions, it takes Von
Hagens and his team up to 800 hours to prepare a whole body by
replacing all water and fat with silicone or other polymers.
The corpses are obtained through the institute's own body
donation program.
Above: Plastinated slices of the brain of someone who died from
a severe hemorrhage are being cured by ultraviolet light.
Facing page: Von Hagens at work fixing body parts in their proper
position and sawing a frozen body into 3.5 millimeter slices *(story
continues)*.

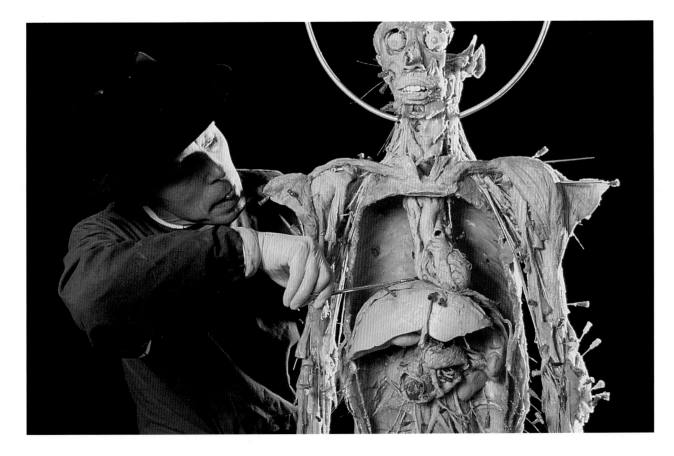

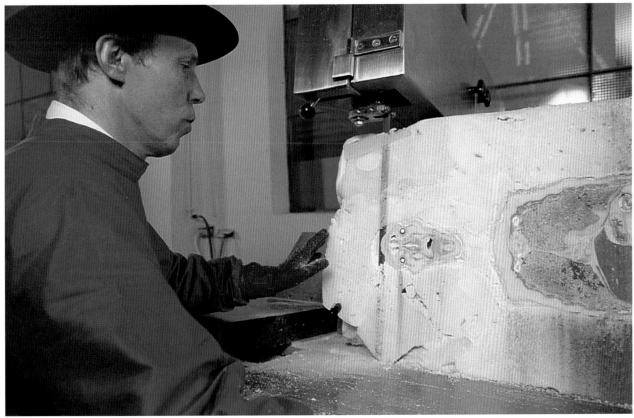

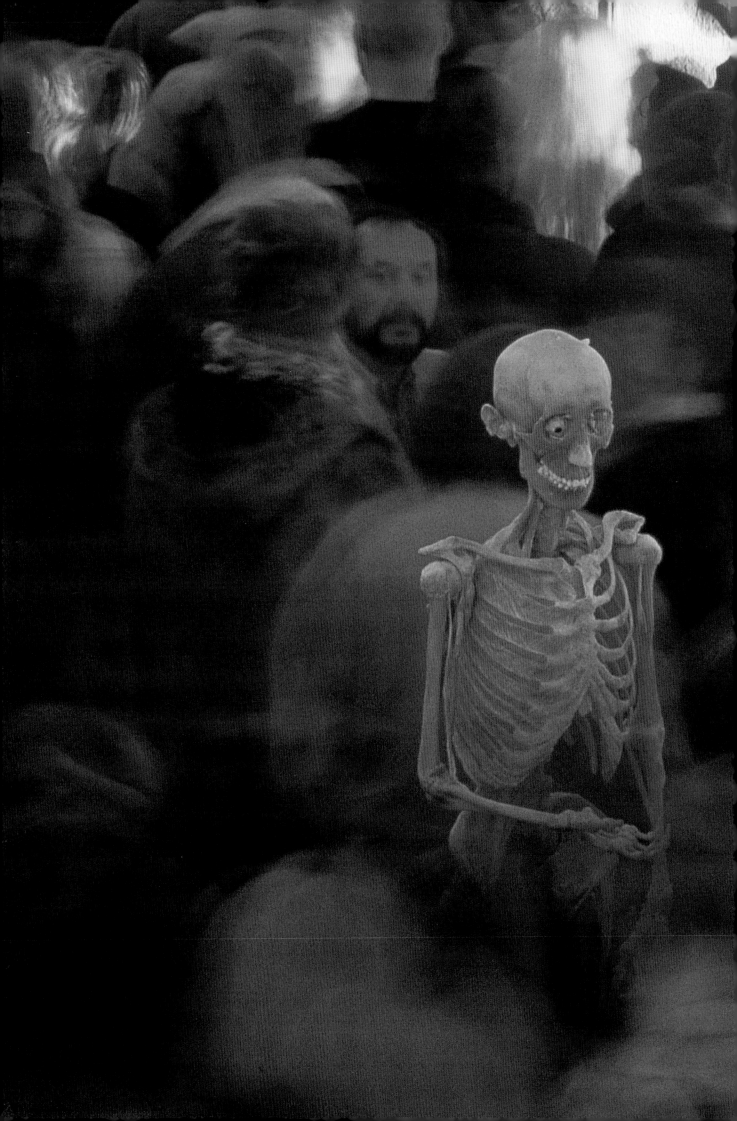

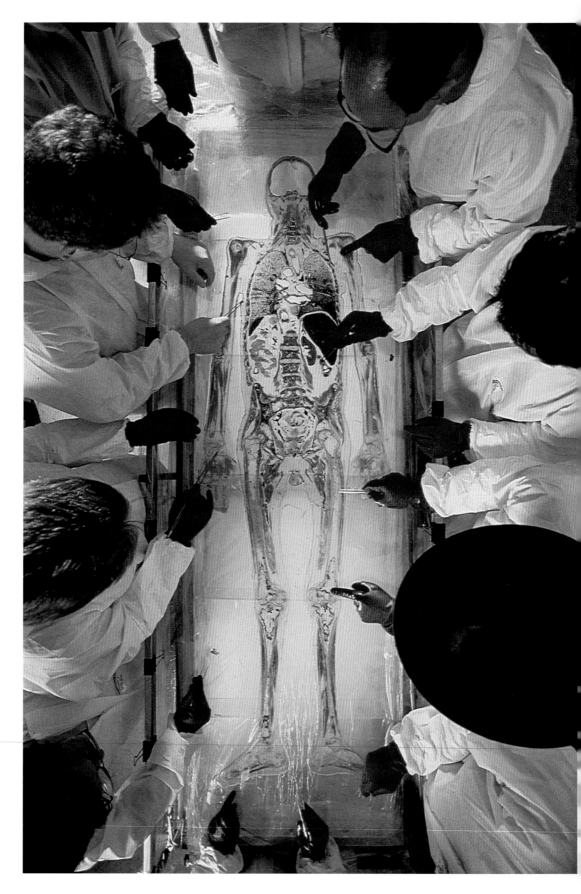

(continued) Professor Von Hagens and his team remove dirt from the frontal section of a male body on a fluorescent screen before curing it between glass plates.

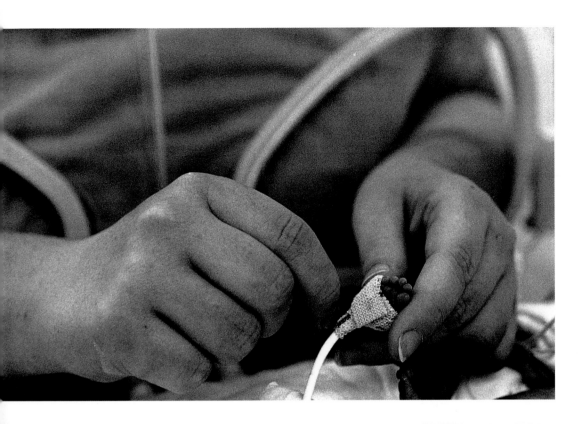

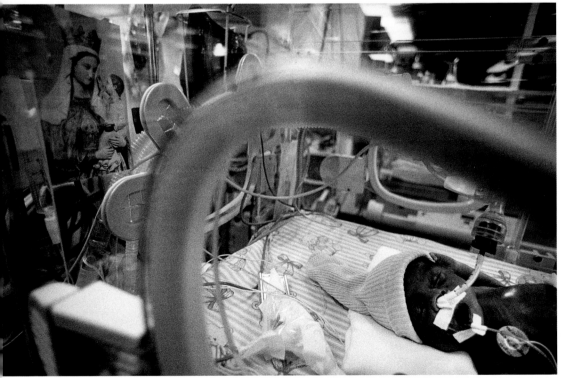

· Jean-Michel Turpin
France, Gamma

3RD PRIZE STORIES

In France between 35,000 and 40,000 babies are born prematurely every year. Some 9,000 of them are delivered up to three months early. At the Antoine Béclère Hospital in Clamart, Dr. Michel Dehan's highly specialized neonatal unit watches over them day and night, until they are strong enough to be taken out into the real world. Above left: Re-animation is in progress to save Elodie, who at birth weighed 470 grams after a 26-week pregnancy. Left: Newly born infant in its incubator *(story continues)*.

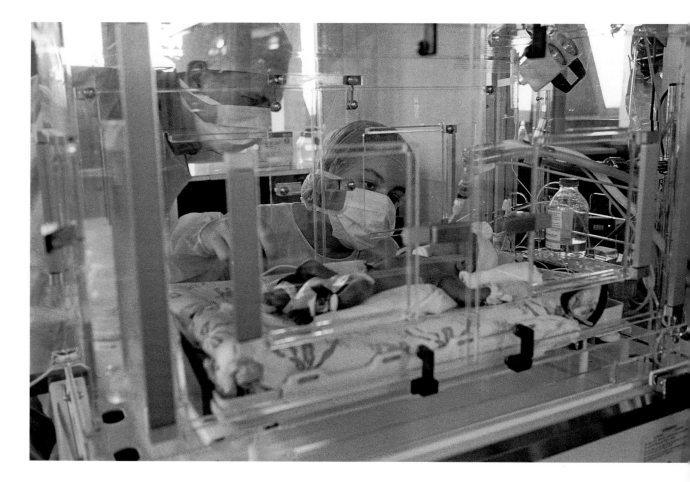

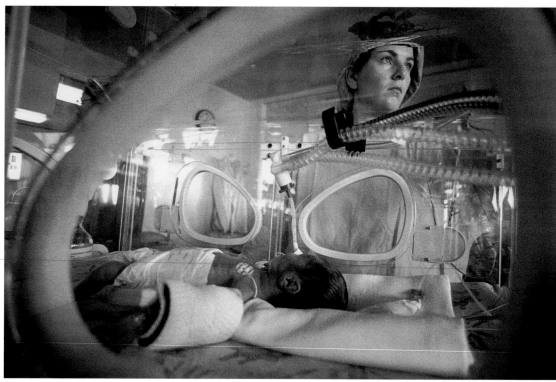

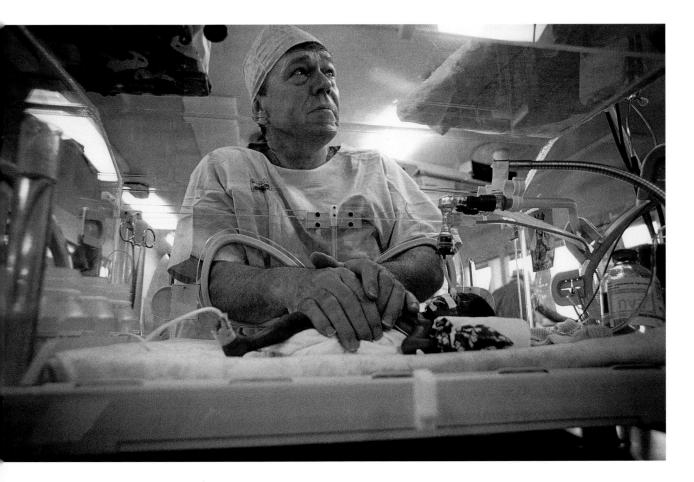

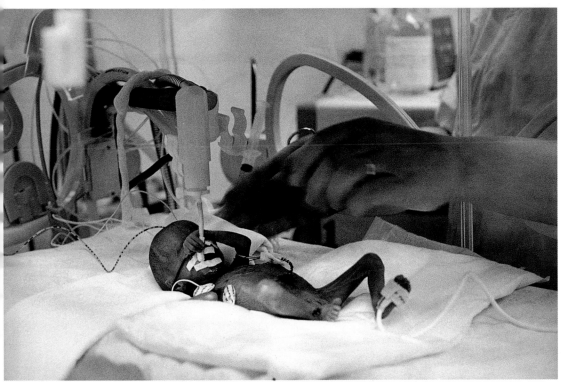

(continued) Facing page: Parents see their offspring for the first time, and a nurse monitors an infant's progress. Above: A physiotherapist stimulates a baby's breathing. Left: This tiny creature was born after a pregnancy of only 25 weeks.

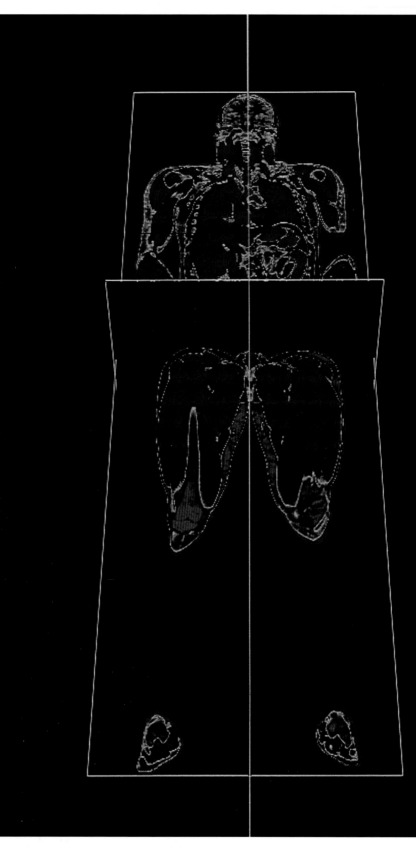

· **Alexander Tsiaras**
USA, for Life Magazine

HONORABLE MENTION STORIES

Just a few years after
Joseph Paul Jernigan's
death sentence had been
carried out, he started
an electronic afterlife.
The body he donated to
science has been quar-
tered, sliced and digi-
tized for pictures like
this longitudinal cross-
section. Jernigan's is the
first human body to
have been entirely trans-
lated into electronic
data using the latest
imaging technology, so
that its multiple layers
can be studied at
any angle.

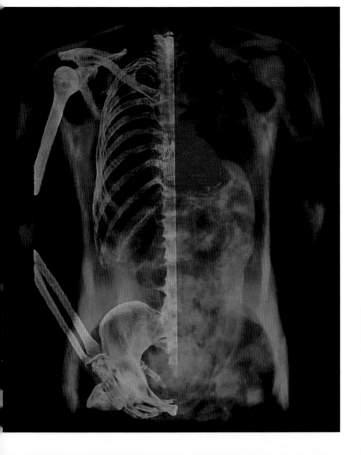

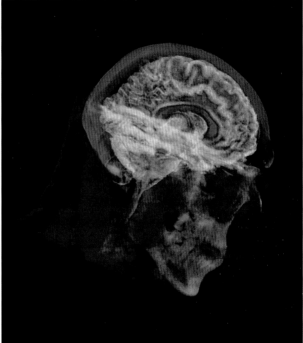

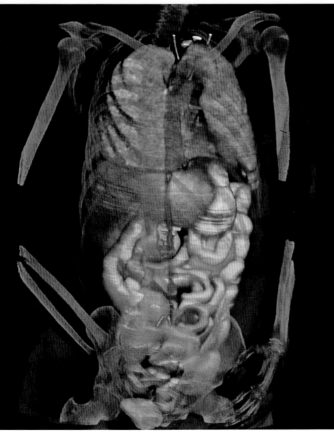

Daily Life

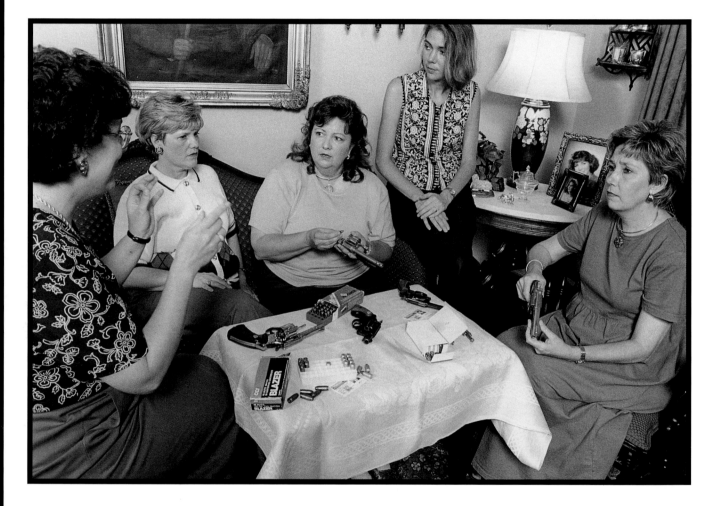

· **Zed Nelson**
*United Kingdom, Independent
Photographers Group*

1ST PRIZE SINGLES

Housewives compare their guns in Memphis,
Tennessee. A number of states across the USA
have recently introduced 'concealed carry'
laws that allow citizens to carry handguns at
all times. Police estimates indicate that
35 million guns are currently in circulation in
the United States.

· Chien-Chi Chang
Taiwan ROC, Magnum

2ND PRIZE SINGLES

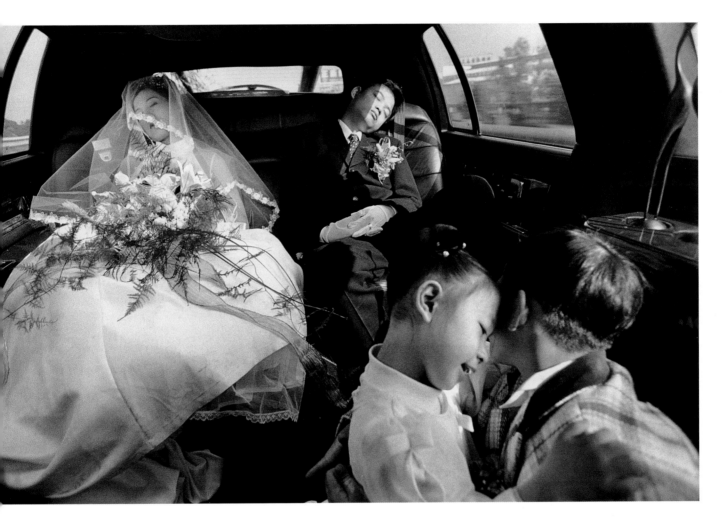

In Taiwan the wedding industry experiences an unprecedented boom. Months before the appointed day couples start lavishing money on the festivities. Elaborate group rituals are organized by professional production companies, and at some weddings the couple's favorite zoo animals are included in the guest list. No wonder the bride and groom are often exhausted when the celebrations are over and it's time to go home.

· Chris Steele-Perkins
United Kingdom, Magnum

3RD PRIZE SINGLES

Abdul Sattar Edhi, a devout
Pakistani Muslim, has
developed an extraordinary
network of social services
throughout his country.
He runs orphanages,
mental hospitals, a cancer
hospice and feeding
programs. He also has 500
ambulances and collects
and buries unclaimed
corpses. Edhi's operation is
funded entirely by dona-
tions from ordinary
Pakistani. Without the
work of his foundation
many of the patients at
this mental hospital would
have died long ago.

World Press Photo Children's Award

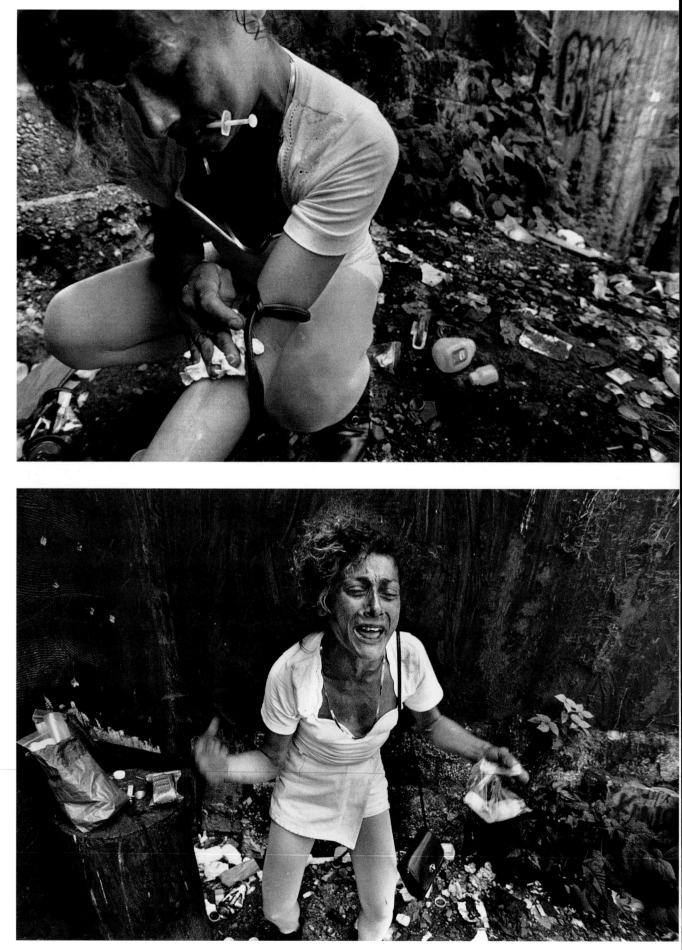

· **Susan Watts**
USA, New York Daily News

WORLD PRESS PHOTO CHILDREN'S AWARD
(facing page, top)
1ST PRIZE STORIES

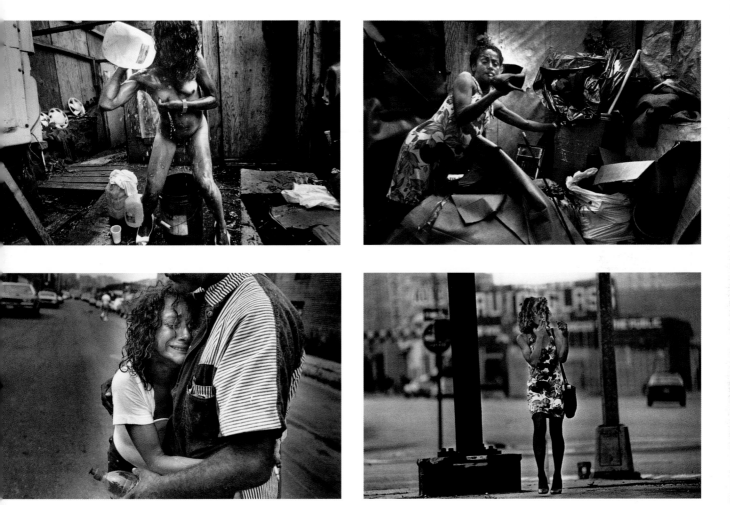

Caught in an urban nightmare of prostitution and drugs, Gloria (33) has been living on the streets of the Bronx, New York City, since her late teens. Once beautiful, she has lost her own teeth and her body is covered with scabs and scars. She needs ten shots of heroin a day and as many tricks to pay for them, making her both predator and prey. One of some 2,500 homeless, drug-addicted prostitutes in New York City, Gloria is shown shooting up in a littered backyard, washing with water she has collected from a fire hydrant, looking for a matching shoe among the plastic bags that hold her possessions, being comforted by a homeless man and waiting for a client at the Bronx's Hunts Point market.

· Jeremy Nicholl
Ireland, Matrix International, USA
for Neue Zürcher Zeitung, Switzerland

2ND PRIZE STORIES

After years of neglect
Sandunovskaya Banya, Russia's
most famous public bathhouse,
has been restored to its former
splendor. Located close to the
Kremlin, the 200-year-old baths
used to be popular with
Communist Party cadres. Today
they are a favorite meeting place
for Moscow's nouveau riche.
Above, a group of revelers from
the world of banking and security
celebrate a birthday in a private
area with its own steam room.
Facing page: The church-like
changing room gets very crowded
at weekends. After visiting the
steam room, a client is scrubbed by
a staff member *(story continues)*.

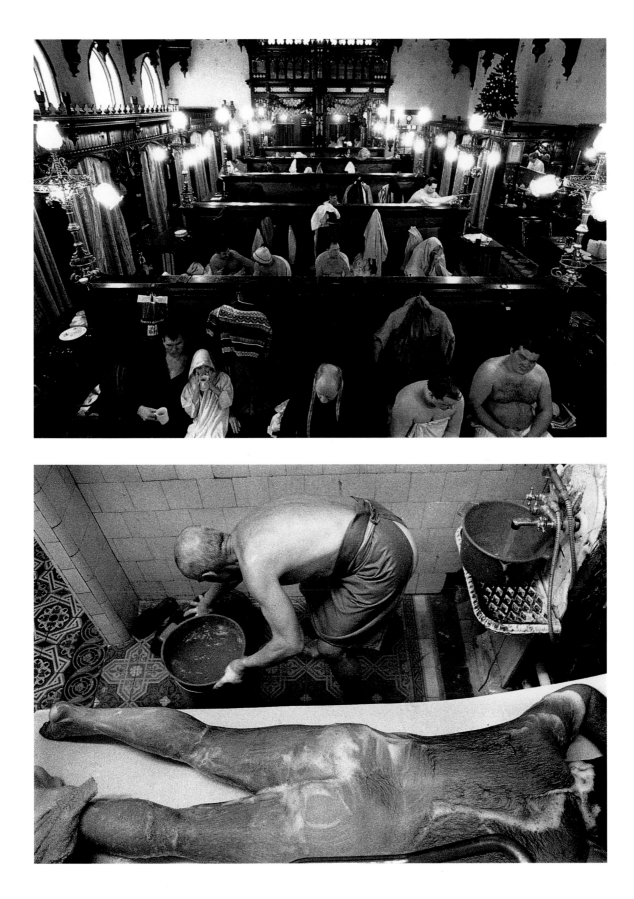

(continued) Below: Reduced rates apply for the pensioner drying her hair in this picture. Manicure and pedicure facilities are also available at the Sandunovskaya baths.

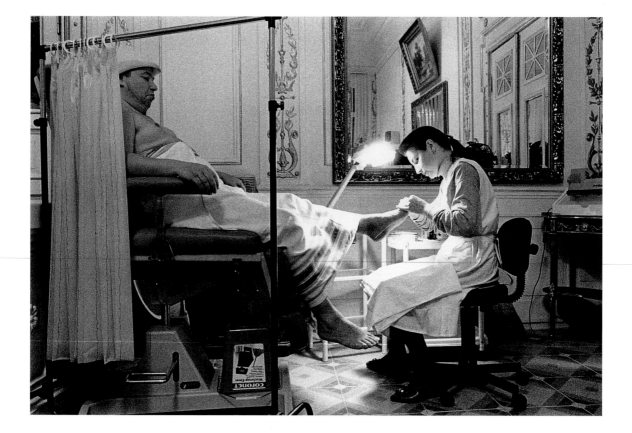

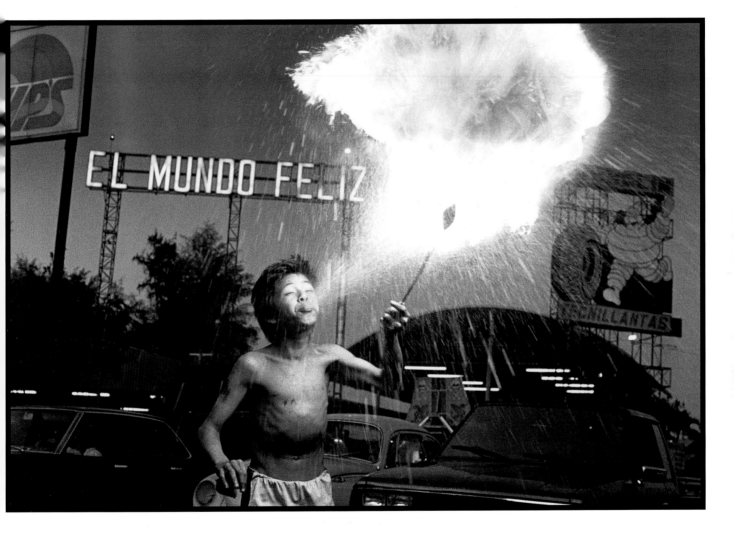

· Fernando Moleres
Spain, Rapho, France

3RD PRIZE STORIES

Estimates from the International Labor Organization
indicate that in 1997 250 million children — five times as
many as five years before — were involved in child labor
all over the world. The problem is visualized in this story,
shot in Central and South America, Africa and Asia. Above:
In the streets of San Salvador, 12-year-old Fernando scrapes
some cash together by directing the traffic and entertaining
drivers with his fire-eating antics *(story continues)*.

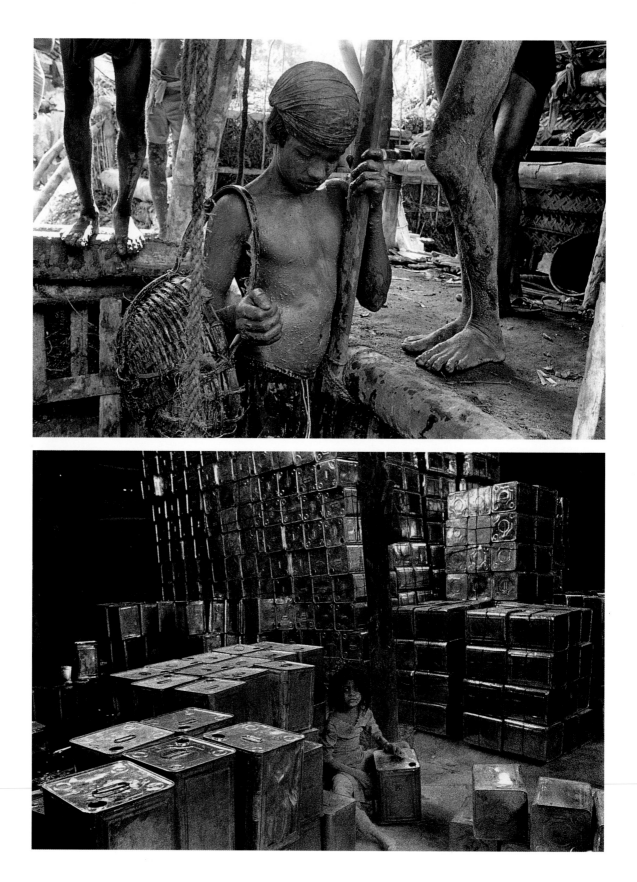

(continued) Top: For the owners of this Sri Lankan mine, which yields precious stones, the employment of child workers has many advantages: they are small, agile and cheap. Above: In a warehouse in Ahmedabad, India, noxious substances are used by children to clean oil cans for recycling. Facing page: The octopuses landed at dawn in Stonetown on the coast of Tanzania are killed and tenderized by young workers, who beat them for an average of five minutes each.

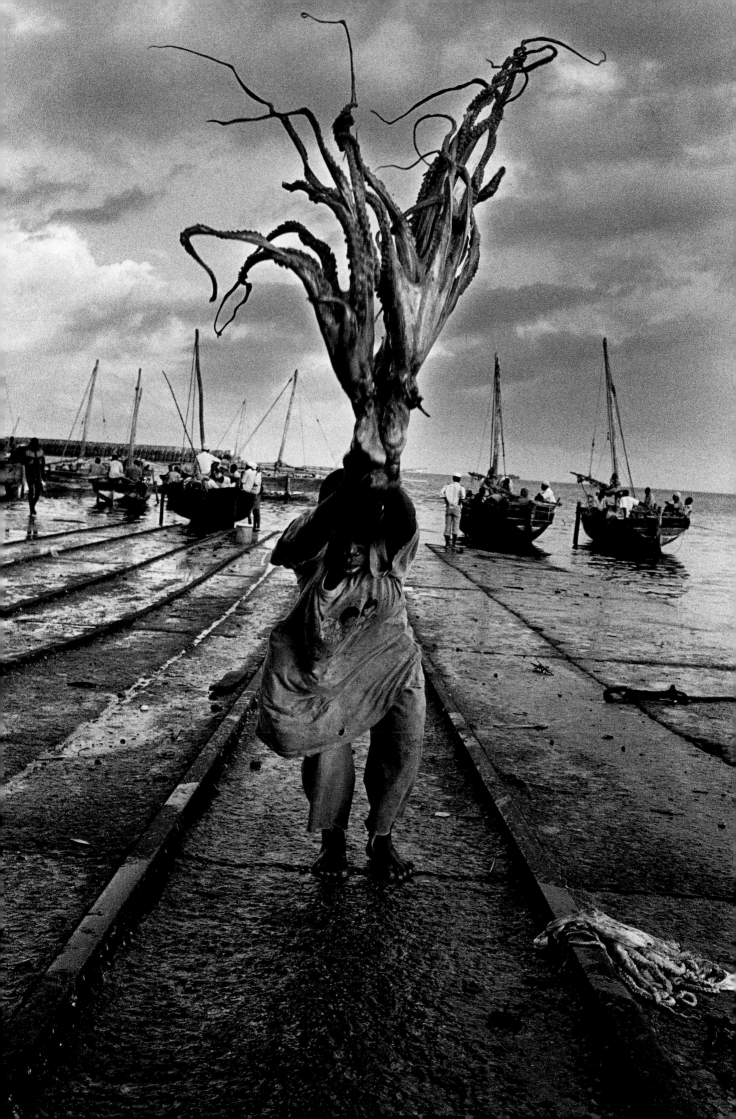

The Arts

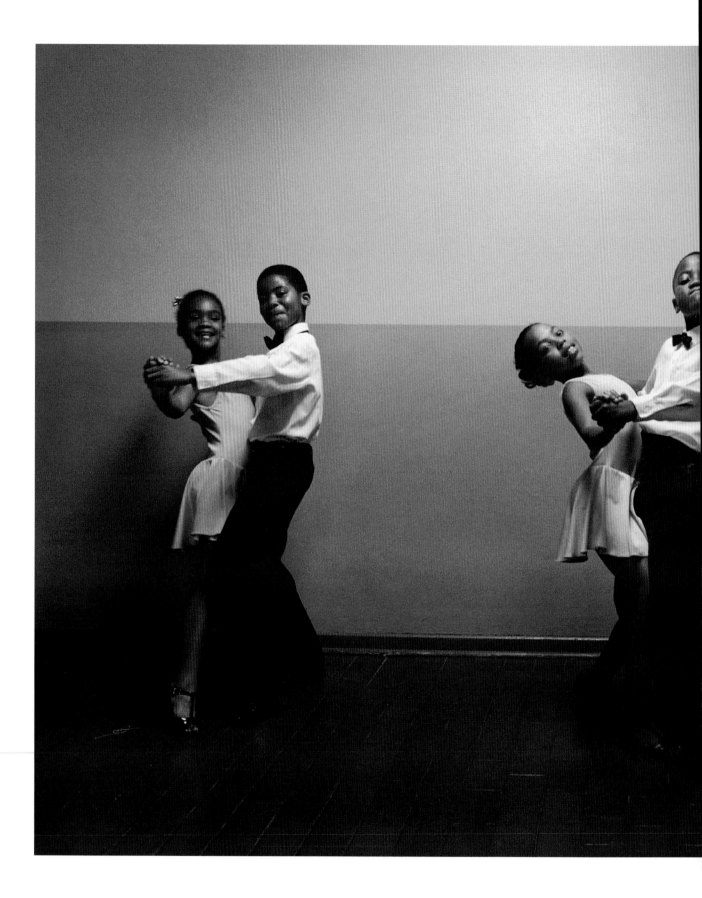

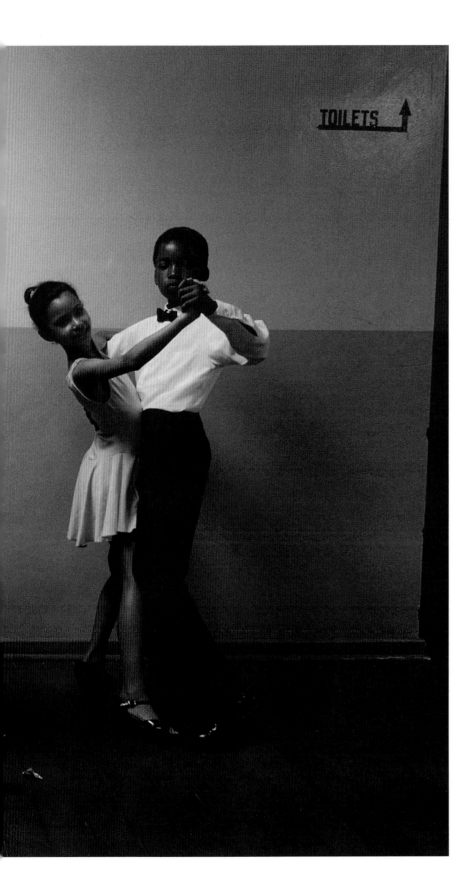

· Jodi Bieber
South Africa,
for The Independent,
United Kingdom

1ST PRIZE SINGLES

In South Africa's black
townships ballroom
dancing has caught the
imagination of the
young. At the dance
academy of Ennerdale
near Johannesburg, Paul
Kgole, the country's only
black ballroom judge,
teaches his pupils to think
of themselves as winners
in both dance contests
and life in general.

· Harald C. Schmitt
Germany, Stern

2ND PRIZE SINGLES

Members of the Ea Sola dance company rehearse at
the conservatory in Ho Chi Minh City. Vietnamese
dancer and choreographer Ea Sola, who now lives in
Paris, has made the inner conflict of her native country
the theme for her production *Il a été une fois* (Once
upon a time). The dancers have to sing and dance at
the same time, stretching their skills to the limit.

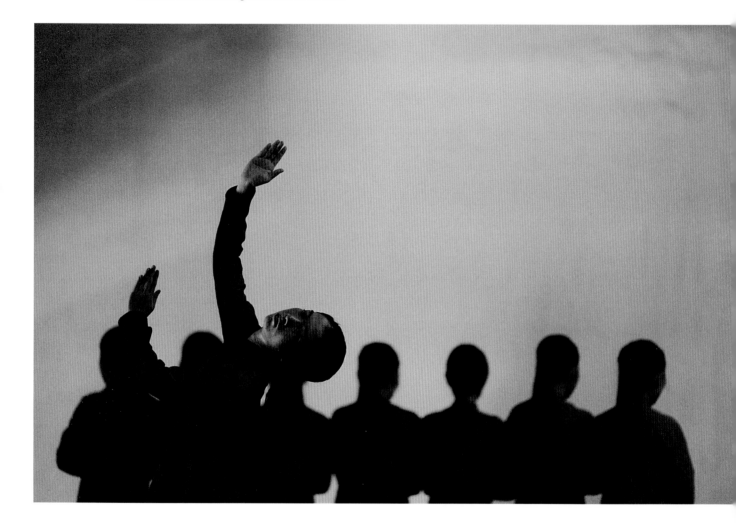

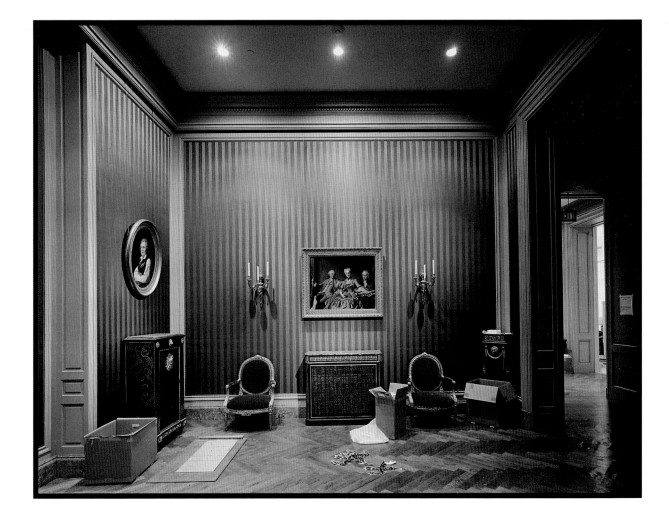

· Robert Polidori
France, Agence Planet for The New Yorker, USA / Geo, France

3RD PRIZE SINGLES

1997 saw the opening in Los Angeles of the Getty Center.
Architect Richard Meier's creation, which overlooks both
the city and the Pacific Ocean, has taken 13 years to build
and cost a billion dollars. Covering 45 hectares, the
center's Getty Collection strongly focuses on European
painting and sculpture. The room shown here (France,
1760-1775) is one of 14 dedicated to the decorative arts.

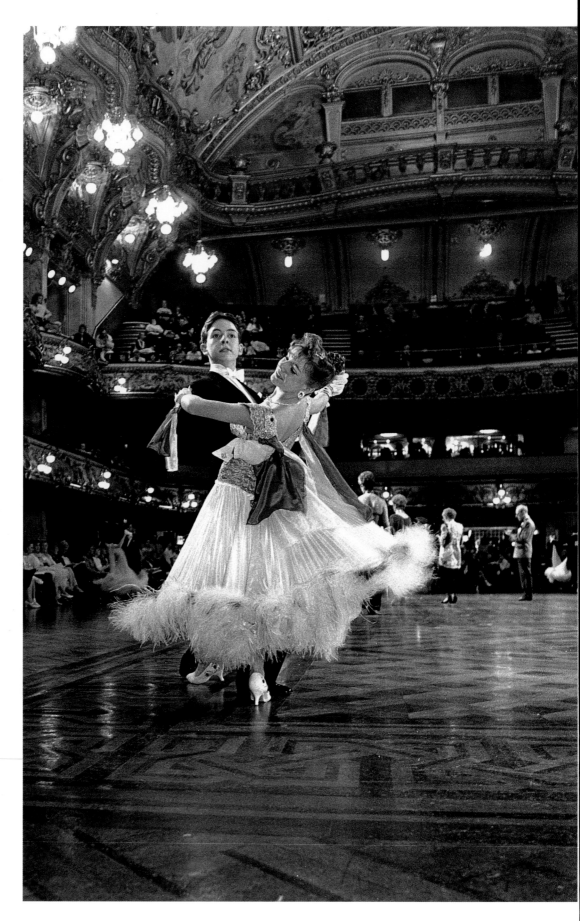

· Vanessa Winship
United Kingdom

1ST PRIZE STORIES

In April 2,000 young hopefuls from all over the world met in Blackpool, England, to compete in the Junior Ballroom Dancing Festival. The splendid Tower Ballroom formed the perfect backdrop for the event. Facing page : Welsh girls pose for their picture in front of a scale model of the building where the festival took place. Tension mounts backstage before the announcement of the winners' names *(story continues)*.

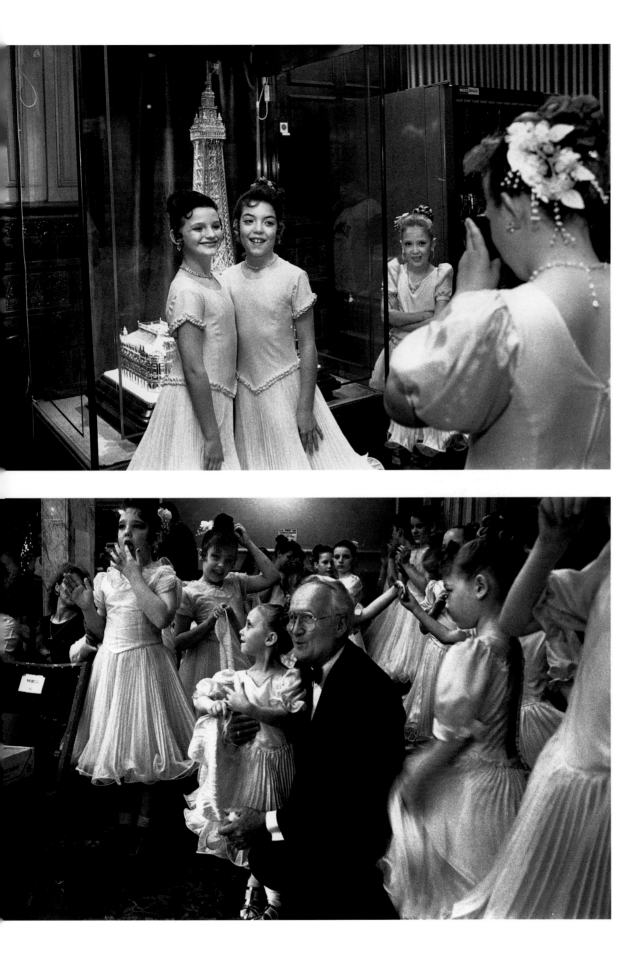

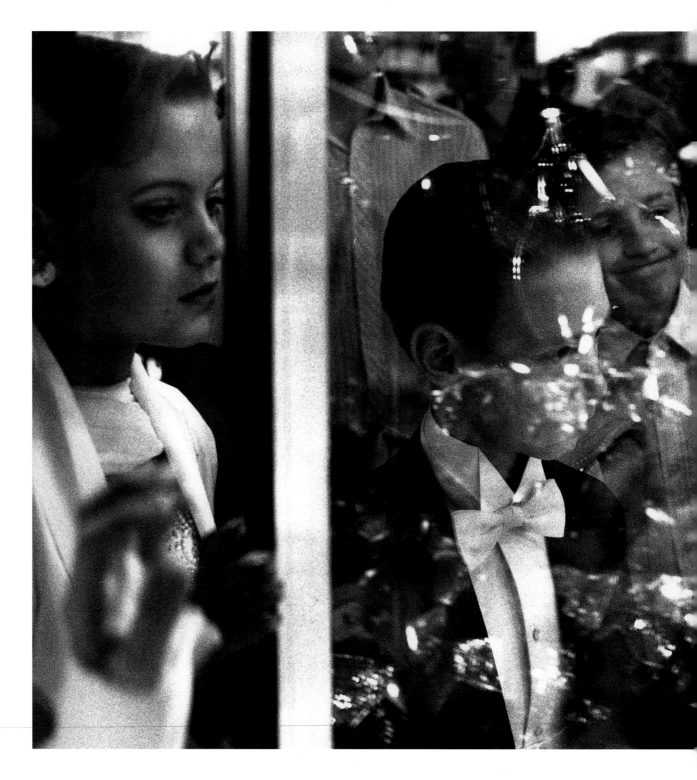

(continued) Breaks in the dancing program afforded the opportunity to make friends with competitors from other countries ... and play arcade games (above). Facing page, top: These teenagers are from Portugal. Participants came from as far afield as Siberia and South Africa.

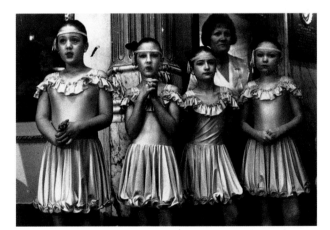

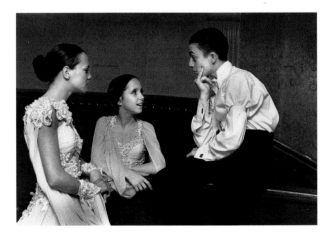

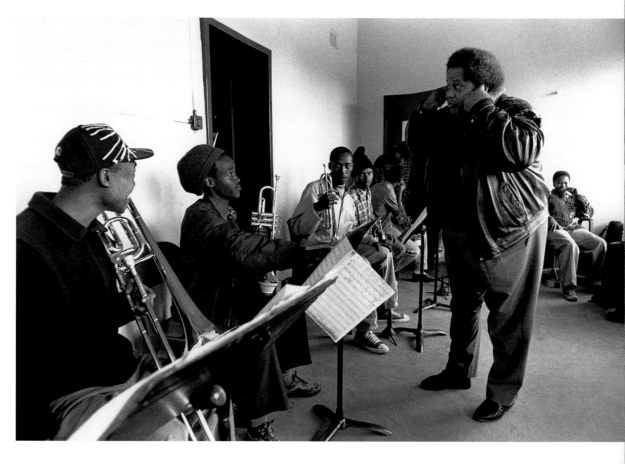

· Jodi Bieber
South Africa

2ND PRIZE STORIES

In a township east of Johannesburg Johnny Mekoa has established the Gauteng music academy, where he teaches jazz music — along with dedication and discipline — to underprivileged black youths. He is pictured above rehearsing with his orchestra for a concert later in the week. Facing page: 24-year-old Johnny Seotlolla learnt to play the alto tuba at his local church. He is now studying the trumpet and is a member of the academy's band *(story continues).*

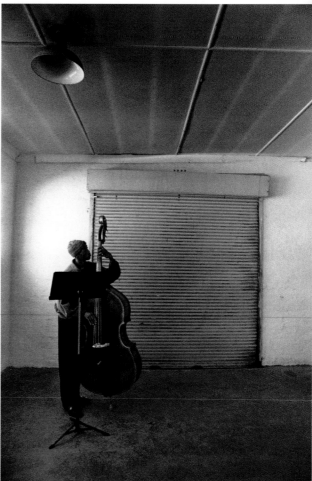

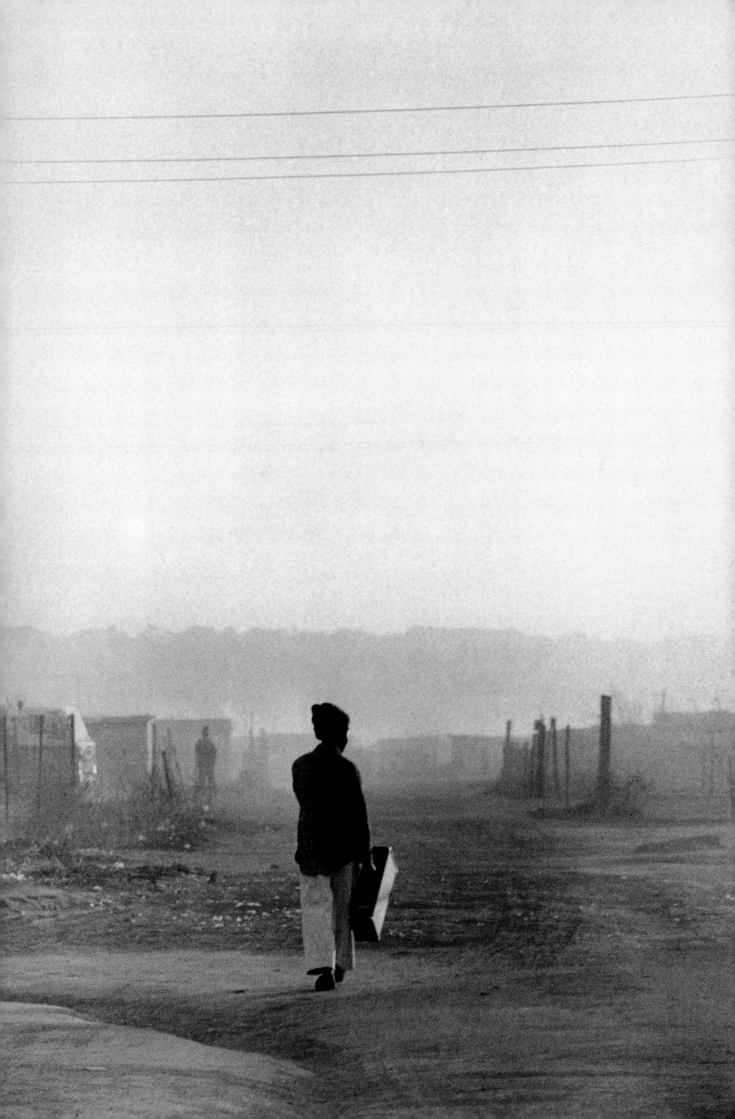

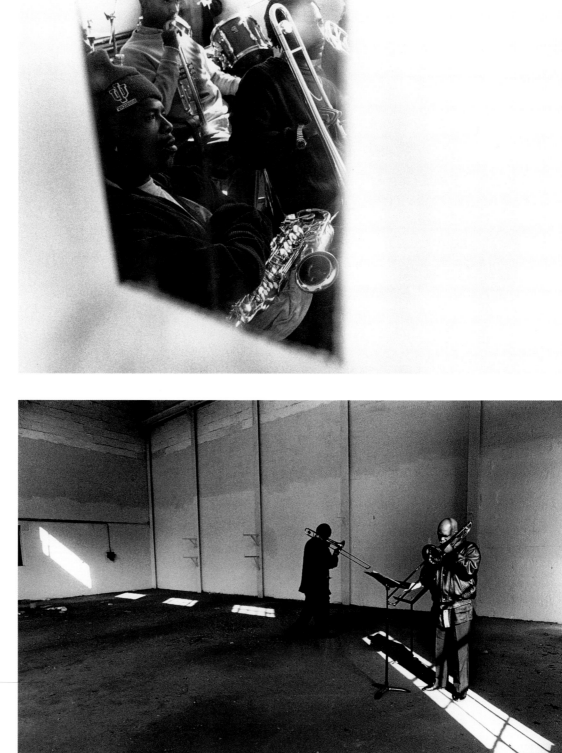

(continued) The Gauteng music academy is funded by donations. Gifts are also paying for the instruments, which are on loan to students. As the facilities are minimal, the young musicians have to practice where they can.

· Joseph McNally
USA, Life Magazine

3RD **P**RIZE **S**TORIES

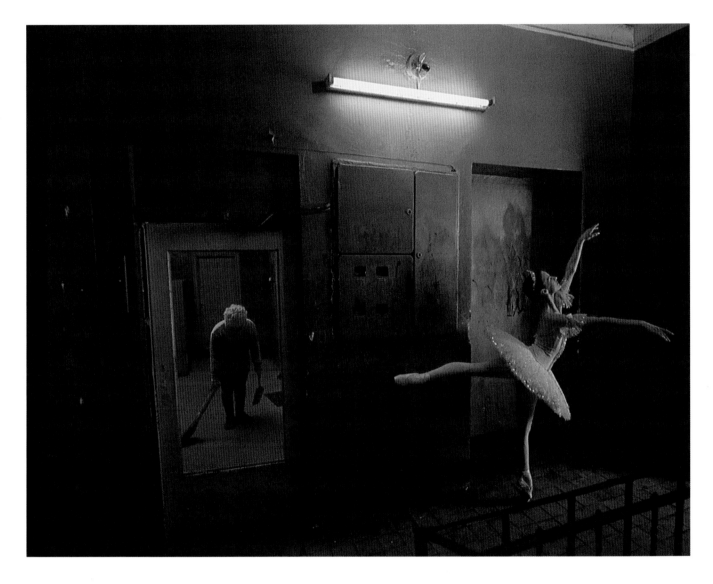

Members of the Bolshoi Ballet, perhaps the world's most famous classical dance company, pose in different locations in Moscow as part of the celebrations marking the city's 850th anniversary. Above, Anna Ivanova is portrayed in a tenement building as Aurora from *The Sleeping Beauty (story continues)*.

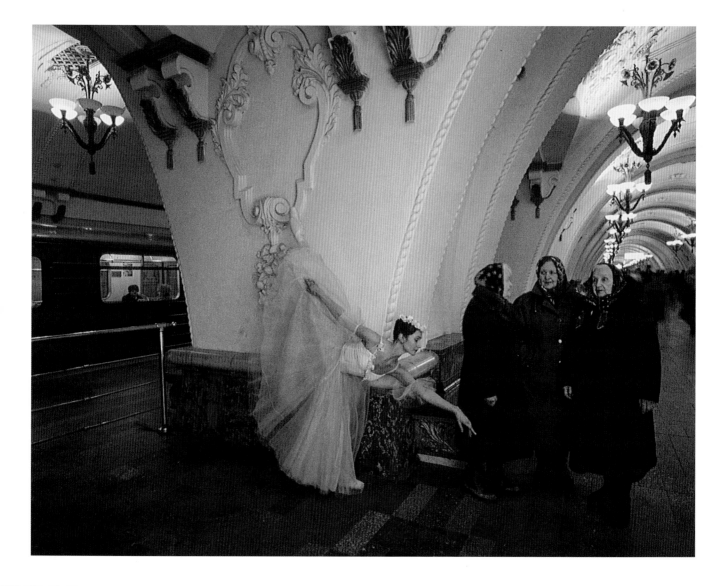

(continued) Above: The Arbatskaya metro station provides the backdrop for Tatyana Rastorgueva as Sylphide. Facing page: A dancer strikes a triumphant pose among symbols of the former Soviet Union. Gennadiy Yanin leaps into the air in his role of the Golden God from *La Bayadère*. The location is a gourmet restaurant that used to be a bakery.

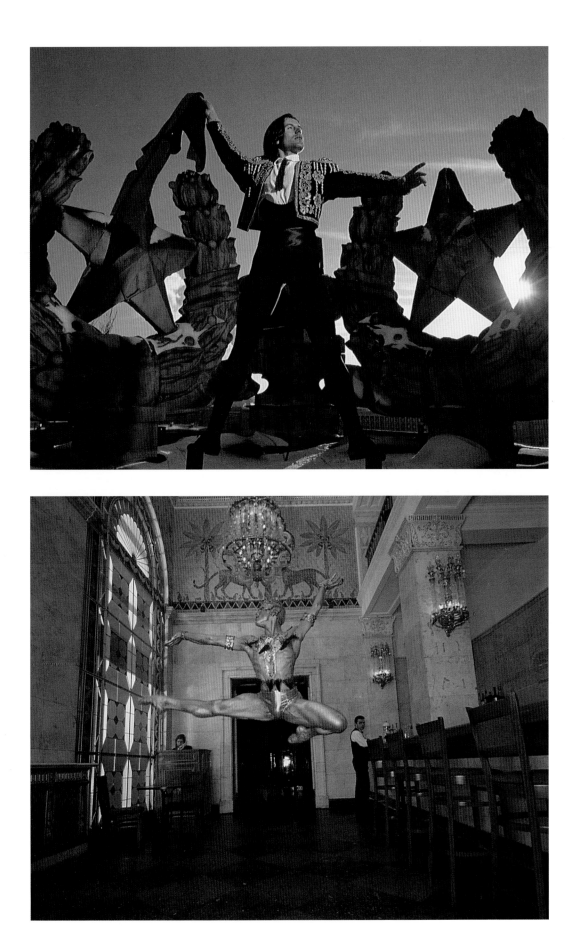

· Howard Schatz
USA

Honorable Mention Stories

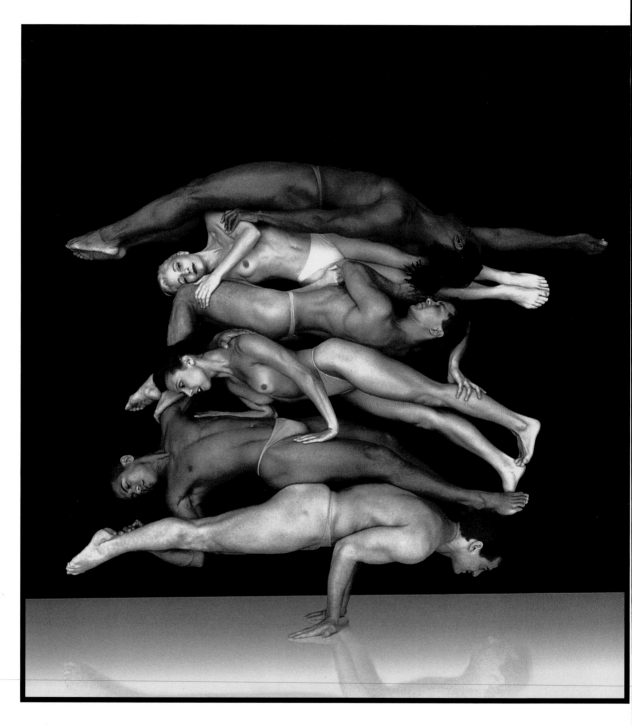

The photographer addressed the complexities of freezing moments in dance, the art of movement. Making extreme demands on the dancers, he created in his studio images fit to be photographed. He attempted, in other words, to condense the energy of movement into the split second of exposure. Above: The horizontal harmony of six dancers of the Pilobolus Dance Theater.

Shannon Chain of the
American Ballet Theater.

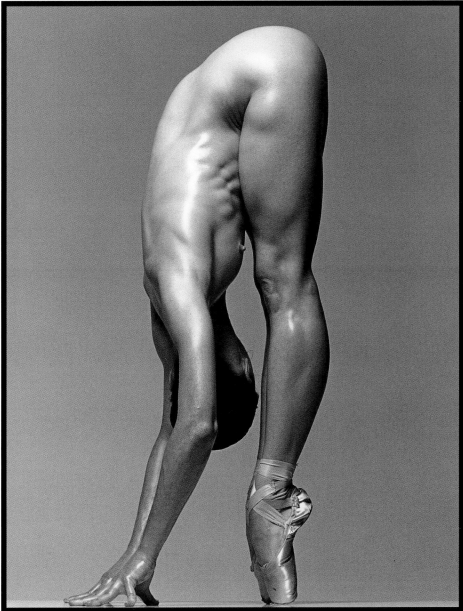

Kevin Ware of the
ODC/San Francisco,
a West Coast modern
dance company.

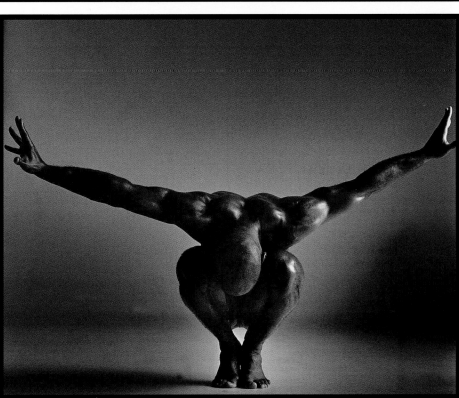

Nature and the Environment

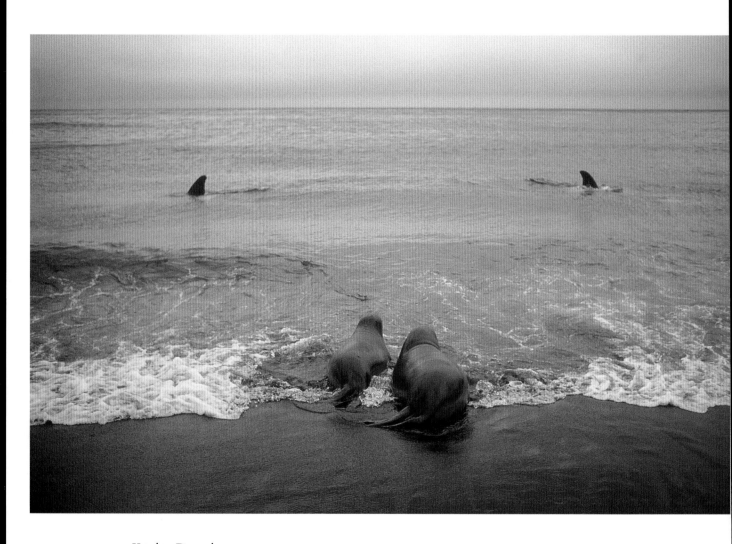

· **Xavier Desmier**
France, Rapho

1ST PRIZE SINGLES

Two killer whales patrol close to the beach, biding their time
until a pair of six-week-old sea elephants take the plunge into
the Antarctic Ocean. Every September sea elephants come
ashore here to deliver their young, who gain five kilos a day
from birth. Their parents, meanwhile, lose up to half their
weight. When hunger finally drives them back into the water,
the whales will be waiting.

· Arthur Harvey
USA, Gamma Liaison for Newsweek

2ND PRIZE SINGLES

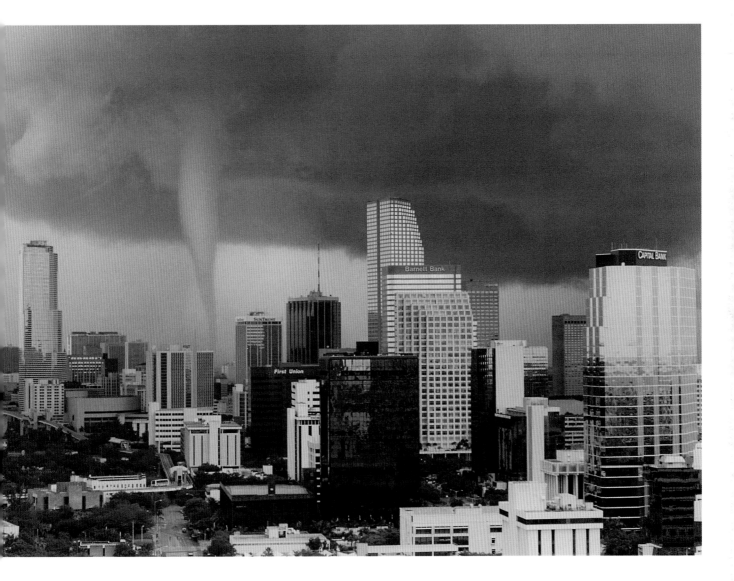

At 2pm on May 12 a tornado swirled through downtown Miami, Florida. Thousands of people in the metropolitan area witnessed the storm, which had been forecast by the National Weather Office more than 24 hours before. The tornado, which developed southwest of the city and cut a swath of up to 135 meters wide, did not cause much damage.

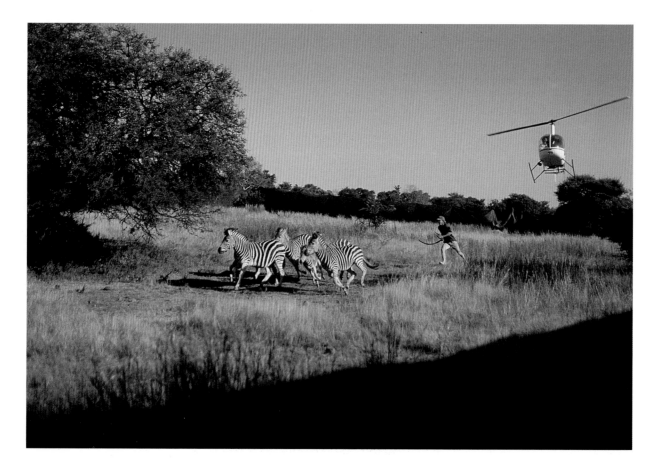

· Jim Leachman
USA, for The New York Times Magazine

3RD PRIZE SINGLES

A capture crew chases a herd of zebra into a stockade
south of Johannesburg. In South Africa private ranchers
are redefining the concept of wildlife. The government
now allows them to own the animals on their properties,
which has given rise to a new form of hands-on wildlife
management. Dividing into ranches aimed at hunting,
breeding or eco-tourism, the new sanctuaries cover roughly
three times the area of South Africa's national parks.

· Carol Guzy
USA, The Washington Post

Honorable Mention Singles

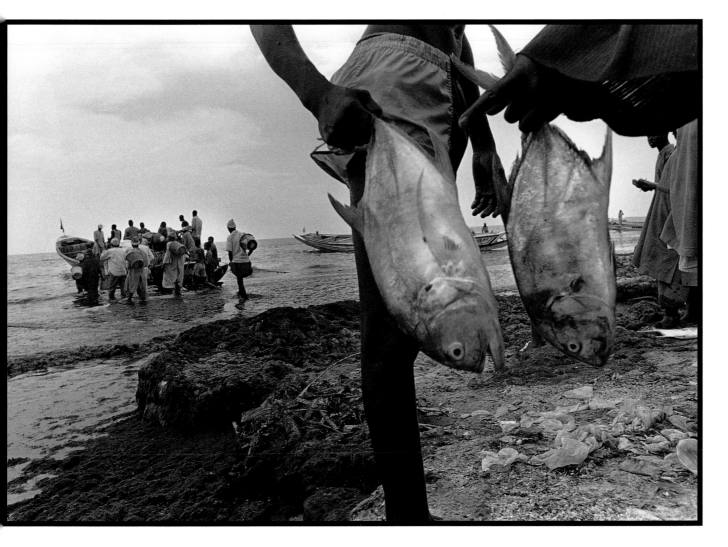

Senegalese fishermen dis-
cuss their meager catch.
A few years ago a deal
between the government
and the European Union
gave EU trawlers access to
these waters. Fishing now
generates an estimated 70
percent of Senegal's reve-
nue, but the sea is being
depleted by high-tech
trawlers and local fishermen
often return with empty
nets.

· Gideon Mendel
South Africa, Network
Photographers,
United Kingdom for
Condé Nast Traveler, USA

1ST PRIZE STORIES

The traditional lifestyle
of the hunter-gatherers
of southern Africa
known as bushmen is
on the edge of extinc-
tion. Yet a few villages
continue their attempts
to be self-sufficient,
supplementing what the
land yields with a little
cattle farming. Here five
men from the Namibian
village of Chokwe set off
on a hunting expedition.
They are armed with
bows, poisoned arrows
and flexible poles used
to hunt hares *(story
continues)*.

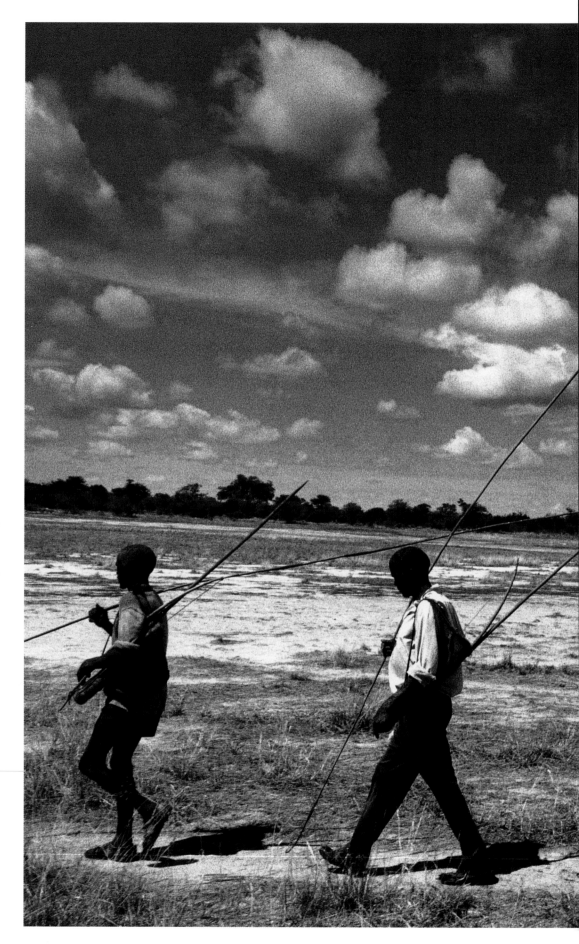

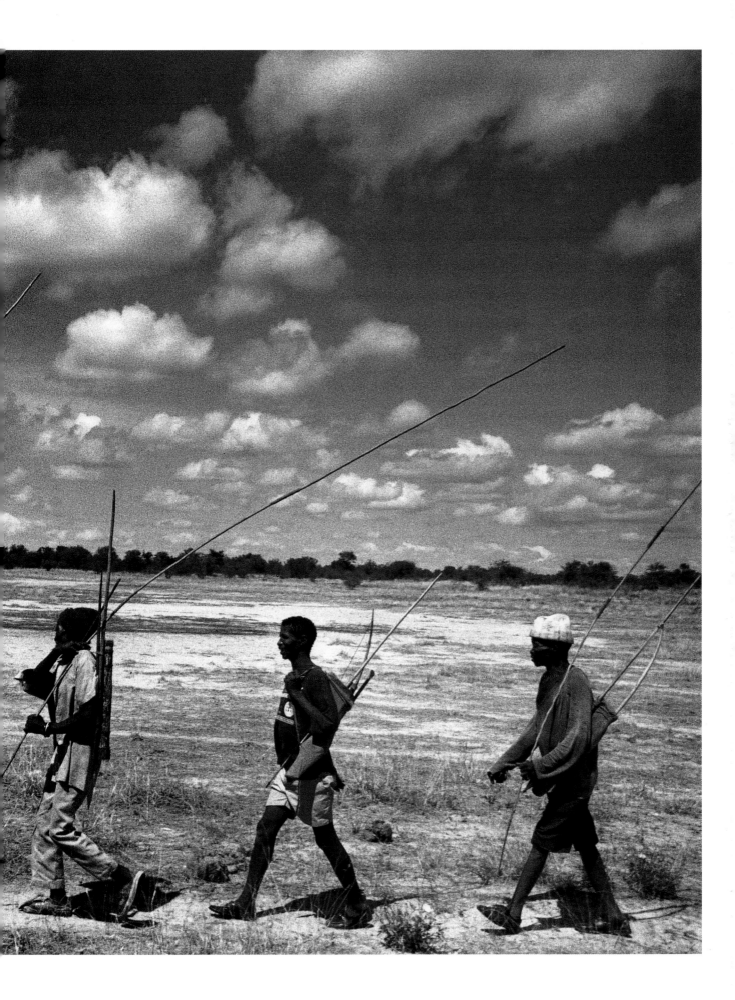

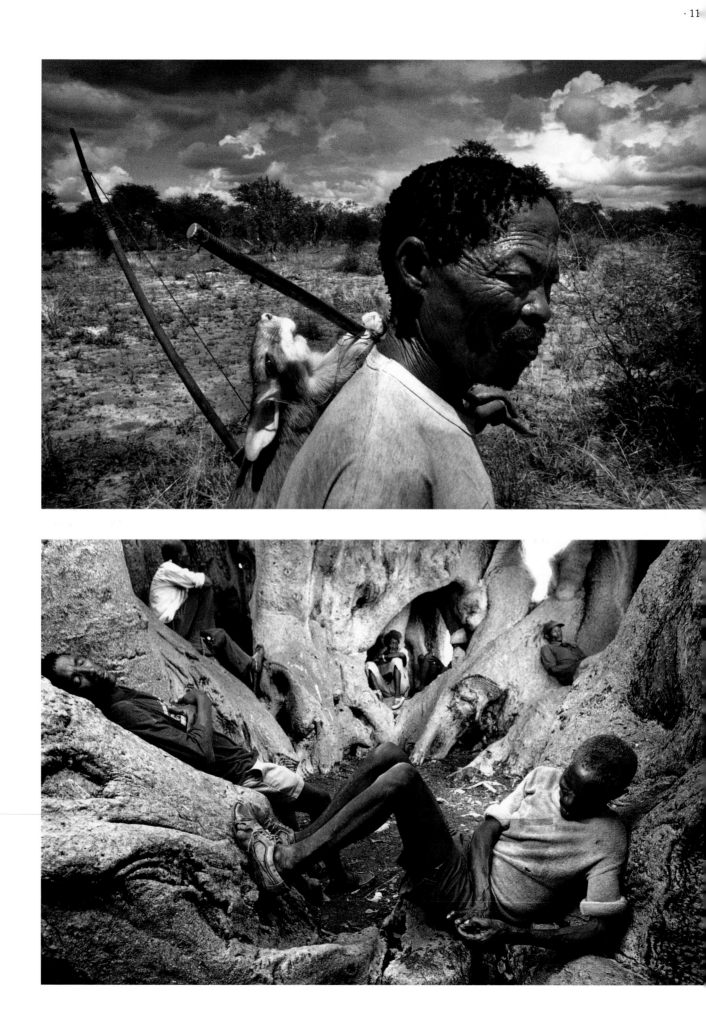

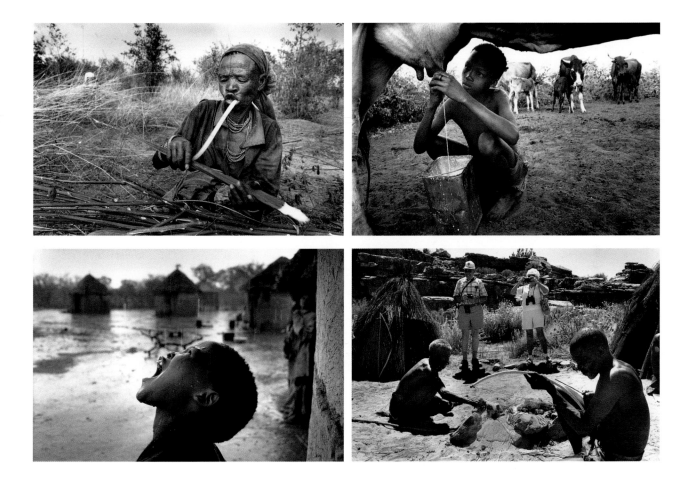

(continued) Facing page, top: Old Kaece carries a spring hare back to his village. He is one of the few bushmen who retain the traditional hunting skills. Bottom: Bushmen use the folds of a massive baobab tree to relax after an unsuccessful hunt. This page, from top left: An old woman uses her teeth to strip bark from a reed which she will use to tie up saplings for the construction of a hut. A boy milks a cow in Makuri village in north-eastern Namibia. Without cattle, the village can no longer sustain itself. A young boy rejoices in the arrival of the long-awaited summer rains, the heaviest in the region in 20 years. In South Africa, San bushmen have been moved to a site near Cape Town to set up the tourist village of Kagga Kamma. Here American tourists watch them as they manufacture hand-crafted souvenirs.

· Gilles Nicolet
*France, Saola for National
Geographic Magazine, USA*

2ND PRIZE STORIES

Cameroon's vast
Adamaoua plateau is
home to a great variety
of animal species. Sambo
(right) and Adamou
(facing page) are among
the few hunters versed
in capturing pythons.
They crawl into the
snakes' lairs, grab them
with their bare hands
and pull them out by
their heads. The python
held here by Sambo is
only 3.5 meters long (the
African rock python can
grow up to 6 meters). Its
lower jaw is split, prob-
ably as a result of a fight.
Facing page: After the
python skins have been
cleaned and dried, they
are sold to tanners in the
far north of Cameroon to
be turned into handi-
crafts. Traders pay up to
US$60 for a large python
including the meat.

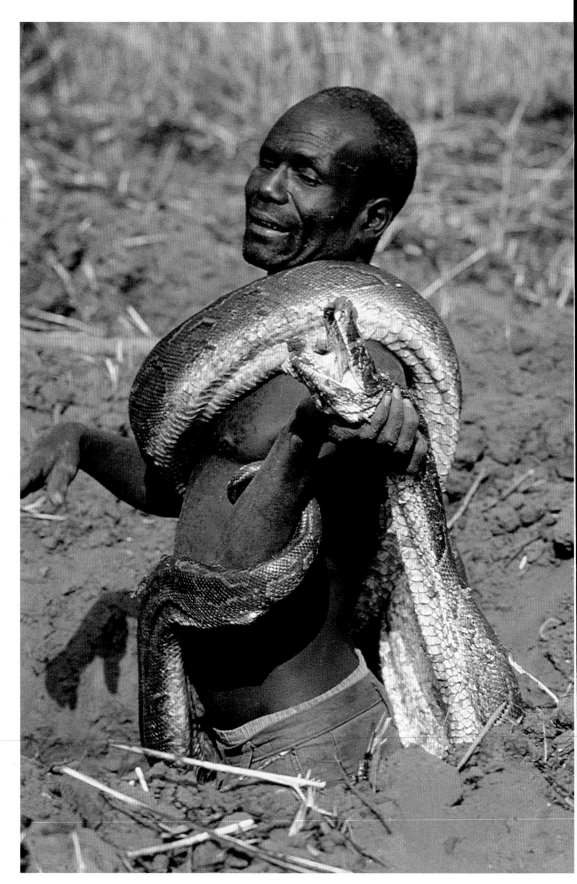

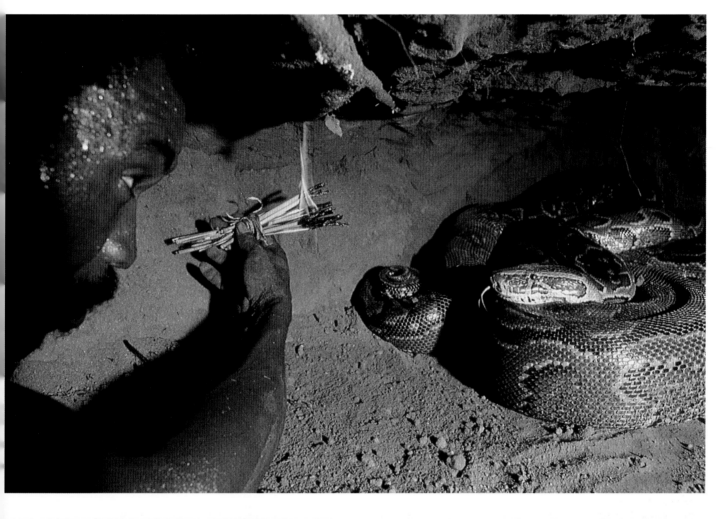

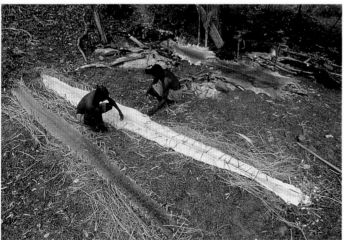

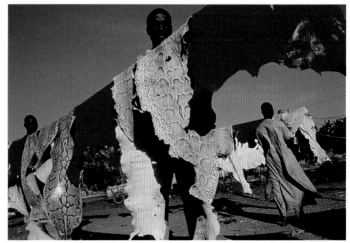

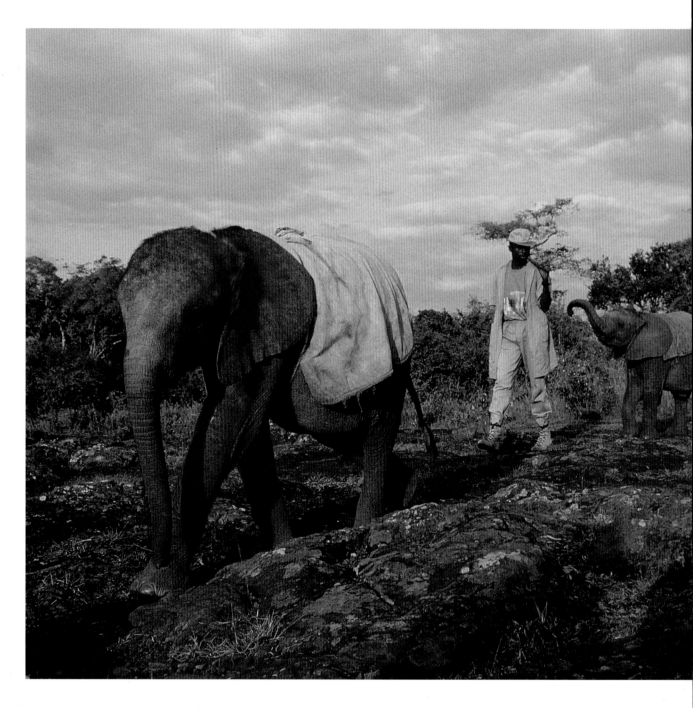

· Jim Leachman
USA, for Smithsonian Magazine / Terre Sauvage, France

3RD PRIZE STORIES

At a rehabilitation center in Nairobi, Kenya, a trained staff of eight are looking after orphaned elephants with a view to releasing them back into the wild — though this may take some years. The animals develop an extraordinary bond with their keepers, who take care of them 24 hours a day.
Above: The elephant on the left survived a gunshot wound, but ivory poachers killed his mother. Facing page: A young orphan peeps out from behind a tree. An elephant rescued from a mud-hole two weeks after he was born relaxes with his keeper in Nairobi National Park *(story continues)*.

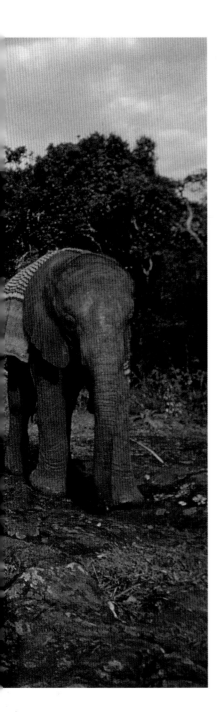

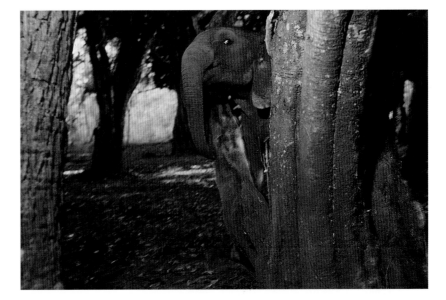

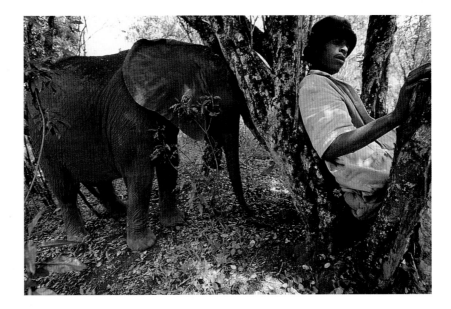

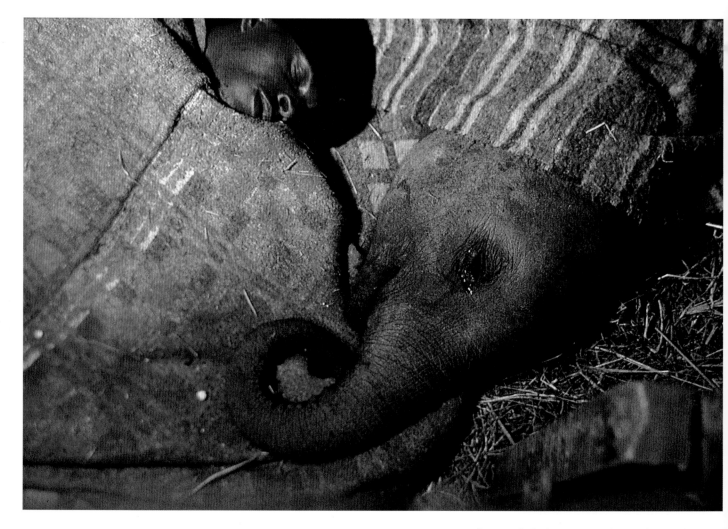

(continued) The keepers even sleep with their charges.

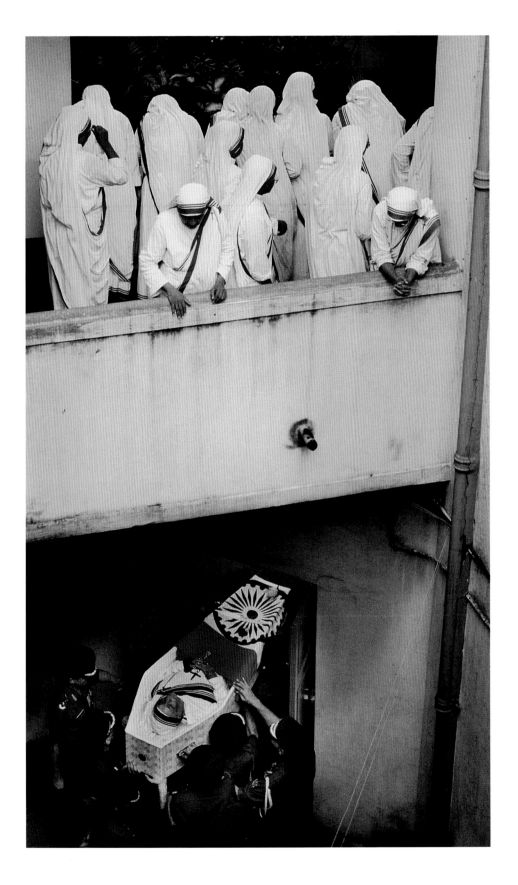

· Eric Luke
Ireland, The Irish Times

2ND PRIZE SINGLES

The body of Mother Teresa is carried into a private courtyard in Calcutta. She received an Indian state funeral. Born into an Albanian Catholic family as Agnes Bojaxhiu, the diminutive nun started working among Calcutta's poorest in the late 1940s and was awarded the Nobel Peace Prize in 1979. When she died on September 13 at the age of 87, she had come to symbolize Christian charity. Today more than 4,000 nuns are working for Mother Teresa's Missionaries of Charity at hundreds of relief centers all over the world.

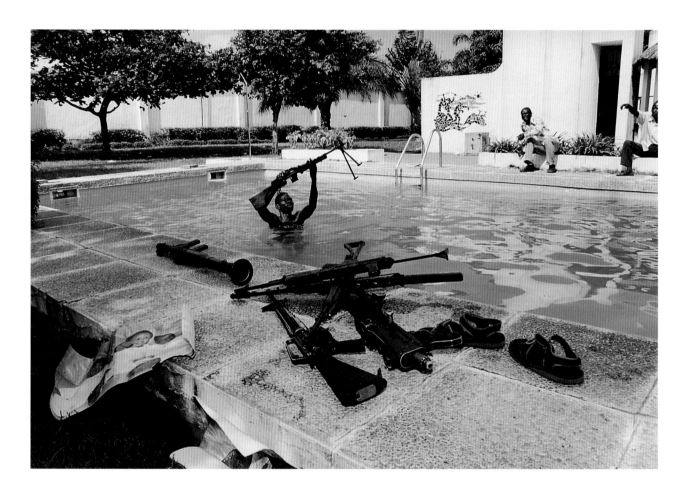

· Perry Kretz
Germany, Stern

3RD PRIZE SINGLES

In Zaire, machine guns are retrieved from the swimming pool belonging to Mobutu's son Kongolo. On May 18, after a seven-month military campaign, Laurent Kabila's rebel forces captured the capital Kinshasa. They deposed Mobutu, who fled Zaire and died in Morocco a few months later. Kabila renamed the country the Democratic Republic of Congo. In his inauguration speech as president he promised elections in April 1999.

· Brian Walski
USA, Boston Herald

HONORABLE MENTION SINGLES

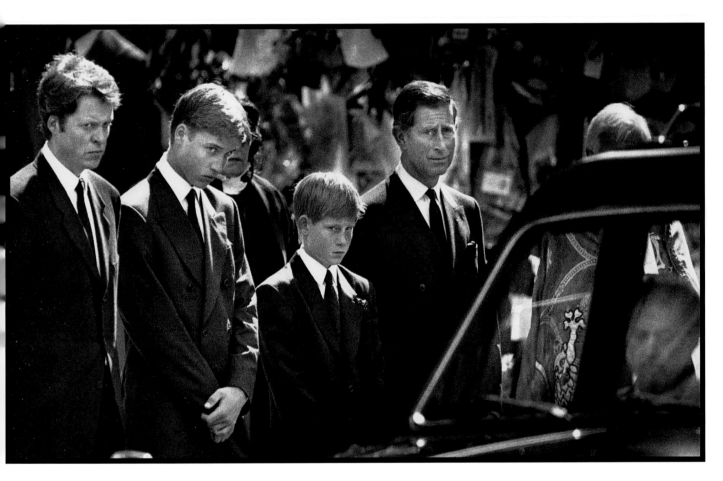

Princess Diana's brother, Earl
Spencer, her sons William and
Harry and her ex-husband Prince
Charles watch as the hearse
carrying Diana's body leaves
Westminster Abbey. A week after
she had been killed in a contro-
versial car crash in Paris the
whole world joined the family
in an emotional farewell.
The princess was buried on an
island at Althorp, her family's
estate, on September 6.

· Gideon Mendel
*South Africa, Network
Photographers, United Kingdom*

1ST PRIZE STORIES

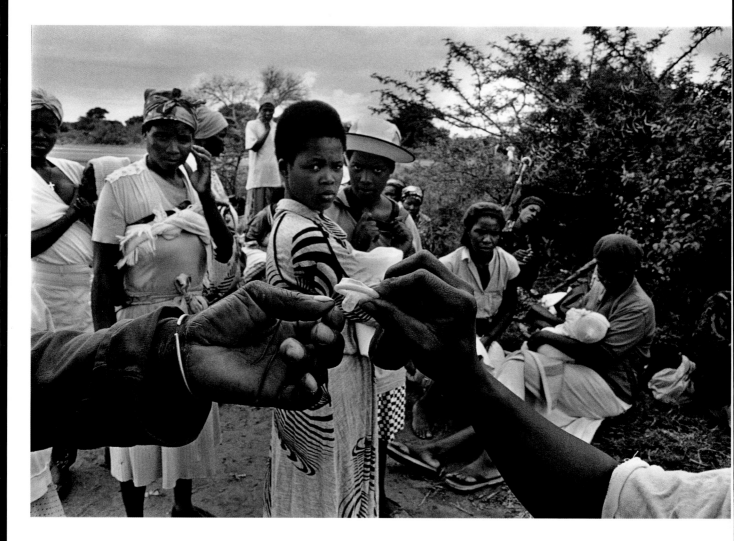

According to the World Health Organization, 30 million people
have been infected by the HIV virus. Nearly two-thirds of them
live in Africa south of the Sahara desert. This story shows the
human dimensions of the epidemic. Educational initiatives play
an important role in raising public awareness of HIV and AIDS.
Above, the use of condoms is demonstrated to women waiting at
a rural clinic in Kwazulu, South Africa. Facing page: At a fishing
village in Tanzania a local theater group performs a play about
AIDS involving much audience participation. Surrounded by
family members, an AIDS patient dies of kidney failure in a
mission hospital *(story continues)*.

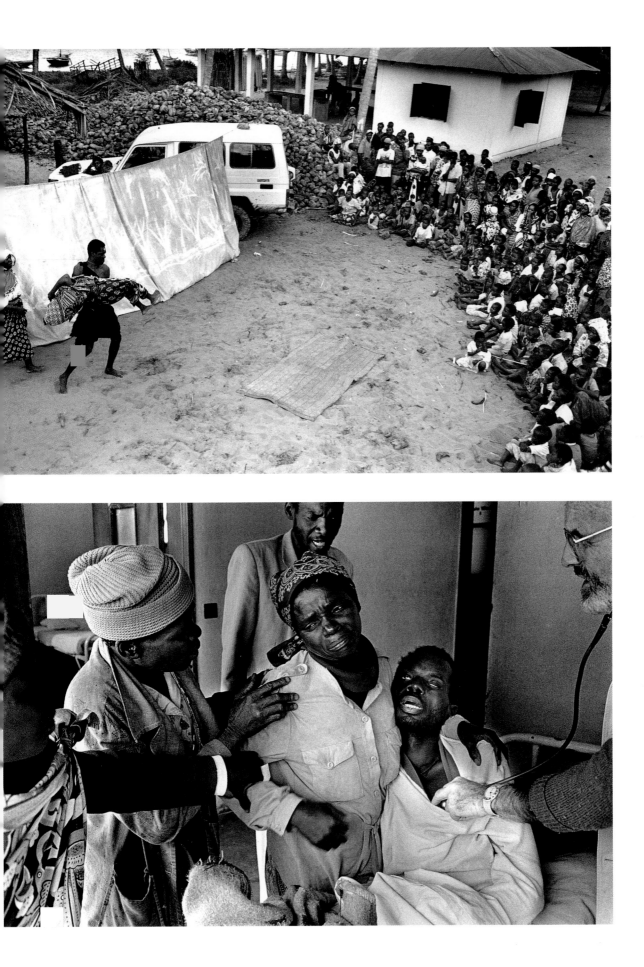

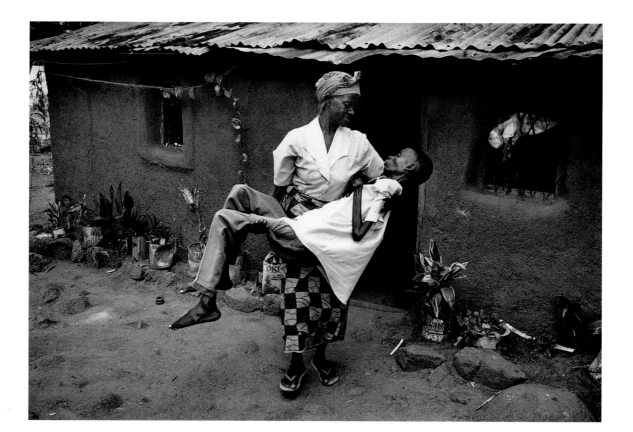

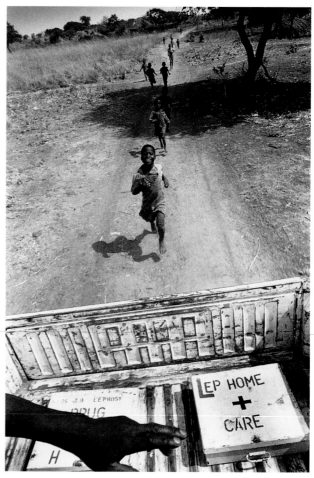

(continued) Top: Outside Mwanza, in the Great Lakes region of Tanzania, a woman carries her grown son, who suffers from AIDS, out of their house so that he can sit in the shade and chat to passersby. Right: Children chase a medical vehicle leaving a Zambian village. The local Chikenkata Hospital, run by the Salvation Army, pioneered the idea of moving the care of AIDS patients into their own homes.

· Francesco Zizola
Italy, Agenzia Contrasto

1ST PRIZE SINGLES *(following pages)*
2ND PRIZE STORIES

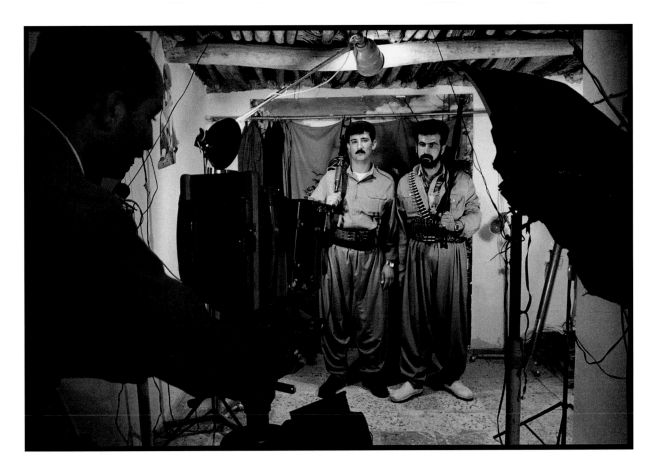

Numbering 26.3 million, the Kurds constitute the fourth largest
ethnic group in the Middle East. Since the end of the first World
War they have been scattered around different countries. In Iraq
and Turkey Kurds form almost a quarter of the population, with
smaller minorities in Iran and Syria. In Iraq, where these images
were shot, they achieved virtual autonomy, but this has been
severely undermined by factional fighting between warlords.
Above: Two *peshmergas* (freedom fighters) pose for a photogra-
pher in their village, which was destroyed during the Gulf War.
Following pages: This patient at Sulaimanya Teaching Hospital
suffered serious burns when a bomb exploded near her home
(story continues).

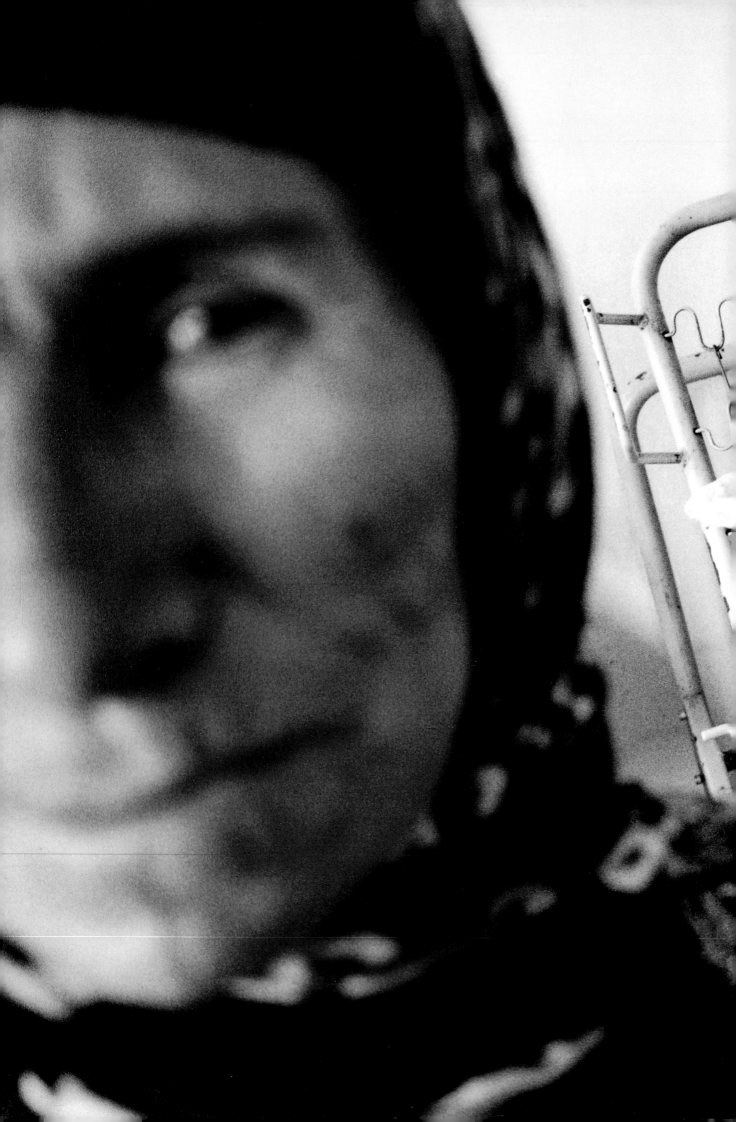

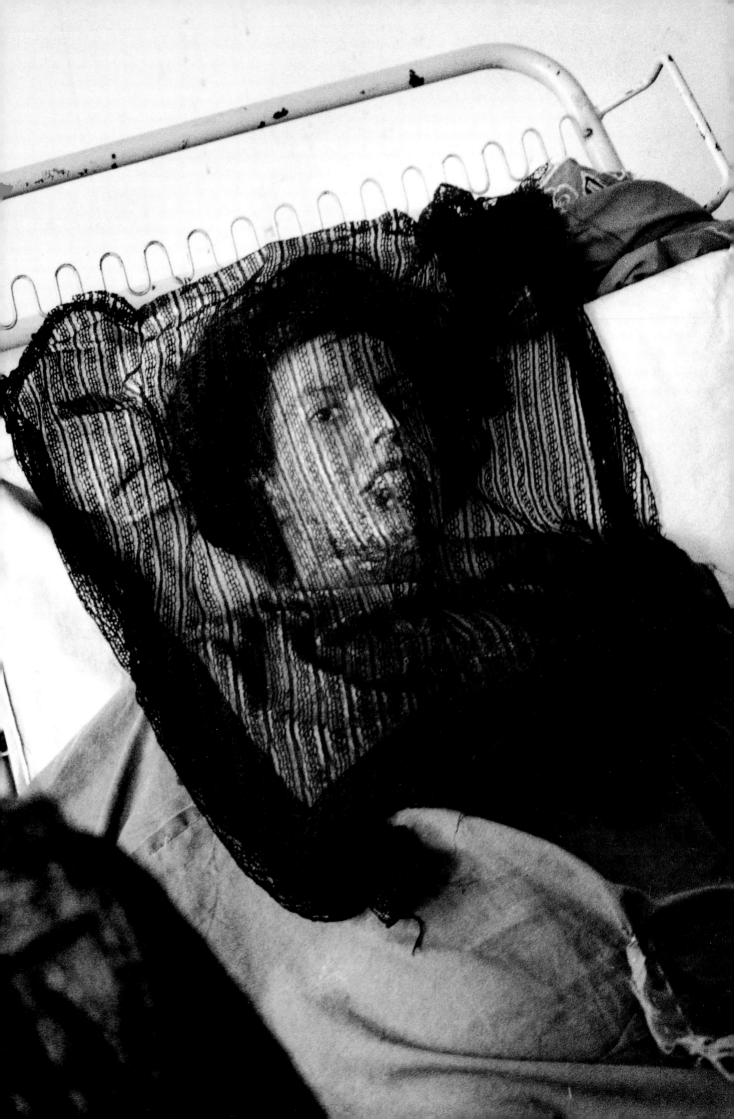

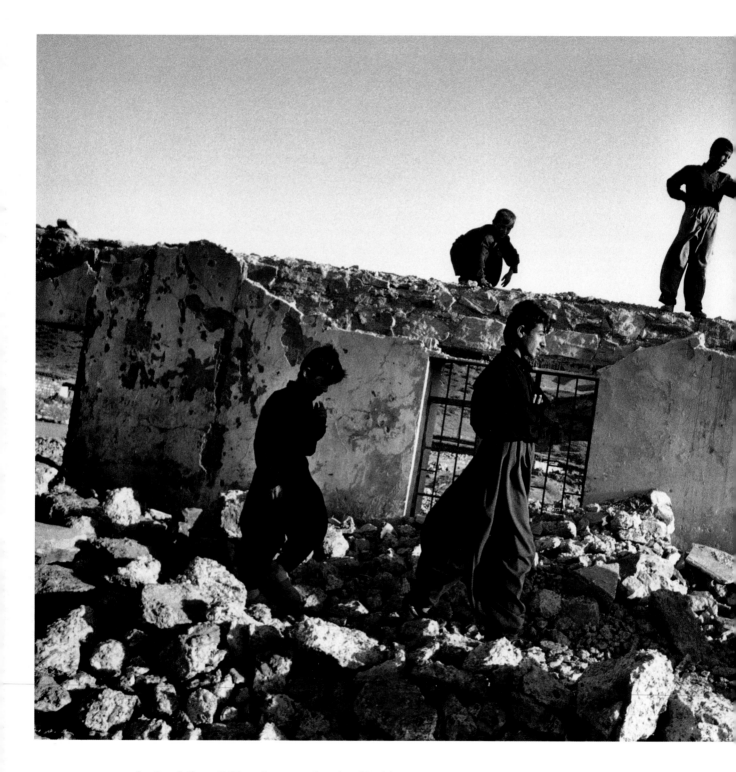

(continued) Above: Children play among the ruins of Penjuin, a
town on the Iranian border destroyed by Saddam Hussein.
Facing page, from top: Women air their grief at the funeral of a
young land mine victim in Chanchamal. In a separate explosion,
the man at center lost his son. Soldiers line up for a training ses-
sion under the flag of Kurdistan, which is recognized by no one.

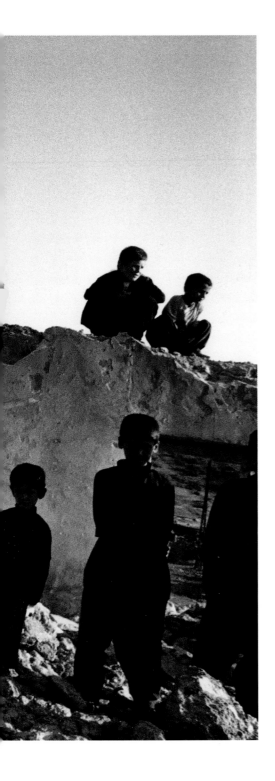

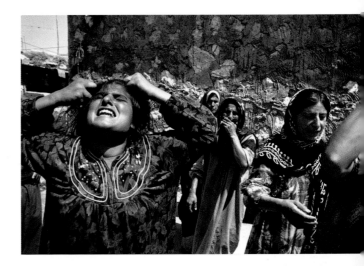

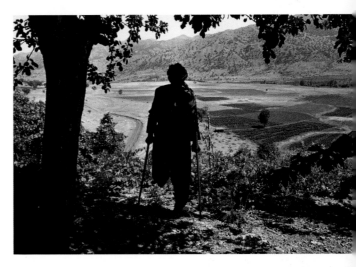

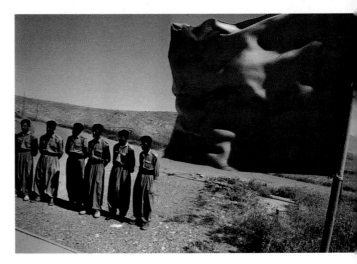

· Maciej Skawinski
Poland, Rzeczpospolita Magazine

3RD PRIZE STORIES

In July Poland, Germany and the Czech Republic suffered the worst floods to hit the area this century. Over a period of two weeks more than 100 people perished. Cattle drowned, harvests were lost and thousands of homes, factories, roads and bridges were damaged or destroyed. The river Oder on the border between Germany and Poland rose four meters above its normal level. These two images of Zelazno in south-western Poland show an evacuation from a flooded house and an armored vehicle being swept off by the strong current.

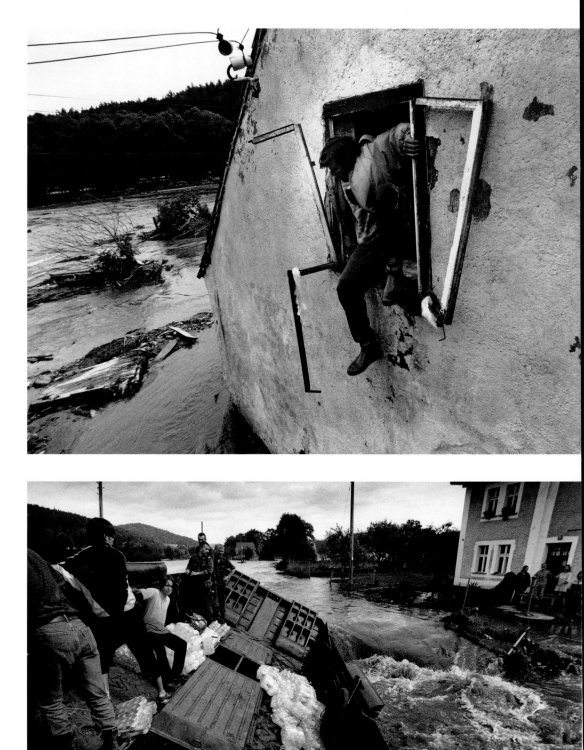

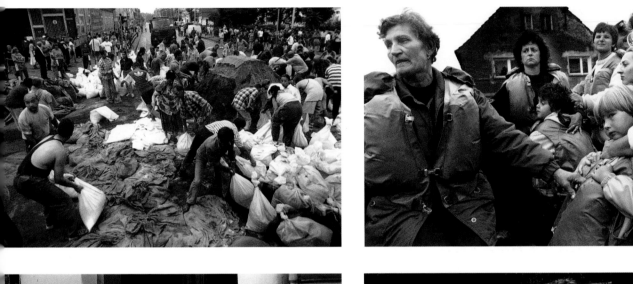

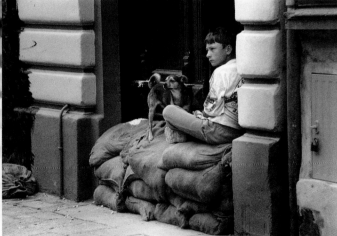
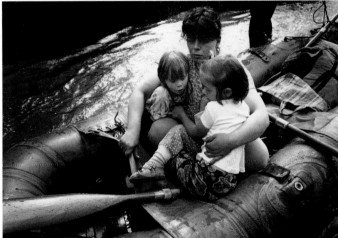

From top left: Inhabitants of
Nowa Sol feverishly work on the
construction of a dam. After the
flood, women and children return
home to Pilce. A young boy
prepares to sit it out in Nowa Sol.
A woman is evacuated from
Wroclaw with her children *(story
continues)*.

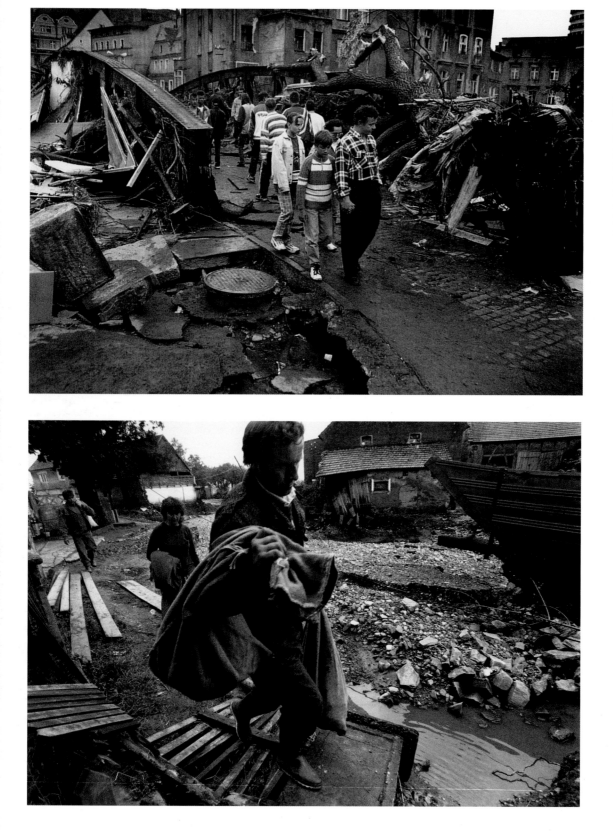

(continued) Left: After the deluge, people assess the havoc wreaked by the river in Klodzko. Below: These inhabitants of Pilce lost their homes altogether. The Polish authorities decided to construct a lake on the site to prevent floods in the future.

Prize winners

d Press
o of the
1997
, Algeria,
e France

n Grieves
Massacre in
ha, Algeria,
tember

orld Press
of the Year
honors the
rapher
photograph,
d from all
, can be
lly regarded
photojourna-
ncapsulation
year: a pho-
h that repre-
n issue, situ-
r event of
ournalistic
tance and
clearly dem-
tes an out-
ng level of
perception
eativity.

d Press
o
ren's
rd

Watts, USA,
ork
News
, Prostitute
rug Addict

4

ternational
en's jury
s the
ren's Award
the entries for
orld Press
Contest. The
f schoolchil-
s composed of
rs of national
tional con-
organized by
g media in
ountries.

Spot News Singles
1 Wendy Sue Lamm, USA, Agence France Presse
Confrontation between Palestinians and Israelis, Hebron, 9 April

Page 10

2 Anonymous, Algeria, Sipa Presse for Paris Match, France / Time Magazine, USA
Victim of the Massacre in Frais-Vallon, Algeria, 7 January

Page 11

3 Massimo Sciacca, Italy
Arrest of Highway Robber, Albania, 17 March

Page 12

Spot News Stories
1 Santiago Lyon, USA, The Associated Press
Anti-Government Rebellion, Albania

Page 13

2 Kadir van Lohuizen, The Netherlands, Agence Vu, France for Vrij Nederland
Train from Biaro to Kisangani, Zaire, May

Page 16

3 Silvia Izquierdo, Peru, Reuters
Commandos Storm Japanese Ambassador's Residence, Lima, 22 April

Page 19

People in the News Singles
1 Hocine, Algeria, Agence France Presse
Woman Grieves after Massacre in Bentalha, Algeria, 23 September

Page 4

2 Judah Passow, USA, Network Photographers, UK for Das Magazin, Switzerland
Israeli Soldiers Help Injured Palestinian, Hebron

Page 28

3 Joachim Ladefoged, Denmark, Politiken
Funeral of Man Killed by Stray Bullet, Berat, Albania

Page 22

People in the News Stories
1 Joachim Ladefoged, Denmark, Politiken
Albanians

Page 21

2 Judah Passow, USA, Network Photographers, UK
Ten Years of Intifada

Page 27

Prize winners

Sports Singles

1 *Jed Jacobsohn, USA, Allsport USA*
Evander Holyfield after Being Bitten by Mike Tyson, Las Vegas, 28 June

Page 37

2 *William Frakes, USA, Sports Illustrated*
Maurice Greene Wins 100m at World Athletics Championships, Athens, 3 August

Page 38

3 *Christopher Pillitz, Brazil, Network Photographers, UK for Stern, Germany*
Brazilian Priests' Football Team

Page 39

3 *David Modell, UK, Independent Photographers Group*
The End of the Tory Era

Page 32

Sports Stories

1 *Eric Mencher, USA, The Philadelphia Inquirer*
Little League Baseball Team on Tour

Page 40

2 *Aristide Economopoulos, USA, The Jasper Herald*
Gay Rodeo

Page 44

3 *Dudley M. Brooks, USA, The Washington Post*
No Kid Gloves

Page 46

Honorable mention
Craig Golding, Australia, Sydney Morning Herald
Australian Grand Sumo Tournament

Page 49

Portraits Singles

1 *Michael S. Wirtz, USA, The Philadelphia Inquirer*
Woman Puts on a Burka, Afghanistan

Page 52

2 *Peter Dammann, Germany, Mare Magazine*
Cadet of Kronstadt Naval Academy, Russia

Page 53

3 *Carol Guzy, USA, The Washington Post*
Muhammad Ali

Page 54

Portraits Stories

1 *Antonin Kratochvil, Cz Republic, Saba Photo for Deta USA*
Willem Dafoe

Page 56

Science and Technology Singles
1 *Stephen Ferry, USA, Gamma Liaison for Life Magazine*
Dolly, First Cloned Mammal

Page 65

2 *Marc Steinmetz, Germany, +49 photo for Focus*
'Plastinated' Human Skeleton

Page 72

3 *Oliver Meckes and Nicole Ottawa, Germany, Eye of Science for Geo*
Pubic Lice

Page 66

Science and Technology Stories
1 *George Steinmetz, USA, National Geographic Magazine*
Applied Robotics

Page 68

3 *Tom Stoddart, United Kingdom, Independent Photographers Group*
Tony Blair's Election Campaign

Page 62

2 *Marc Steinmetz, Germany, +49 photo for Focus*
Anatomical Preparation of Human Bodies by 'Plastination'

Page 70

3 *Jean-Michel Turpin, France, Gamma*
Neonatal Hospital Ward

Page 75

Daily Life Singles
1 *Zed Nelson, UK, Independent Photographers Group*
Memphis Housewives Compare Handguns

Page 80

2 *Chien-Chi Chang, Taiwan ROC, Magnum*
Newlyweds, Taiwan

Page 81

3 *Chris Steele-Perkins, UK, Magnum*
Courtyard of Mental Hospital, Pakistan

Page 82

Honorable Mention
Alexander Tsiaras, USA, for Life Magazine
Interior Views of the Human Body

Page 78

bbha, Italy,
zia Contrasto
an Nobility

58

The Arts
Singles
1 *Jodi Bieber, South
Africa, for The
Independent, UK*
Ballroom Dancing
Students at
Ennerdale Academy,
South Africa

Page 92

2 *Harald C.
Schmitt, Germany,
Stern*
Ea Sola Dance
Company at
Rehearsal

Page 94

3 *Robert Polidori,
France, Agence
Planet for The New
Yorker, USA / Geo,
France*
French Decorative
Arts Room, Getty
Museum, Los
Angeles

Page 95

Daily Life
Stories
1 *Susan Watts,
USA, New York
Daily News*
Gloria, Prostitute
and Drug Addict

Page 84

2 *Jeremy Nicholl,
Ireland, Matrix
International, USA
for Neue Zürcher
Zeitung, Switzerland*
Moscow Bathhouse

Page 86

3 *Fernando
Moleres, Spain,
Rapho, France*
Child Workers

Page 89

The Arts
Stories
1 *Vanessa Winship,
UK*
Junior Ballroom
Dancing Contest

Page 96

2 *Jodi Bieber, South
Africa*
Gauteng Music
Academy

Page 100

3 *Joseph McNally,
USA, Life Magazine*
Dancers of the
Bolshoi Ballet

Page 103

Honorable men
Howard Schatz
USA
Dance: 'Passion
Line'

Page 106

In 1998, 3,627 photographers from 115 countries submitted 36,041 entries. The participants are listed according to nationality as stated on the contest entry form. In unclear cases the names are listed under the country of mailing address.

AFGHANISTAN
Zalmai Ahad

ALBANIA
Fusha Albes
Felix Bilani
Ruzhdi Demiri
Rexhep Elezi
Zamir Marika
Marketin Pici
Llesh Prendi
Zhani Terpini

ALGERIA
Anonymous
Zohra Bensemra
Hocine
Ouahiba Kichou

ARGENTINA
Marcelo Aballay
Martin C.E. Acosta
Humberto Lucas Alascio
Bernardino A. Avila
Diego Azubel
Mauricio Bustamante
Ruben Adrian Cabot
Marcelo Capece
Pablo Enrique Cerolini
Mario Cocchi Viola
Daniel Dapari
Diego Del Carril
Alberto Alejandro Elias
Benito Espindola
Daniel Garcia
Julio Giustozzi
Daniel A.F. Gomez
Maria Elena Hechen
Claudio Herdener
Esteban MacAllister
Enrique Marcarian
Miguel Angel Mendez
Alejandro Jose Mezza
Luis Alberto Micou
Jacobo Daniel Mizrahi
Maria Luisa Musso
Fernando de la Orden
Guillermo Adrian Pardo
Hernan Gabriel Pepe
Javier A. Pereyra
Sergio Adrian Piemonte
Daniel Alfredo Piris
Angel Roberto Pittaro
Santiago Porter
Pablo Aurelio Puente
Josè Luis Raota
Delfo Rodriguez
Juan José Rojas
Julio César Sanders
Juan Jesús Sandoval
Mariano Federico Solier
Osvaldo Stigliano
Gustavo Marcelo Suarez
Luciano Thieberger
Omar Torres
Alberto Enrique Trotta
Antonio Valdez
Guillermo Viana
Juan Carlos Vollaro
Henry von Wartenberg
Dani Yako
Sebastian Zzyd

AUSTRALIA
Jacqueline Allman
Panizza Allmark
Dave Anderson
David Basioli
Kerry Berrington
Mario Bianchino
Torsten Blackwood
Philip Blenkinsop

Mario Joseph Borg
Ronald Fredrich Bull
Graig Cahill
Sharon Cavanagh
Steve Christo
Warren Clarke
Tim Clayton
Simon Cocksedge
Sebastian Costanzo
Robert Cox
Nick Cubbin
David Dare Parker
John Donegan
Stephen Dupont
Christopher Elfes
Nicole Clare Emanuel
Brendan Esposito
Margaret Fullich
Robert Garvey
Kirk Gilmour
Craig Golding
Steve Gosch
John Grainger
Edward Grambeau
David Gray
Patrick Hamilton
Patrick Hannagan
Mathias Heng
Phil Hillyard
Glenn Hunt
Ray E. Kennedy
Danny Khoo
Julian Kingma
Jean-Dominique Martin
Alexander Massey
Fiona McDougall
Darren McNamara
Andrew Merry
Wayne Miles
Russell Millard
Palani Mohan
Graham Monro
Renee Nowytarger
Nolen Oayda
Trent Parke
Sonia Payes
Jeremy Piper
Belinda Morgan Pratten
Adam William Pretty
Peter Rae
Jason Reed
Sarah Reed
Simon Renilson
Ilana Rose
George Salpigtidis
Sean Kennedy Santos
Milan Scepanovic
Russell Shakespeare
andrew Shaw
John Sherwell
Steven Siewert
Sean Sylvester
Tasso Taraboulsi
Andrew C. Taylor
Paul Tyson
Jon Van Daal
Angelo Velardo
Sylvia Vincent
Bohdan Warchomij
Greg Wood
Andy Zakeli

AUSTRIA
Heimo Aga
Toni Anzenberger
Michael Appelt
Harald Arnold
Leo Baumgartner
Hellfried Böhm
Angela Brachetti
Robert Fleischanderl
Stepp Friedhuber
Alfred R. Friese
Jan A. Friese
Peter Granser
Stefan Haring
Raphael Just
Robert Klein
Paul Kolp
Lois Lammerhuber
Karl Lang
Christian Lapp
Evy Mages
Wolfgang Mayer
Sascha Osaka
Reiner Riedler
Peter Rigaud
Chris Sattlberger

Ludwig Vysocan
Nikolaus Wagner

AZERBAIJAN
Elnour Babaev
Jegar Djafarov
Mirnaib Hasanoglu

BANGLADESH
Abir Abdullah
Shahidul Alam
Alam Md. Ferdous
Mir Mahboob Ashraf
Tapas Barua
Akter Bayazid
Pranayan Chakma
Mohidul Md. Haque
Md. Zakir Hossain
Md. Irfanul Islam
P. Karmakar Buddha
Mufty Munir
Syed Rafiquer Rahim
Pavel Rahman
Khaled Sattar
Hashi Talukdar
Md. Main Uddin
Md. Zia Zahir Pallab

BARBADOS
Clifton Henry

BELARUS
Yuri Ivanov
Anatoli Kleshchuk
Vladimir Razan
Vladimir Sachek
Vladimir Shlapak

BELGIUM
Dimitri Ardelean
Karim Ben Khelifa
Hilde de Bock
Patrick Bollen
Eric Brasseur
Bert van den Broucke
Filip Claus
Marc de Clercq
Mine Dalemant
Marc Deville
Yvan Deweerdt
Tim Dirven
Karl Donvil
Thierry Geenen
Patrick de Kuysscher
Catherine Lambermont
Didier Lebrun
Jan Locus
Firmin de Maitre
Frederic Materne
Olivier Matthys
Koen Meyers
Jean-Pierre Monhonval
Kris Mouchaers
Koen Opgenhaffen
Kris Pannecoucke
Olivier Polet
Luc Struyf
Dieter Telemans
Gaël Turine
Stephan Vanfleteren
Louis Verbraeken
Tim de Waele
François Walschaerts

BOLIVIA
Sandra Boulanger
Enzo de Lucca Calderon
D. Mercado Montano
Eduardo Ruiz Gumiel
Hugo José Suarez

BOSNIA-HERZEGOVINA
Ranko Cukovic
Fuad Foco
Zijah Gafic
Senad Gubelic
Muhamed Husic
Edin Karahusic
Nihad-Nino Pusija
Zlatko Tulic
Drago Vejnovic

BRAZIL
Ludmila Achkar Petrillo
Marcelo Rudini Alcarde
M. Alves da Cruz Lima
E. Paixao Alves Peixoto

Sergio Amaral
Paulo Amorim
C. Aquino Bocayuva
Alberto Cesar Araujo
Ana Araújo
Alvisio Arruda
Nário Barbosa
Alexandre Battibugli
Moraes Beatriz
Mario Borges Junior
Gil V. de Brito Maia
Manoel de Brito
Marcelo Buainain
Eneraldo Carneiro
Vinicius de Castro
Ivaldo Cavalcante Alves
Adalmir Chixaro
A. Claro de Oliveira
A.A. Coelho Cardoso
Tina Coelho
Custódio J.B. Coimbra
Jose Luis da Conceição
Maurilo Clareto Costa
José Cristovao Bernardo
A. da Cunha Noguiera
Leonardo Dias Correa
André Ricardo Durao
Cristiane Ribas D´Avila
Helena D´Lucia
Evelson Rodrigues
Ricardo Fasanello
U. Fernandes de Freitas
Javi Fernandez da Silva
Edivaldo Ferreira
Pedro Luiz Ferreira
C. E. Gomes e Souza
Jair Grandin
Yone Guedes da Costa
F. Guedes de Lima
Rose Guerra
Geraldo Guimaráos
Dulce Helfer
Clovis Ferreira Lima
Vladia Lima
Levis Litz
Moacyr Lopes Jr
Denilson Machado
Edison Machado
Benito Maddalena
Guilherme Maranhão
F.A. Torres Martinho
L.C. de Melo Nuñes
Marcia Mendes
Fernando A. Miceli
Eny M.J. de Miranda
Mathilde Molla
William Nery de Abreu
Luiz Nicolella
Cleide Maria de Oliveira
R. Barreiros Oliveira
Ronaldo de Oliveira
L. Palhares de Mello jr
Raimundo Palló
Hipolito Pereira
Christopher Pillitz
Paulo Martins Pinto
M. Pinto dos Santos
Marcos Prado
Carol Quintanilha
Heudes Regis
Caio Esteves Ribas
Levy Freire Ribeiro Filho
Christina Rufatto
Paulo R. Santos Araújo
Roberto Setton
A. Severino da Silva
Alex Silva
Jose C.D. da Silva
José Patricio da Silva
Claudio L. Silva da Silva
Gleice Mere S.R. Silveira
M. A. Siqueira Campos
G.C. Soares dos Santos
Wilton de Sousa Jr.
Renato de Souza
Fernando Souza
Francisco A. de Souza
M. de Souza Mendes
Mabel Sra Feres
Rosane Talayer de Lima
José Varella
Cláudio Versiani
Renata Victor
Pedro França Viegas
Marcelo Vigneron
Mônica Zarattini

BULGARIA
Dimitar Bogdanov
Nick Chaldakov
Roumen Gueorguiev
Mishel Guerón
Nikolai Iliev
Lyubomir Jelyaskov
Atanas Kanchev
Jordan Petev
Ivan Sabev
Todor Todorov
Ivaylo Velev
Vesel Vesselinov

BURKINA
Guira Bare

CAMBODIA
Re Missa Mak

CAMEROON
Raphaël Mbiele Happi

CANADA
Carlo R. Allegri
Chris Anderson
Peter Andrews
Kevin J. Argue
Tim Atherton
Brian Atkinson
Jan Becker
Stan Behal
Bernard Beisinger
Jean-Francois Bérubé
Tony Bock
Ruth Bonneville
Jeff De Booy
Bernard Brault
Peter Bregg
Geraldine Brophy
Joe Bryksa
Shaughn Butts
Phil Carpenter
Raymond K.K. Chan
Richard Collins
Gary Crallé
Barbara Davidson
Hans Deryk
Ursula Deschamps
Bruno Dorais
Richard Emblin
Ken Faught
Lisa Fleischmann
Marc Gallant
Brian James Gavriloff
Ken Gigliotti
Claude Gill
Greg Girard
Jon Glowacki
Dina Goldstein
Chris Helgren
Gary Hershorn
Phil Hossack
Emiliano Joanes
Edwin Kaiser
Judith Kostilek
Marie-Susanne Langille
Richard Lautens
Roger Lemoyne
Ron Lenne
Dick Loek
Rick MacWilliam
Sylvain Mayer
Allen McInnis
Jeff McIntosh
Boris Minkevich
Nadia Molinari
Gary Moore
John Morstad
Mark O'Neill
Doug Peterson
Peter Power
Duane Prentice
Ognjen Radosevic
Chris Rainier
Alain Roberge
Chuck Russell
Steve Russell
Rick Rycroft
Robert Semeniuk
Michael Slaughter
Andrew Stawicki
Michael Stuparyk
Homer W. Sykes
Jon Thordarson
Larry Towell
Andrew Vaughan

Chris Wahl
Andrew Wallace
Ron Ward
Poon Water
George Webber
Bernard Weil
Darren Whiteside
Jim Wilkes
Vincent Wong
Andrew Yeung

CHILE
Andrea Ayala Gac
Eduardo Javier Beyer
Javier Enrique Godoy
Alvaro Felipe Larco
Matias Recart
Carlos Reyes Manzo
Juan Francisco Somalo
Jorge Uzon
Frank Villagra Roman

COLOMBIA
Luis Agudelo Cano
Gabriel Aponte Salcedo
Carmelo Bolanos
Gerardo Chaves Alonso
Rodrigo Cicery Beltran
Zoraida Diaz
José Miguel Gomez
Jorge Enrique Henao
Carlos Linares Pinzon
Bernardo Peña Olaya
Inaldo Perez Castillo
Jaime Perez Munevar
Luis Ramirez Ordonez
Orlando Ricci Arango
Carlos Antonio Rios
Henry Romero
Manuel Saldarriaga
Jorge Hernan Sanchez
Liliana Patricia Toro

COSTA RICA
Carlos Borbón Castro
Mario Castillo Navarro
Eduardo López Lizano

CROATIA
Kreso Duric
Marko Gracin
Vlado Kos
Ivan Kovac
Sasa Kralj
Lidija Maricic
Veljko Martinovic
Luka Mjeda
Josip Petric
Zlatko Ramnicer
Denis Stosic

CUBA
Alejandro Azcuy
Julio Bello Aguabella
Feliberto Carrié Fajardo
Héctor R. Fernández
Daniel P. Fonte Fonte
Angel Gonzalez Villegas
Cristóbal Herrera
Huo Yan
Orlando Lois Sarabia
Ernesto Mastrascusa
Eduardo Mojicas Ibánez
Pedro Perez Portales
René Abad Rodríguez
Ahmed Velázquez

CYPRUS
Andreas Vassiliou

CZECH REPUBLIC
Günter Bartos
Tomas Bem
Josef Bradna
Martin Dlouhy
Eduard Erben
Hynek Glos
Lenka Hatasová
Vaclav Hubata-Vacek
Petr Josek
Antonin Kratochvil
Alexandr Kundrát
Dana Kyndrova
Josef Louda
Stepan Lutansky
Michal Novotny
Jaromir Pavicek
Jiri Pekarek

Stanislav Peska
Milan Petrik
Josef Ptácek
Roman Sejkot
Jan Sibik
Herbert Slavik
Josef Sloup
Jaroslav Tatek
Judita Thomova
Jiri Turek
Stanislav Zbynek
Tomàs Zelezny
Iva Zimova

DENMARK
Jens Astrup
Soeren Bidstrup
Claus Boesen
Jan Dago
Casper Dalhoff
Jakob Dall
Francis Joseph Dean
Jacob Ehrbahn
Mads Eskesen
Finn Frandsen
Jan Anders Gravup
Mads Greve
Tine Harden
Klaus Holsting
Nicolai Howalt
Michael Jensen
Jan Eric Johnsen
Nils Jorgensen
Joachim Ladefoged
Ulla S. Larsen
Claus Bjorn Larsen
Soren Lauridsen
Soren Lorenzen
Tao Lytzen
Nils Meilvang
Voja Miladinovic
Michael Mogensen
Hans Otto
Jorgen Petersen
Lars Ronbog
Henrik Bo Ronsholt
Soren Schnoor
Soren Skarby
Preben B. Soborg
Claus Sondberg
Thomas Sondergaard
Jens Morten Sorensen
Torben Stroyer
Karina Thullesen
Ernst Tobisch
Robert Wengler

DOMINICAN REPUBLIC
Juan Jose Nunez Estevez

ECUADOR
Luis Almeido Castro
Jose Alvarado Franco
Diogenes Baldeon
Francisco Bravo
Elder Bravo Naranjo
Stalin Diaz Suarez
Cesar Guaña Cando
Jorge Guzman
Martin Herrera
Victor Ipanaque
Cesar Ignacio Mera
Gerardo Mora Drovet
Dolores Ochoa
Jorge Penafiel
Leen Prado Viteri
Jose Sanchez
Jorge Vinueza Garcia

EGYPT
Khaled El Fikki
Bassam El-Zoghby
Wessam Mahanna
Magdy Mahdy Abdallh
D. Mohamed Mostafa
Waled Zenhom

EL SALVADOR
F. Campos Sosa
Fernando Golscher
J. Lara Barrera
William Martínez

ERITREA
Tesfaldet Kidane
Zewdi Kidane
Eyob Tecle

Kidane Teklemariam

ESTONIA
Tiit Räis
Viktor Vesterinen

FINLAND
Jaakko Avikainen
Hannes Heikura
Petteri Kokkonen
Matti Matikainen
Juhani Niiranen
Pentti Nissinen
Erkki Raskinen
Ilkka Uimonen
Hannu Vierula
Eva Wardi

FRANCE
Pascal Aimar
Frédéric Amat
Thierry Ardouin
Patrick Artinian
David Atlan
Maher Attar
Patrick Aventurier
Patrick Bard
Georges Bartoli
Gilles Bassignac
Eric Bauer
Patrick Baz
Christian Bellavia
Remi Benali
Alain Bétry
Olivier Blaise
Thierry Boccon-Gibod
Bruno Boudjelal
Denis Boulanger
Denis Bourges
Philippe Bourseiller
Eric Bouvet
Patrice Bouvier
Philippe Brault
Jérôme Brézillon
Frederic Buxin
Christophe Calais
Patricia Canino
Serge Canto
Stephane Cardinale
Jean-François Castell
Fabian Cevallos
Patrick Chapuis
Christian Charlon
Olivier Chouchana
Pierre Ciot
Jacques Cochin
Thomas Coex
Stephane Compoint
Laurent Conchon
Jerome Conquy
Carl Cordonnier
Gilles Coulon
Olivier Culmann
Philippe Dannic
Gautier Deblonde
Anne Delassus
Jerome Delay
Cyril Delettre
Didier Della Maggiora
Pascal Deloche
Jacques Demarthon
Michel Denis-Huot
Xavier Desmier
Bertrand Desprez
Patrick Dewarez
Eric Dexheimer
Robert Deyrail
Christophe Dubois
Vincent Dubourg
Sean Marc Dugas
Richard Dumas
Emmanuel Dunand
Patrick Durand
Alain Ernoult
Darryl Evans
Albert Facelly
Eric Feferberg
Guy Ferrandis
François Fontaine
Gérard Fouet
Eric Gaillard
Raphaël Gaillarde
Michel Gangne
Gérard Gastaud
Jean-Loup Gautreau
Françoise Gavazzana
Shtylia Gazmend
Yves Gellie

Arthur Gerbault
Francis Giacobetti
Frédéric Girou
Georges Gobet
Philippe Gontier
Didier Goupy
José Grain
Sylla Grinberg
Jacques Grison
Olivier Grunewald
Claude Le Guillard
Laurence Guillot
Antoine Gyori
Valéry Hache
Philippe Haÿs
Julien Hékiman
Guillaume Herbaut
Daniel Heuclin
Nguyen Hop
Boris Horvat
Françoise Huguier
Olivier Jobard
Armineh Johannes
Philippe Juste
Laurence Kourcia
Patrick Kovarik
Jean Philippe Ksiazek
Olivier Lacour
Jean-Claude Laffitte
Patrick Landmann
Francis Latreille
Christophe Lepetit
Gaël Leroux
Christian Lionel Dupont
Tony Lopez
Philippe Lopparelli
Pascal Maine
Pascal Maitre
Etienne de Malglaive
Richard Manin
Christophe Maout
Renaud Marchand
Clement Martin
Jérôme Martin
Pierre Mérimée
Jean Philippe Mesguen
Patrick Mesner
Gilles Mingasson
Sebastien Moine
Stephan Moitessier
Luc Moleux
Herve Negre
Lisay Nelio
Gilles Nicolet
Alain Noguès
Alexandra Oxacelay
Thierry Pasquet
Cédric Pasquini
Pascal Pavani
Gerard Planchenault
Mathieu Polak
Robert Polidori
Vincent Prado
Luc Quelin
Jean Claude Revy
Joël Robine
Michel Roget
Alexis Rosenfeld
Jean-Philippe Rousseille
Olivier Roux
Patrick Roux
Cyril Ruoso
Lizzie Sadin
Joël Saget
Erik Sampers
Eric Sander
Patrice Saucourt
Henri-Alain Segalen
Roland Seitre
Christophe Simon
Govin Sorel
Michel Spingler
Daniel Staquet
Franck Stromme
Stephane Tabet
Jean-Luc Tilliere
Patrick Tourneboeuf
Jean-Michel Turpin
Gérard Uferas
Gil Varela
Laurent Vautrin
Louis Vincent
Christian Vioujard
Hervé Williencourt
Bernard Wis

GEORGIA
David Gujabidze

Simon Kiladze

GERMANY
Adalbert Adaszynski
Alexander Alfes
Carola Alge
Albert Alten
Michael S. Anacker
Oto Ansgar
Bernd Arnold
David Auggerhofer
Ulrich Baatz
Florian Bachmeier
Theodor Barth
Sibylle Bergemann
Günter Bersch
Klaus Beth
Antje Beyen
Andreas Birresborn
Andreas Bohnenstengel
Sebastian Bolesch
Lutz Bongarts
Karsten Bootmann
Alexander Borm
Wolfgang Borm
Marcus Brandt
Frank Bredel
Lothar W. Brenne
Hans-Peter Brenneken
Ulrich Brinkhoff
Christian Brinkmann
Hans Jürgen Britsch
Martina Buchholz
Hans-Jürgen Burkard
Rainer Bültert
Wolf Böwig
Peter Christmann
Sven Creutzmann
Anthony Crossley
Ulf Dahl
Peter Dammann
Uli Deck
Uschi Dresing
Hauke Dressler
Thomas Dworzak
Erwin Döring
Sven Döring
Winfried Eberhardt
Jochen Eckel
Hans Richard Edinger
Werner Eifried
Wolfgang Eilmes
Peter Elbeshausen
Stephan Elleringmann
Malte Engelhardt
Ralf Erhlich
Martin Ernst
Thomas Ernsting
Hans-Georg Esch
Volker Essler
Rüdiger Fessel
Wolfgang Fillies
Sven Fischer
Ute Fischer
Ian Fonosch
Klaus Franke
Arve Frase
Guido Frebel
Jürgen Freund
Peter Frischmuth
Mike Fröhling
Ulrike Frömel
Sascha Fromm
Daniel Fuchs
Jochen Funk
Albrecht Gaebele
Jan Gallas
Horst Galuschka
Andreas Gefeller
Uwe George
Ralf Gerard
Christoph Gerigk
Markus Gilliar
Peter Ginter
Bodo Goeke
J. Goethel
Igor Gorovenko
Eberhard Gronau
Oliver Grottke
Ute Hachemer
Kerstin Hacker
Hacky Hagemeyer
Kurt Hamann
Marita Hammer
Alfred Harder
Alexander Hassenstein
Wim van der Helm
Ilja Clemens Hendel

Jürgen Henschel
Andreas Herzau
Catharina Hess
Markus C. Hildebrand
Erik Hinz
Stefan Hippel
Markus Hippeli
Ralf Hirschberger
Marcus Darryl Hirthe
Thomas Hoepker
Udo Horn
Christian G. Irrgang
Lajos Jardai
Dirk Jeske
Christian Jungeblodt
Monika Jäger
Henning Kaiser
Enno Kapitza
Wolfgang Kaszubiak
Marcus Kaufhold
Reinhard Kemmether
Falk Kienas
Hannes Kirchner
David Klammer
Hans-Jürgen Koch
Heidi Koch
Vincent Kohlbecher
Christian Kosak
Uwe Kraft
Rainer Kraus
Reinhard Krause
Tom Krausz
Gert Krautbauer
Guido Krawczyk
Ralph Krein
Perry Kretz
Stephan Krudewig
Dirk Krüll
Bernhard Kunz
Andrea Künzig
Roland Köhler
Andreas Labes
Bernd Lammel
Andreas Lang
Karl Lang
Martin Langer
Gudrun Laufer-Vetter
Martin Leissl
Jens Liebchen
Dorothea Loftus
André Lützen
Birgit-Cathrin Maier
Uwe Mann
Hans von Manteuffel
Ralf Maro
Willi Matheisl
Sönke Matz
Markus Matzel
Armin Maywald
Oliver Meckes
Rudi Meisel
Wolfram Meisel
Karl-Heinz Melters
Heiko Meyer
Jens Meyer
Judith Michaelis
Roger Mohr
Knut Mueller
Christian Muhrbeck
Konrad R. Müller
Peter Müller
Achim Multhaupt
Horst Nebe
Gertrud Neumann
Axel Nordmeier
Hans Günther Oed
Ogando
Wulf Olm
Stefan Orge
Christoph Otto
Jens Palme
Günter Passage
Laci Perenyi
Frank Peters
Fritz Pölking
Stefan Pompetzki
Paulus Ponizak
Christian Popkes
Jan Erik Posth
Bernd Potschka
Ulrike Preuss
Frank Pusch
Karsten-Thilo Raab
Thomas Rabsch
Csaba Peter Rakoczy
Roland Rasemann
Mark Oliver Reck
Karin Rocholl

Norbert Rosing
Volkel Rost
Barbara Rzepka
Frederik Röh
Jens Rötzsch
Stephan Sagurna
Gerard Saitner
Mark Sandten
Martin Sasse
Sabine Sauer
Rüdiger Schall
Frank Schilberbach
Michael Schindel
Jordis Schlösser
Wolfgang Schmenner
Hans-Jürgen Schmidt
Bastienne Schmidt
Harald C. Schmitt
Werner Schmitt
Walter Schmitz
Edgar-Rainer Schoepal
Markus Schreiber
Mike Schröder
Frank Schröter
Bernd Schuller
Frank Schultze
Friedhelm Schulz
Marc Oliver Schulz
Helmut R. Schulze
Horst Jürgen Schunk
Gerd Schütt
Stephan Schütze
Hartmut Schwarzbach
Karsten Schöne
Christoph Seelbach
Stephan Siedler
Bertram Solcher
Ralph Sondermann
René Spalek
Heiko Specht
Volker Steger
Torsten Steinke
Marc Steinmetz
Ralf Stockhoff
Angelika von Stocki
Stefanie Sudek
Patrick Sun
Murat Türemis
Jay Ullal
Guenay Ulutuncok
Marcus Vogel
Wolfgang Volz
Helmut Wachter
Markus Wächter
Martin Wagner
Frank P. Wartenberg
Stefan Warter
Wolfram Weber
Eberhardt Wedler
Tim Wegner
Roland Weihrauch
Markus Weiss
Petra Welzel
Detlef Westerkamp
Frank Westphal
Kai Wiedenhöfer
Frank Wiese
Peter von Zschinsky
Samuel Zuder

GREECE
Yannis Behrakis
Mihalis Boliakis
Nikos Chalkiopoulos
Iakovos Chatzistayrou
Greg Chrisochoidis
Vassilis Constantineas
Pavlos Fisakis
Theodosis Giannakidis
Yiorgos Karahalis
Mikhail Katsaitis
Giannis Kolesidis
Yiannis Kontos
Maro Kouri
Nickos Koutsopanos
Thomas Lappas
Kosmas Lazaridis
Dino P. Metropoulos
P. Papadimitropoulos
Constantinos Petrinos
Spiros Petrovas
Nicolas Pilos
Lefteris Pitarakis
G. Stavrakantonakis
Thanassis Stavrakis
Patroglos Stellakis
Sophie Tsabara
John Vellis

Alexandros Vlachos

GUATEMALA
Luis Garcia

HONG KONG, S.A.R. CHINA
Robyn Beck
Ho Wing Kin Garrige
Chi Kwan, Jeffrey Pang
N.G. Robert
So Hing Keung

HUNGARY
Eva Arnold
Bela Gy. Balazs
András Bánkuti
Imre Benkö
Gabor Bognar
Esther Borbas
Bela Csonka
Gyula Czimbal
Zsolt Demers
Szabolcs Dudas
Peter Fodor
Imre Földi
Csaba Forrásy
Jozsef Gjarmati
Peter Harsanyi
Angela Kallo
István Keserü
Attila Kisbenedek
Bence Kovács
Attila Kovács
Tamás Mike
Ferenc Németh
Zsolt Pataky
Peter Rakosi
Tamás Révész
Zsuzsa Schiller
Csilla Simon
Lajos Sods
Róbert Szabó
Péter Szalmás
Abel Szalontai
Péter Zádor

ICELAND
Ragnar Axelsson
Arnaldur Halldorsson
Kristinn Ingvarsson
Julius Sigurjonsson
Kjartan Thorbjörnsson

INDIA
Sunil Adesara
Ananda
Bindu Arora
Asish Bal
Baldev
Dilip Banerjee
Tarapada Banerjee
Pablo Bartholomew
Utpal Baruah
Samir Basu
Shyamal Basu
Jayanta Battacharyya
Sandesh Bhandare
Rajesh Kumar Bhasin
Paul Bhaskar
Dharmesh S. Bhavsar
Pampa Biswas
Dhiman Bose
Nand Kishore Budhoodi
Hersh W. Chadha
B. Chandrakumar
Chirodeep Chaudhuri
Sachin Chitnis
Bikas Das
Moni Sankar Das
Pabitra Das
Prabuddha Das Gupta
Saibal Das
Arko Datta
Rajib De
Krishna Deo
Uday Deolekar
Noshir Desai
P. R. Devadas
Nilayan Dutta
Santosh Dutta
Gautam Sen
Victor George
Vasanth Ghantasala
Nimai Chandra Ghosh
Sanjoy Ghosh
Soumitra Ghosh
Uttam Ghosh

Alok B. Guha
Heri Gunawan
Dodo Hawe
Dipak Hazra
Fawzan Husain
Subramoney R. Iyer
B.K. Jain
M.K. Jain
C.K. Jayakrishnan
Jeejo John
Kuriyan Johnson
Anita Khemka
C. Ratheesh Kumar
Prabhakar Kusuma
A. Kuttibabu
Bhupesh Chandra Little
Shyamal Maitra
Sailendra Mal
Subhash Malhotra
Zakir Ali Marhoom
amit Mehra
Dilip Mehta
Jewella C. Miranda
Aloke Mitra
Dakoo Mitra
Dines Mukherjee
Sajal Mukherjee
James Sundar Murthy
Naik Sandeep
Dev Nayak
Swapan Nayak
Kedar Nene
R. Padmanabhan
Shailesh Patel
Devdatta Patil
Gautam Patole
C.B. Pradeepkumar
Shakeel Qureshy
M.K. Abdul Rahman
Raghu Rai
Kamal Rana
Ratan Shanti Swaroop
Sheilesh Raval
Ravinder Kumar
Duggempudi Ravinder
K.K. Ravindran
Ravuir Koteswara Rao
Kushal Ray
Arunangsu Roy
Jayanta Saha
Rakesh Sahai
Partha Protim Sarkar
A.S. Satheesh
Dominic Sebastian
Bijoy Sengupta
Aziz Shah
Harsh Shah
Hemendra A. Shah
Hemant Shirodkar
Uday M. Shirodkar
Ajoy Sil
Bandeep Singh
P. Sivakumar
Ellikkal V. Sreekumar
Paul Swapan
Manish Swarup
Leen Thobias
Bino Thomas
Rajen M. Thomas
U. Unni Krishnan
Upendra Upadhyay
Agus Wahyudi
Anil Kumar Warrier

INDONESIA
Bambang Afadjar
Astuti Andharini
Jack Andu
Bayu Ismoyo
Sinar Goro Belawan
Tjitra Winarno Brata
Wibudiwan Tiria Brata
Ali Budiman
Ade Dani Setiawan
Achmad Yessa Dimyati
M. Djupri
E. Fiap
Henky Hamdani
Eddy Hasby
Roy Hendroko
Iim Ibrahim
Edwin Karim
Kholid
Nyoman Krisnadi
Pujianto Johan Leo
Aris Liem
Henry Lopulalan

Mak Pak Kim
Harto-Solichin Margo
Aris Munandar
Nuraini Tjitra Widya
Pang Hway Sheng
Poltak Panggabean
Paulus Patmawitana
Andhika Prasatya
Dedi H. Purwadi
Purwanto
Putra Madi Rumekso
Sutrisna Ramli
Yayat Ruhiat
A. Rusdiansyah
Sandhi Irawan
Setyawan
Poriaman Sitanggang
Tarko Sudiarno
Arief Suhardiman
Yayat Sukarta
Cecep Sulaeman
Mr. T.P. Sumedi
Toto Sunyoto
S. Tanrawali
Josua Victor Tanugerah
Sakaria Tanzil
Nonot S. Utomo
R.A.B. Widjanarko
Bagong Zelphi

IRAQ
Saleh Af Samawi
Noor Aldien Hussien
Ibrahim S. Nadir

IRELAND
Laurence Boland
Desmond Boylan
Deirdre Brennan
Matthew Browne
Cyril Byrne
Bruce Crummy
Colman Doyle
Kate Horgan
Eric Luke
Dara Mac Dónaill
David Maher
Eoin McCarthy
Ian McIlgorm
Adrian Melia
Brendan Moran
Seamus Murphy
Jeremy Nicholl
Jack P. Nutan
Joanne O'Brien
Kyran O'Brien
Alan O´Conner
Leo Regan
David Sleator
Mick Slevin
Eamon Ward

IRAN
Yadollah Abdi Kaloraz
Seleh Abutaleb
Kaveh Ahmadi
Arash Akhtari Rad
Hassan Amdjadi
Aslon Arfaa
Saeed Ashrafi
Jamshid Bairami
Bita Bakhtjov
Hassan Chapi
Nader Davoodi
Fatemeh Dejam Tabah
Ila Deriss
Majid Dozdabi Movahed
Javad Erfanian
Amir Reza Fatoorehchi
Amir Ghassemnegad
G. Hafezalghoran
P. Hooshmandzadeh
Seid Majid Hosseiny
Hashem Javad Zadeh
Alireza Karimi Saremi
Ronen Kedem
Saeid Khamesipour
Majid Khamseh Nia
M. Khodadadash
Shadi Khonsari
M. Kouchakpour
Manoocher
Mahour Masaeean
Hadi Mehdizadeh
Behrooz Mehri
Morteza Mohamad
Madjid Mola Abasi
Mehdy Monem

Hamid Mozafari
Gholam Reza Nasr
Masoud Nazari Mehrabi
Omid Parsa Nejad
Nader Pirzade
Javad Poursamad
Ali Reza Rouh Navaz
Vahid Sadeghi
Ashkan Sahihi
Hashem Samie Shams
Mohsen Sanei Yarndi
Hassan Sarbakhshian
Khan-Ali Seiamee
Hossein Sharififar
Homeira Soleymani
Abbas Takin
Mojtaba Takin
Sadegh Tirafkan
Mohammadi Valiollah
Arash Yadollahi
Hamid Yousef Lavi

ISRAEL
Yossi Aloni
Shlomo Arad
Joel Assiag
Rina Castelnuovo
Yori Costa
Netanel Doron
Hanoch Grizitzki
Rula Halawani
Liza Hamlyn
Ziv Koren
Michael Kremer
Ilan Kulka
Motty Levy
Ilan Mizrachi
Daud Mizrahi
Barak Oser Ovitz
Ilan Ossendryver
Jacob Saltiel
Roni Schützer
Shaul Schwarz
Natt Shohat
Uri Silberman
David Silverman
Mati Stein
Amit Torem
Yossi Zamir

ITALY
Marco Albonico
Stefano Amantini
Michele Annunziata
Rita Antonioli
Fabio Artusi
Fabiano Avancini
Luigi Baldelli
Domenico Barile
Silvano Bausa
Ernesto Bazan
Angelo Bergamaschi
Marco Bertoldi
Mario Biancardi
Rino Bianchi
Tommaso Bilardo
Marco Bini
Ivano Bolondi
Enrico Bossan
Antonella Bozzini
Giovanni Broccio
Leonardo Brogioni
Gianluca Bucci
Davide Caforio
Antonio Calanni
Antonio Calitri
Luca Cappellaro
Dino Cappelletti
Alessandro Carpentieri
Luca Carra
Stefano Cavalli
Michele Cazzani
Michele Cecere
Raffaele Celentano
Filippo Chiesa
Carlos Cicchelli
Giacomo Cinquepalmi
Elio Ciol
Ascanio Raffaele Ciriello
Francesco Cito
Pier Paolo Cito
Dario Coletti
Claudio Colombo
Gianni Congiu
Guido Cozzi
Enrico D'aiuto
Enrico Dagnino
Marco Delogu

Giovanni Diffidenti
Dario de Dominicis
Katinka Donagemma
A.E. Dossi De Gregoris
Sara Elter
Malance Ettore
Neri Fadigati
Franco Felce
Giuliano Ferrari
Sergio Ferraris
Fabio Fiorani
Giorgia Fiorio
Massimiliano Fornari
Rosario De Gaetano
Bruna Ginammi
Silvio Giuliani
Simona Granati
Gualtiero Grossi
Marco Guidetti
Guido Harari
Marina Imperi
Daniel Kermody
Roberto Koch
Nicola Lamberti
Francesco Lanteri
Cristiano Laruffa
Ciro Lauria
Michele Lisi
Ricardo de Luca
Stefano de Luigi
Valentina Macchi
Mauro Maffina
Franco Maglione
Paolo Magni
David Maialetti
Alex Majoli
Jo Mangone
Annunziata Manna
Fausto Marci
Antonio Marconi
Claudio Marcozzi
Ilvo Marelli
Enrico Mascheroni
Pier Maulini
Giovanni Mereghetti
Gianluca Miano
Mauro Minozzi
Dario Mitidieri
Bruno del Monaco
Luca Federico Monducci
Mauro Monfrino
Stefano Montesi
Luciano Monti
Alberto Moretti
Giordano Morganti
Andrea Mosso
Emanuele Mozzetti
Gianfranco Mura
Gianni Muratore
Emanuele Muro
Enrico Natoli
Tiziano Neppi
Piero Oliosi
Maurizio Orlanduccio
Michele d´Ottavio
Claudio Palmisano
Ugo Panella
Bruno Pantaloni
Maurizio Panzariello
Carlo Paone
Eligio Paoni
Maurizio Papucci
Eleonora Parcu
Stefano Pavesi
Giampiero Pecci
Giorgio Pegoli
Paolo Pellegrin
Michele Pero
Marco Pesaresi
Fabrizio Pesce
Paolo Petrignani
Giovanni Piesco
Paolo Pintus
Maria Luisa Pirrottina
Antonio Pisacreta
Rosario M. Pomarico
Franco Pontiggia
Paolo Porto
Ciro Quaranta
Giuliano Radici
Roberto Radimir
Sergio Ramazzotti
Alberto Ramella
Mario de Renzis
Andrea de Rose
Andrea Sabbadini
Luca Sanguineti
Gianluca Santoni

Elio Scalahandre
Massimo Sciacca
Angela Shobha
Paolo Siccardi
Romano Siciliani
Martino Sig Motti
Sangiovanni Silva
Giovanni Simeone
Paolo Simonazzi
Tano Siracusa
Massimo Siragusa
Attilio Solzi
Maxim Spinolo
Ricardo Tagliabue
Giampiero Turcati
Angelo Turetta
Marco Vacca
Riccardo Venturi
Stefano Veratti
Massimiliano Verdino
Massimo Viginanza
Fabrizio Villa
Claudio Vitale
Luca Zampedri
Francesco Zizola
Aldo Zizzo
Stefano Zotti

IVORY COAST
Issouf Sanogo

JAMAICA
Junior Dowie

JAPAN
Tetsuya Akiyama
Shigetaka Doi
Fumiaki Fukuda
Katsunobu Furuya
Koji Harada
Itsuo Inouye
Akira Ishihara
Bon Ishikawa
Takaaki Iwabu
Takatoshi Kambe
Chiaki Kawajiri
Toshio Kohsaka
Masato Kudo
Toshi Matsumoto
Ichiroh Morita
Shinichi Murata
Takuma Nakamura
Seiji Nomura
Atsuko Otsuka
Nobuko Oyabu
Q. Sakamaki
Toshikazu Sato
Nobuo Serizawa
Ekisei Sonoda
Hiroyuki Taira
Kuni Takahashi
Tadao Takako
Iwasaki Teru
Masayuki Tomimoto
Katsuyuki Uchibayashi
Yutaka Yonezawa

JORDAN
Mohamed Abdannabi
Iyad Ahmad
Amira Al Homshi-Hujaij
Lina Al Omary
Saleh Massad
Emad Matahen
Samer Momani
Jamal A. Issa Nasrallah

KENYA
Maxwell Agwanda
Ivan Kariuki Colbeck
Anthony Kimani
Luke Njeru Nyaga
Henry Muriithi Nyage
Malachi Owino Muga
Khamis Ramadhan
Paul Waweru

KUWAIT
Ali Nasser A. Al-Roumi
Majed Al-Sabej
Raed Quteina

LATVIA
Aigars Eglite
Andris Kozlovskis
Ritvars Skuja
Laimonis Smits
Zigismunds Zalmanis

LEBANON
Ahmad Al-Zein
Oussama Ayoub
Joseph Barrak
Sivak Davidian
Olga Elias
Ramzi Haidar
Bassam Lahoud
Samer Mohdad
Ali Nami Jaffer
Hussein Naser El Din
Adour Ourfalian
Haidar Ramzy
Aziz Taher

LESOTHO
Tseleng Mahase
Evelyn Mntuyedwa
Tiny Sefuthi

LIECHTENSTEIN
Eddy Risch

LITHUANIA
Joranas Bruzinskas
Kazimiera Linkevicius
Romualdas Pozerskis
Albertas Svencionis

LUXEMBURG
Yvan Boeres
Jean-Claude Ernst
Luc Kohnen

MACEDONIA
Milan Dzingo

MALAWI
Govati Nyirenda

MALAYSIA
Jaafar Abdullah
Chan Eng Gee
Chong Voon Chung
Goh Hock Loong
Goh Seng Chong
Idrus Hashim
How Wee Choon
Lee Lay Kin
Leong Chun Keong
Lim Beng Hui
Jeffrey Lim Chee Yong
Lim Chien Ting
Lim Poh Chin
Lion Chien Ying
Sundar Marathamuthu
Tajudin Muhd. Yaacob
Ong Choon Min
Ismail Seliman
Soong Chee Shin
Seng Huat Tan
Sang Tan
Teh Eng Koon
Teh Pek Ling
Wong Chiew Kung
Yau Choon Hiam
Yusman Mohd. Yunus
Mazlan Zulkifly

MALTA
Michael Ellul
Matthew Mirabelli
Darrin Zammit Lupi

MAURITIUS
Sarvottam Rajkoomar

MEXICO
Armando Arorizo
Ulises Castellanos
Carlos Cazalis Ramirez
Ismael Chumacero
Maroos Delgado Vargas
Sergio Dorantes
Damian Dovarganes
Daniel Arturo Esqueda
Jose Fuentes Franco
Marco Garcia Campos
Gabriel Jiménez
Leopoldo Kram
Pericles Lavat
Fernando Lopez Romero
Luis Ivan Manjarrez
Enrique Mejía
Victor Mendiola Galván
Juan Ignacio Ortega
Tomas Ovalle
Ireri de la Peña Campa

Christina Piza Lopez
Carlos Puma
Ernesto Ramírez
Oscar Salas-Gómez
Armando Santibánez
Juan Ugalde Trejo
Rodolfo Valtierra
Paulo Miquel Vidales
Jose Luis Villegas

MOROCCO
Mustapha Ennaimi
Khalid Hbabat
Oubelkhir Mohamed
Abdelhak Senna

MOÇAMBIQUE
Ana Maria Rodriguez

NEPAL
Chandra Shekhar Karki
K.C. Rajesh
Sujan Shrestha

NETHERLANDS
Jan Banning
Shirley Barenholz
Gerlo Beernink
Peter den Bekker
Frank van den Berg
Marcel van den Bergh
Reinout van den Bergh
Peter Blok
Jan Bogaerts
Morad Bouchakour
Ahmet Bozdag
Dirk Buwalda
Kees van Dongen
Rob Doolaard
Leo Erken
Hans Franz
Aloys Ginjaar
Robert Goddijn
Guus van Goethem
Martijn van de Griendt
Mario de Groote
Ronald Hammega
Sacha Hartgers
Maarten Hartman
Baldwin Henderson
Tanja Henderson
Teun Hocks
Wim R. Hofland
Sjoerd van der Hucht
Frédéric Huijbregts
Evelyne Jacq
Vincent W. Janniuk
Christina Jaspars
Marie José Jongerius
Hans Kamstra
Geert van Kesteren
Arie Kievit
Cor de Kock
John Lambrichts
Rob Lange
Albert Langenberg
Frans Marten Lanting
Gé Jan van Leeuwen
Jaco van Lith
Kadir van Lohuizen
Guilain D. Lucassen
Vincent Mentzel
Willem Middelkoop
Peter Muller
Alex ten Napel
Benno Neeleman
Mark van Oel
Pascal Ollegott
Lenny Oosterwijk
Patrick Post
Pim Ras
Edgar van Riessen
Martin Roemers
Joshua Rood
Gerhard van Roon
Ruben Schipper
Peter Schols
Peter Schrijnders
Henry Snellenburg
Michel Sterrenberg
Koen Suyk
Jaap Teding
Marie Cécile Thijs
Ruben Timman
Toma Tudor
Sander Veeneman
Teun Voeten
Robert Vos

Juan Vrijdag
Emily Wiessner
Petterik Wiggers
Matty van Wijnbergen
V. van de Wijngaard
René de Wit
Herman Wouters
Inge Yspeert
Rop Zoutberg

NEW ZEALAND
Scott Barbour
Geoff Dale
Marion van Dijk
Mark Dwyer
Mark Graham
Michael Hall
David Hancock
Neil John MacKenzie
Robert Marriott
Mark Marriott
Peter James Quinn
Phil Reid
Martin de Ruyter

NIGERIA
Sunday Adedeji
Tunde Akingbade
Ademola Akinlabi
Onyenso F. Azuogu
Henry Chukwuedo
Mike Iroanya
Atanda Mudashiru
Matthew Odeyiola
Julius Ogunleye
Pius Okeosisi
Joseph Bioye Oyewande
Saturday Isiwe

NORTH KOREA
Chae SungWoo
Cho Inwong
Cho Sung-su
Choi Jinyeun
Choo Youn-Kong
Ham Jae-ho
Jae Hwan Kim
Jeong Gyoung Youl
Joo Hyun Youn
Jung Hansik
Jung Yangkyun
Kim Jinpyoung
Kim Jooho
Kim Sunkyu
Kyung Ae Lee
Lee Hoon-Koo
Lee Jungho
Lee Young Hwan
Soo-Hyun Park
Yoon Ok

NORWAY
Odd R. Andersen
Morten Antonsen
Oddleiv Apneseth
Paal Audestad
Havard Bjelland
Stein Jarle Bjorge
Terje Bringedal
Pal Christensen
Jan Tore Glensen
Johnny Helgesen
Pal Hermansen
Elin Hoyland
Erik Wiggo Larsen
Bo Mathisen
Mimsy Moller
Janne Moller-Hansen
Otto von Münchow
Ola Solvang
Inge Ove Tysnes

PAKISTAN
Mahmood Arif
Ilyas Dean
Saeed Khan
Farah Mahbub

PALESTINA AUTONOMOUS TERRITORIES
Awad Awad

PANAMA
Essdras M. Suarez

PARAGUAY
Gabriel Heber Carballo
Hugo Fernández Enciso

PEOPLE'S REPUBLIC OF CHINA
Bai Xueyi
Baiying
Bao Weidong
Cao Fu Chuan
Cao Wei Song
Cao Zhi Fei
Chang W Lee
Juan Chen
Chen Bing
Chen Hai Ping
Chen Weidong
Chen Zhan
Cheng Heping
Cheng Qi
Chenke Jingye
Chiang Yung-Nien
Chinese Photographer
Cui Bo Qian
Cui Zhi Shuang
Dalang Shao
Den Yuyi
Dewen Zhang
Fan Lie
Fan Ying
Fan Zong Lu
Fang Zhong
Fu Chun Wai
Fuchun Wang
Gong Xiao Song
Gu Yongwei
Guo Jianshe
Guo Minglee
Han Jiren
Han Yun Min
Hao Weiping
He Guhei
He Yong Qing
Hua Yang
Huang Jingda
Huang Min Xiong
Huang Yiming
Huang Yukui
Ji-Chang Liu
Jia Guorong
Jian-Nan Xi
Jiang Jian
Jiang Shangbo
Jiao Bo
Jing Si Liou
Ju Guangcai
Jun Sun
Juyang
Lan Hongguang
Lee Kingcheng
Li Chen
Li Cheng
Li Jie Jun
Li Kaijie
Li Nan
Li Pin
Li Xiaoguo
Li Xiaoning
Li Yong
Liang Daming
Liang Ping
Liao Anze
Stan Lim
Ling Qin
Liu Jie Min
Liu Wei
Liu Xingming
Edmund Lo Yuk Kwong
Lu Hui Bin
Lu Jinquan
Lu Zhong Bin
Ma Hongjie
Zhili Man
Mao Shuo
Meng Cheng
Miao Fengwu
Ming Zhong
Pang Zhengzheng
Peng Hao
Peng Niah
Pi Dawei
Qian Han
Qijie Shuang
Qing Jing Song
Qiu Yan
Qungang Chen
Ren Shao Hua
Ren Xihai
Shen Xuexi
Shen Zhuqing
Shi Jiang Xue

Song Bujun
Song Gang Ming
Sun Hong Bin
Sun Yu Hiu
Sun Zhijun
Sun-Chuan
Tang Jian
Teng Ke
Tian Fei
Tsang Wai Tak
Tse Chi-Tak
Wana Baolao
Bo Wang
Wang Huan Miao
Wang Jianmin
Wang Jianwei
Wang Jijun
Wang Jing
Wang Liqiang
Wang Qiang
Wang Wen Tong
Wang Yao
Wang Ye
Wei LieQun
Hu Wei-Ming
Welyuan Zhang
Ricky Wong
Wu Haibo
Wu Maojia
Wu Shi Hua
Wu Shuijin
Wu Xue-hua
Wu Yaolin
Xie Minggang
Xie Qi
Xie Wenyeu
Xin Liu
Xinke Wang
Xu Guo Kai
Xu Jianrong
Yan Bailiang
Liu Yang
Yang Da Hai
Yang Delu
Yang Lei
Yang Tiejun
Yao Fan
You HongYuan
Yu Hai Bo
Yu Ning
Yuan Xiao Zhen
Zeng Nian
Zhang Baoqi
Zhang Gang
Zhang Guo Yin
Zhang Jingyun
Zhang Xi Zhen
Zhang Yan
Zhang Yanhui
Zhang Yi
Zhang Yulin
Zhang Zhi Qiang
Zhao Jian Wei
Zhao Li Jun
Zhao LiuYing
Zhao Qing
Zhao Tongjie
Zhao Ya Shen
Zhao Youqiang
Zheng Chenggong
Zhi Jian
Yan Ming Zhou
Zhou Guoqiang
Zhou Qing Xian
Zhou Xiao Hui
Zhou Yinjie
Zhou Zi Dong
Zhu Minghui
Zhu Qinghe
Zhu Wenliang
Zhuang Yingchang
Zou Quig

PERU
Paolo Aguilar Boschetti
Mariana Bazo
Martin Bernetti Vera
Jose Felix Chuquiure
Hector Emanuel
Elsa Estremadoyro
Roberto Huarcaya
Silvia Izquierdo
Cecilia Larrabure
Maria Ines V. Menacho
Mayu Maria de Fatima
Daniel Pajuelo
Susana Pastor
Jaime Augusto Rázuri

Flor Ruiz Munoz
Renzo Uccelli Masías
Maria Consuelo Vargas
Justo Pastor Vargas

PHILIPPINES
Edwin Calayag
Manuel Ceneta
Arlene Chua
Revoli Cortez
Allan Cuizon
Romeo Gacad
Oliver Y. Garcia
Victor Kintanar
Natalie Ann D. Milabo
Antonio Preuaredondo
Bobby Timonera
Damiano Tiunayan
Edwin Tuyay

POLAND
Cebula Arkadiusz
Piotr Biegaj
Piotr Blawicki
Witold Borkowski
Antoni Chrzastowski
Pach Daniel
Janusz Filpczak
Jan Glowacki
Tomasz Griessgraber
Piotr Grybanski
Tomasz Gudzowaty
Jaroslaw, Jozef Jasinski
Piotr Jaskow
Maciej Jawornicki
Jaroslaw Jurkiewicz
Slawomir Kaminski
Andrzej Karolak
Grzegorz Klatka
Jerzy Kleszcz
Agnieszka Koltonik
Marek Koperkiewicz
Robert Kowalewski
Hilary Kowalski
Kacper Krajewski
Damian Kramski
Witold Krassowski
Okulewicz Krystyna
Przemek Krzakiewicz
Damazy Kwiatkowski
Andrzej Luc
Mieczyslaw Michalak
Jan Mierzanowski
Krzysztof Miller
Jacek Morgas
Juliusz Multarzynski
Marek Piekara
Henryk Pietkiewicz
Radoslaw Pietruszka
Aleksander Rabij
Krzysztof Rak
Piotr Rogatty
Olgierd M. Rudak
Marcin Sauter
Slawomir Sierzputowski
Maciej Skawinski
Waldemar Sosnowski
Konrad Stawicki
Piotr Sumara
Wojtek Szabelski
Robert Szykowski
Lukasz Trzcinski
Jacek Turczyk
Piotr Wojcik
Leszek Wroblewski
Maria Zbaska
Bartomiej Zborowski
Andrzej Zielinski
Leszek Zmijewski

PORTUGAL
Arthur Almeida
P.M. Barão da Cunha
José Barradas
Rita Carmo
Antonio M.C. Carrapato
Jose C.A. de Carvalho
António José Conceiçao
Eduardo Gageiro
Filipe Miguel Guerra
Vitor Moutinho
Bruno Neves
Rui Hernani Ochoa
L. de J. Oliveira Negrao
José Manuel Ribeiro
João Rodrigues
E.M. dos Santos Costa

Alexandra Nunes Silva
Pedro Sottomayor
Tiago Sousa Dias
José Pedro Teixeira
Orlando Pereira Teixeira
João Tuna
Ursula E. Zangger

ROMANIA
Marian Am Ghel
Adrian Ovidiu Armanca
Remus Nicolae Badea
Emil Bănuti
Lucian Crisan
Dorian Delureanu
Zsolt Fekete
Radu Ghitulescu
Doru Mirel Halip
Matei Horvath
Nicu Ilfoveanu
Dragos Lumpan
Adrian Luput
George Maier
Daniel Mihailescu
Eugen Moritz
Eugen Negrea
Marius Nemes
Mircea Opris
Radu Pop
Tudor Porumb
Tudor Predescu
Ioana Tiganco

RUSSIA
George Akhadov
Andrey Arkhipov
Victor Avdeev
Dmitry Azarov
Yuri Balbyshev
Alexander Beliaev
Alexey Belyantchev
Serge Bereseve
Vladimir Bochkarev
Evgeny Bogdanov
Alexei Boitsov
Alexander Bomza
Boris Chugunov
Alexander Chumichev
Valery Degtyarev
Dmitri Donskoy
Michael Evstafiev
Vladimir Fedorenko
Alexey Fedorov
Vladimir Filimonov
Constantine Franovski
Vladimir Galynkin
Igor Gavrilov
Stanislav Gnedin
Andrej Golovanov
Alexander Gronsky
Serghei Ignatief
Kiril Kalinichenko
Eugeniy Karmayev
Nickolay Kireev
Sergei Kivrin
Ilona Kolesnichenko
S. Kumpanlychenko
Yevgeni Kondakov
Alexei Kondrashkin
Valery Korenchuk
Sergei Kovalev
Michail S. Kovalev
Anatoliy Kovtun
Denis Kozhevnikov
Igor Kravchenko
Boris Kremer
Eduard Kudriavitsky
Alexey Kunilov
Edvard Lapovok
Vladimir Larionov
Oleg Lastochken
Dmitry Leanov
Valeri Levitine
Anatoly Maltsev
Nikolai Marochkin
Victor Martchenko
Juri Martjanow
Sergey Maximishin
Sergei Medvedev
Paul Meyer
Boris Michalevkin
Sergei Mikhejev
Wiktor Miller
Alexei Myakishev
Alexander Nemenov
Nicolai Nizov
Michael Nosov
Vladimir Novikov

Anton Oparin
Alexander Oreshnikov
Alexander Ovchinnikov
Sergei I. Parushkin
Valentina Pavlova
Vladimir Perventsev
Alexander Polyakov
Jevenij Risikov
Vladimir Rodionov
Andrei Rojkov
Gulnara Samoilova
Sergei Samokhin
Alexei Sazonov
Walerij Schtschekoldin
Oleg Schukin
Ivan Sekretarev
Alexander Sergio
Sergei Shekotov
Roman Shklovsky
Viktor Shokhin
Nikolay Sidorov
Oleg Sizonenko
Alexander Skorniakov
Pavel Smertin
Georgiy Stoliarov
Jouri Strelets
Andrey Suchkov
Vitaly Sutulov
Vladimir Syomin
Igor Tabakov
Elena Tikhonova
Nikolai Titov
Alexandr Tkachov
Victor Tshernov
Alexander Ussanov
Igor Utkin
Sergei Vasilev
Djachkov Vassily
Vladimir Velengurin
Igor Vereschagin
Anatoly Vilyahovsky
Vladimir Vvatkin
Vitalya Yakovlev
Alexander Yaroslavtsev
Anton Zabrodsky
Juri Zaritovsky
Konstantin Zavrazhin
Anatoly Zernin
Anatoli Zhdanow
Ludmila Zinchenko

SAUDI ARABIA
Reem Al Faisal
Zaki Al-Sinan
Abdallah Aldubaikhi
Hassen Ali Hussin
Baker Dawood Sindi

SENEGAL
Moussa Kamara

SINGAPORE
Chang King Boon
Kwok Kwong Choo
Lai Lam Tuck

SLOVAKIA
Peter Brenkus
Otto Gender
Danka Haskova
Milan Illik
Marek Velcek

SLOVENIA
Tomo Jesenicnik
Natalija Juhnov
Tomi Lombar
Darije Petkovic
Marko Sommer

SOUTH AFRICA
Tyrone Arthur
Gary Bernard
Marilyn Bernard
Jodi Bieber
Nicky de Blois
Stephen Davimes
Walter Dhladhla
Christiaan Diedericks
Thys Dullaart
Thembinkosi Dwayisa
Jillian Elaine Edelstein
Brett Eloff
Brenton Geach
Charmaine Gibbon
Benny Gool
Louise Gubb
Themba Hadebe

George Hallett
Shaun Harris
Brian Hendler
John Peter Hogg
Rian Horn
Jon Hrusa
Andrew Ingram
Shelley Kjonstad
Christiaan Kotze
Sue Kramer
Alf Kumalo
Anne Laing
Barry Lamprecht
Kim Ludbrook
Motlhalefi Mahlabe
Gideon Mendel
Eric Miller
Mpho Mphotho
Hannes Mundey
Steven Naidoo
Christine Nesbitt
Mykel Nicoladu
Juda Nuwenya
Cathrijn Pinnock
Doug Pithey
Jean M.J. du Plessis
Raymond Preston
Karel Prinsloo
Karin Retief
Roger Sedres
Justin Sholk
Joao Silva
Garth Stead
Caroline Suzman
Guy Tillim
Johann van Tonder
Roy Wigley
Lindsay Young
Naashon Zalk
Anna Zieminski
Siyabulela Obed Zilwa

SPAIN
Tomás Abella
Isuan Albecano y Calvo
Rogerio Allepuz
Diego Alquerache
Jesús Antoñanzas
Antonio Arabesco
Francisco Arcenillas
Juan Armentia Hernaez
Cristian Baitg
Sandra Balsells
Erika Barahona Ede
Juan Carlos Barbera
Alvaro Barrientos
Jordi Bedmar Pascual
Enrique Luis Beltran
Hector Bermejo
Manuel Berral Pérez
Alfredo Caliz Bricio
José Camacho
Fernando Camino
Koro Cantabrana Ruiz
Alfonso Carreto Ruiz
Carlos Carrión Buchó
Angel Casaña
Cristobal Castro
Carma Casulá Oliver
Gustavo Aldofo Catalan
Koldo Chamorro
Santiago Cogolludo
Isabel Corral Jam
Matias Costa
Jose Luis Cuesta Solera
Daniel de Cullá
Ricard Domenech
Paco Elvira
Alvaro Felgueroso Lobo
Quim Giró Fabrega
Toni Gonzalez Santiso
Isaac Hernández
Julian Jaen Casillas
Julen Alonso Laborde
Santy López
Jesus Macipe Roy
Kim Manresa Mirabet
Enric F. Marti
Angel Martinez Colina
Javier Martinez Llona
Gonzalo Martinez
Albert Maso Planas
César Mateu i Beltran
Carlos Minguell Baños
Fernando Moleres Alava
Sofia Moro Valentín
José Muñoz

José Manuel Navia
Josep Maria Oliveras
Florencio Palencia
Cipriano Pastrano
Antonio Pérez
Eudaldo Picas Vinas
Elisenda Pons Oliver
Jordi V. Pou
L. Alberto Prieto
Victor Rodriguez
Luis Miguel Ruiz
Gervasio Sanchez
Luís Sanchez Davilla
Jorge Sierra Antinolo
Tino Soriano
José Antonio Tejero
Jorge L. Torres
Enrique Truchuelo
Xulio Villarino Aguiar
Mikel Zabala Markuleta

SRI LANKA
Saman Mendis
Antony Philip S. Moses
G.D. Vijayadasa
Sriyantha Walpola

SUDAN
Taha Bushra Abdel
Frabi Mohd. Ahmed
Abdala Yunis Alhaj
Alfateh Al Dekhery
Haider Hassan Fouad
Mohamed Hassan
M. Nur El Dien

SWEDEN
Martin Adler
Jörgen Ahlström
Vassil Anastasov
Torbjörn Andersson
Jens Assur
Roland Bengtsson
Göran Billeson
Sophie Brandström
Stefan Ed
Hannu Einarsson
Leif Engberg
Ake Ericson
Bernt-Ola Falck
Mikael Forslund
Johan Gunséus
Johnny Gustavsson
Lasse Halvarsson
Paul Hansen
Peter Hoelstad
Tommy Holl
Peter Jigerström
Thomas Johansson
Peter Kjellerås
Mans Langhjelm
Chris Maluszynski
Tommy Mardell
Paul Mattsson
Jack Mikrut
Per-Anders Pettersson
Kai Ewert Rehn
Lennart Rehmann
Tobias Röstlund
Torbjörn Selander
Hakan Sjöström
Göran Stenberg
Per-Olof Stoltz
Michael Svensson
Roger A. Turesson
Curt Waras
Thure Wikberg
Jan Wiridén
Karl-Göran Zahedi

SWITZERLAND
Eric Jacques Aldag
Fathi Amdouni
Karl E. Ammann
Marco D'Anna
Philippe Antonello
Patrick Armbruster
Manuel Bauer
Peter W. Baumann
Monica Beurer
Andreas Blatter
Mathias Braschler
Markus Bühler
Christoph Bürki
Laurent Crottet
Pierre Dubois
Bertrand Dumas

Michael Freisager
Peter Frommenwiler
Daniel Fuchs
Mariella Furrer
Marianne Fürst
M. von Graffenried
Marie Hippenmeyer
Tobias Hitsch
Robert Huber
Roger Huber
Jean-Marie Jolidon
Alexander Keppler
Thomas Kern
Pius Koller
Patrick B. Krämer
Beatrice Lang
Paoluzzo Marco
Felix von Muralt
Charles Page
Josef Ritler
Daniel Schwartz
Johannes Sieber
Laurent Patrick Stoop
Roland Tännler
Hélène Tobler
Valdemar Verissimo
Olivier Vogelsang
Xavier Voirol
Silvia Voser
Roger Wehrli
Thomas Zemp

SYRIA
Akram Gatrif
N.Hammami
Fadi Masri Zada
Issa Touma

TAIWAN ROC
Chien-Chi Chang
Tai-Pao Chang
Chen Yaoho
Lake Fong
Huang Tzyy-Ming
Lin Daw-Ming
Peng-Chieh Huang

THAILAND
Jetjaras Na Ranong

TRINIDAD AND TOBAGO
Abigail Hadeed

TURKEY
Mustafa Abadan
Zekeriya Albayrak
A. Antakyali
Fikret Ay
Cem Dagtas
Celâl Demirbilek
Murat Germen
Bahri Karatas
Süleyman Kayaalp
Birsen Keskin
Cemal Köyük
Fahrettin Gütkan Örenli
Hamza Sahin
Erkut Sahin
Kerem Saltuk
Sedat Aral
Ahmet Sik

UKRAINE
Alex Abramov
Stefan Alekyan
Sergiy Avramenko
Alexander Chekmenyov
Sergei Cherednichenko
Boris Dvornij
Vladimir Falin
Aleksandr Glyadelov
Vadim Koslovsky
Efrem Lukatsky
Ivan Melnik
Alexander Nerubaev
Vladimir Osmushko
Oleg Poddubniy
Sergey Svetlitsky
Alexander Yudin

UNITED ARAB EMIRATES
Safia Abdullah
Mhic Chambers

UNITED KINGDOM
David Ahmed

Julian Anderson
Julian Andrews
John Angerson
Dan Atkin
Richard Baker
Stephen Barnby
Frank Baron
Jennifer Bates
Piers Benatar
Martin Bennett
Eleanor Bentall
Vince Bevan
Martin Birchall
Dave Black
Shaun Bloodworth
Michael Booth
Shaun Botterill
Adil Bradlow
Ian Bradshaw
Charles Breton
Simon Brooke Webb
Patrick Brown
Clive Brunskill
Gary Brunskill
Peter Byrne
Gary Calton
David Campion
Angela Catlin
Graham Chadwick
Stephen Chapman
Paul Chappells
Anthony Charlton
Wattie Cheung
Paul Clements
Andrew Cleverley
Nick Cobbing
Chris Coekin
Bryn Colton
Steve Connors
Michael Cooper
Paul Cooper
Anthony Cordt
Tom Craig
Michael Justin Creedy
David Cruickshanks
Tim Cuff
Simon Dack
Prodeepta Das
Howard J. Davies
Adrian Dennis
Dawn Derrick
Hamish Devlin
Nigel Dickinson
Janet Elisabeth Dixon
John Downing
Frazer Dryden
Craig Easton
Amanda C. Edwards
Ben Edwards
Colin Edwards
Johnny Eggitt
Neville Elder
Jonathan Elderfield
Sophia Evans
Barbara Evripidou
Dominic Faulder
Adrian Fisk
Steve Forrest
Stu Forster
Gordon Fraser
Stuart Freedman
Clive Frost
Peter Fryer
Kent E. Gavin
George Georgiou
John Gichigi
John Giles
Paula Glassman
Martin Godwin
Michael Goldwater
David Gordon
Mark R. Graham
Simon Grosset
Julia Guest
Andy Hall
Robert Hallam
Graham Hamilton
Richard Hanson
Graham Harrison
Judy Harrison
Joshua Haruni
James Hawkins
Andrew Hendry
Michael Hewitt
James Hill
Steve Hill
Lynn Hilton
Jim Hodson

David Hogan
Jim Holden
Mike Hollist
Rip Hopkins
Derek Hudson
George Hunter
Jeremy Hunter
Roger Hutchings
Chris Ison
Mark Jamieson
Peter Harley Jay
Tom Jenkins
Andy Johnstone
Findlay Kember
Thobias James Key
Mike King
Ross Kinnaird
David Kinsella
Gary Knight
Herbie Knott
Taras Kovaliv
Colin Lane
Kalpesh Lathigra
T.J. Lemon
Jon Levy
Barry Lewis
Graham Lindley
Alex Livesey
Paul Lowe
Simon Mark Lunt
Peter MacDiarmid
Donald MacLeod
Alex MacNaughton
Peter H. Marlow
Paul Marriott
Clive Mason
Jenny Matthews
Ed Maynard
Eric Mc Cowat
Don McCullin
David McGee
John McIntyre
William A. McLeod
Toby Melville
Sacha William Miller
Dod Miller
Allan Milligan
David Modell
Doug Moody
Mike Moore
Steve Morgan
Nevil Mountford
Rebecca Naden
Pauline Neild
Zed Nelson
Tina Norris
Jonathan Olley
Kevin Oules
Jeff Overs
Dan Oxtoby
Ali Kazim Ozluer
Warren Page
Mark Pain
Andy Parsons
Steve Parsons
Alan Peebles
Gerry Penny
Tom Pilston
Olivier Pin-Fat
Gary Prior
Chris Procaylo
Steve Pyke
Steve Race
Nick Rain
John Rasmussen
John Reardon
Paul Reas
Kiran Ridley
Mike Roberts
Ian Robinson
Stuart Robinson
Paul James Rogers
David Rose
Ian Rutherford
Howard Sayer
Anup Shah
Martin Shields
David Shopland
John Sibley
Chris Sims
David Sinclair
Ben Smith
Bill Smith
Dan Smith
Jim Steele
Michael Steele
C. Steele-Perkins
Jeremy Stockton

Tom Stoddart
Denis Straughan
Graham Stuart
Sean Sutton
Jeremy Sutton-Hibbert
Alan Taylor
Edmond Terakopian
Andrew Testa
Martin Thomas
Mark Thompson
Siôn Tonhig
Ian Torrance
Anastasia Trahanas
Max Vadukul
Paul Vicente
John Voos
Howard H. Walker
Simon Waters
Chris Watt
Denis Waugh
Garry Weaser
Kevin West
Amiran White
Keith Whitmore
Greg Williams
Richard Williams
Vanessa Winship
Philip Wolmuth
Tony Wood
Lloyd Wright
Sandy Young

URUGUAY
José Luis Bello
Oscar Bonilla
Julio Etchart
Enrique Kierszenbaum
Ernesto Lehn Angelides

USA
Jeffrey Aaronson
Sharon Abbady
Jeff Abelin
Michael Ackerman
Kimberlee Acquaro
David Adame
Barbara J. Adams
Michael Adaskaveg
Eric Albrecht
Bill Alkofer
Elise Amendola
Adam Amsinck
Karin Anderson
Nancy Andrews
Charles Rex Arbogast
Charlie Archambault
Marc Asnin
Jane Evelyn Atwood
Stephan Russell Aull
William Auth
Richard Avedon
Ed Bailey
Greg Baker
Diana Baldrica
Karen Ballard
James Balog
Rebecca Barger
Don Bartletti
John Bazemore
John Beale
Al Behrman
Bill Belknap
Al Bello
Benjamin Benschneider
Harry Benson
P.F. Bentley
Nina Berman
Alan Berner
Matt Bernhardt
William Betsch
Todd Bigelow
Molly Bingham
Peter Blakely
Gary Bogdon
John F. Bohn
Ken Bohn
David Bohrer
Deborah Booker
Lou Bopp
Karen Borchers
Harry Borden
Nadia Borowdki Scott
Mark Boster
Jean-Marc Bouju
Jim Brandenburg
Alex Brandon
David Brauchli
Christine M. Breslin

Marie Louise Brimberg
Dudley Brooks
Milbert Orlando Brown
Luca Bruno
Simon Michael Bruty
Chris Buck
Robin Buckson
Gregory Bull
Joe Burbank
David Burnett
Barbara Bussell
Kimberly Butler
David Butow
Wade Byars
Renée C. Byer
Beverly Bynum
Mary Calvert
Giuseppe Calzuola
Gary Cameron
Angela Cappetta
Matt Carr
Patrick Carroll
Ovie C. Carter
Kevin P Casey
Radhika Chalasani
Dennis Chamberlin
Franki Chan
Richard A. Chapman
Tim Chapman
Dominic Chavez
Jennifer Cheek
Paul Chesley
Barry Chin
Raymond Chow
Jeff Christensen
Henning Christoph
Laura Chun
André F. Chung
Daniel F. Cima
Mary Circelli
Robert Clark
Timothy A. Clary
Bradley E. Clift
Chuck Close
Rachel Cobb
Gigi Cohen
Melissa Kay Cohen
Carolyn Cole
Jim Collins
Ronald Cortes
James Kristen Craig
Sherwin Crasto
Johnny Crawford
Christopher Crewell
Stephen Crowley
Dexter Cruez
Anne Cusack
Elizabeth Dalziel
Jim Damaske
Richard Darby
Saurabh Das
Giuliano De Portu
Michael Dean
Peter DeJong
William Dekay
Rob Delorenzo
Louis DeLuca
Julie Denesha
Richard Derk
Allan Detrich
Charles Dharapak
O.M. Di Pasquale
Anthony V. DiGiannurio
Nuccio DiNuzzo
Mark Dolejs
Robin Donina Serne
David Doubilet
Larry Downing
Eric Draper
Pamela Duffy
Corinne Dufka
John Dunn
Doug Duran
Andrew Eccles
Aristide Economopoulos
Claudio Edinger
Scott Eklund
Douglas Engle
Eric Engman
Jason Eskenazi
James Estrin
Gary Fabiano
Timothy Fadek
Steven Falk
Eamonn Farrell
M. Clayton Farrington
Najlah Feanny
Deborah Feingold

Paula Ferazzi
J. Ismael Fernández
Stephen Ferry
Mike Fiala
Lisa Finger
Gail L. Fisher
Ted Fitzgerald
Deanne Fitzmaurice
Viorel Florescu
Natalie B. Fobes
William Frakes
Ric Francis
Felice Frankel
Leslie Fratkin
Danny Frazier
John Freidah
Ruth Fremson
Gary Friedman
Patricia Gallinek
Sean Gallup
Eugene Garcia
Alex Garcia
Juan Garcia M.
Mark Garfinkel
Joseph Garnett
Robert Gauthier
Karl Gehring
Georg Gerster
Vadim Ghirda
John Giannini
David P. Gilkey
Shaul Golan
Scott Goldsmith
Monika Graff
Tom Gralish
Alistair Grant
Gordon M. Grant
Edward Grazda
Jason Green
John Green
Stanley Greene
Pat Greenhouse
Michael Greenlar
Al Grillo
N. von der Groeben
David Guralnick
David Guttenfelder
Carol Guzy
Kari René Hall
Duane Hall
Robert Hallinen
Patrick Hamilton
Richard Alan Hannon
Nati Harnik
Mark Edward Harris
Chick Harrity
Steve Hart
Richard Hartog
Arthur Harvey
Cheryl Hatch
Ron Haviv
Kurt Hegre
Richard Heinrich
Gregory Heisler
Mark Henle
Gerald Herbert
Ralf-Finn Hestoft
Carol Hill
Edward J. Hille
Andrew Holbrooke
Jim Hollander
Kevin Horan
Eugene Hoshiko
Rose Howerter
Mark Humphrey
Eric Hylden
Lyn Ischay
Ted Jackson
Jed Jacobsohn
Stephen Jaffe
Kenneth Jarecke
Steve Jessmore
Kim Johnson
Lynn Johnson
Nancy Jo Johnson
Frank B. Johnston
Matthew Jones
Sam Jones
Bonnie Josephson
Ariane Kadoch
Timothy Kao
Sergei Karpukhin
Ed Kashi
Karen Kasmauski
John Keating
Scott Keeler
Charles Kennedy
David Hume Kennerly

James Ketsdever
Cornelius Keyes
Justin Kilcullen
Yunghi Kim
Robert King
Paul Kitagaki, Jr
Sam Kittner
Joan Klatchko
Richard H. Koehler
Dean J. Koepfler
Katherine Kostoff
Bill Kostroun
Jeff Kowalsky
Brooks Kraft
Benjamin Krain
Charles Krupa
Kim Kulish
Amelia Kunhardt
Kenneth Lambert
André Lambertson
Rodney A. Lamkey, Jr
Wendy Sue Lamm
Nancy Lane
George Lange
Kate Lapides
Jenni Meili Lau
Jim Leachman
Steve Lehman
Paula Lerner
Claude Lessig
Heidi Levine
Richard Levine
Ron Levy
Serge J.F. Levy
G. Brad Lewis
James Leynse
Andrew Lichtenstein
Ken Light
Brennan Linsley
Steve Liss
Michael Llewellyn
Frank Borges Llosa
Gerard Lodriguss
Mary Lommori Vignoles
David Longstreath
Rick Loomis
Jose R. Lopez
Jackie Lorentz
Jim LoScalzo
Pauline Lubens
Dave Luchansky
Kendra Luck
Melvin Jack Luedke
Raymond Lustig
Christian de Lutz
Santiago Lyon
John MacDougall
Preston Mack
Jim MacMillan
Jose Luis Magana
James F. Mahoney
Joe Mahoney
H. John Maier, Jr
John Makely
Jay Mallin
Larry Mangino
Jeff Mankie
Ray Manning
Mary Ellen Mark
Brad E. Markel
Bullit Marquez
Dan Marschka
Pablo Martínez
Bebeto Matthews
Robbie McClaren
Linda McConnell
John McConnico
Gerald McCrea
Steve McCurry
John McDonnell
Rebecca McEntee
Mark McEvoy
Todd McInturf
Rick McKay
Kirk McKoy
Lennox McLendon
Jeffrey McMillian
Joseph McNally
Wally McNamee
Win McNamee
Daniel Mears
Steven Medd
Kent E. Meireis
Martin Mejia
Steve Mellon
Eric Mencher
William Mercer-McLeod
Jeff Mermelstein

James Michalowski
Ethan Miller
George W. Miller III
Lester J. Millman
Doug Mills
Mark Milstein
Liana Miuccio
Andrea Modica
Mark W. Moffett
Genaro Molina
Jim Mone
Scott Moon
John Moore
Viviane Moos
John Moran
Debbi Morello
François Mori
Christopher Morris
Paul Morse
Michael Mosby
Sanjid Mosharrof
Matthew Moyer
Joyce Naltchayan
Jon Naso
Steven Nehl
Gregg Newton
Nick Nichols
Robert Nickelsberg
Steven Ralph Nickerson
Martina Nicolls
Louise Ann Noeth
Michael O'Neill
Charles M. Ommanney
Morgan Ong
Edward Ornelas III
Francine E. Orr
Charles Osgood
Carlos R. Osorio
José M. Osorio
Will van Overbeek
Annie O´Neill
Wally Pacholka
Manuello Paganelli
Todd Panagopoulos
Kenneth Papaleo
Judah Passow
Bryan Patrick
Peggy Peattie
David Pellerin
Arndt Peltner
Randy Pench
Lucian Penkins
Hilda M. Perez
Ilene Perlman
Freddy Perojo
Ezio Petersen
David Peterson
Mark Peterson
Srdjan Petrovic
Joanna B. Pinneo
Spencer Platt
William Plowman
Daniel Polin
Arthur Pollock
David Portnoy
Mark Powell
Thomas Pritchett
Jaydie Putterman
Alex Quesada
Joseph Raedle
Susan Ragan
John Ranard
Tony Ranze
Anacleto Rapping
Steve Rasmussen
Laura A. Rauch
Patrick Raycraft
Steven L. Raymer
Laurent Rebours
Robert Reeder
Tom Reese
Lara Jo Regan
Tim Revell
Eugene Richards
Roger Richards
Rick Rickman
L. Jane Ringe
Eric Risberg
Jeff Roberson
Joshua Roberts
Michael Robertson
Michael Robinson
Paul Rodriguez
Chris Rogers
Rod Rolle
Vivian Ronay
Daniel Rosenbaum
Linda Rosier

Jeffrey L. Rotman
John Rowland
Jeffrey B. Russell
Bob Sacha
Jonathan Safir
Robert Salgado
Amy Sancetta
Tom Sanders
Mark Savage
Stephan Savoia
Andrew Savulich
Allen Schaben
Cindy Schatz
Howard Schatz
Eliot Jay Schechter
Hannes Schick
Erich Schlegel
Ken Schles
Marc Schlossman
Terry Schmitt
Iris Schneider
Jake Schoellkopf
David Schreiber
Jane Schreibman
Mary Schroeder
Richard Schultz
Michael Schwartz
L. Schwartzwald
Andrew Scott
Randall Scott
Thom Scott
David Scull
Cathy Seith
Bob Self
Neil Selkirk
Andrew Serban
Peter Serling
William Serne
Stephen Shames
Sallie Shatz
Stephen Shaver
Shepard Sherbell
Eliot Siegel
Howard Simmons
Luis Sinco
Lynne Sladky
John Slavin
Brian Smale
Dana Smillie
Jack Smith
G. Mark Smith
Brian Snyder
William Snyder
Ted Soqui
Chris Spencer
Fred Squillante
Jamie Squire
Karen Stallwood
John Stamever
Susan Stava
Larry Steagall
Maggie Steber
Joe Stefanchik
Avi Steinhardt
George Steinmetz
Christopher Stewart
Heather Stone
Les Stone
Matt Stone
Wendy Stone
Sher Stoneman
Scott Strazzante
David Strick
Bruce C. Strong
Helen M. Stummer
Miso and Lida Suchy
Akira Suwa
Chitose Suzuki
Lea Suzuki
Sylvia de Swaan
Thor Swift
Susan May Tell
Donna Terek
Shmuel Thaler
Robert P. Thayer
Scott Thode
Irwin Thompson
David Thomson
Jeffrey Thurnher
Charles V. Tines
Peter Tobia
William D. Tompkins
Jonathan Torgovnik
Marguerite Torres
Joe Traver
Robert Trippett
Linda Troeller
Alexander Tsiaras

Chip Turner
Lane Turner
David C. Turnley
Peter Turnley
Susan Tusa
Betty Udesen
Walt Unks
Gregory Urquiaga
Nuri Vallbona
Santosh Verma
Jim Virga
Richard Vogel
Theodore Vogel
Tamara Voninski
Dino Vournas
Armando Waak
William Wade
Tom Wagner
Diana Walker
Robert Wallis
Carl Walsh
Brian Walski
Emile Wamsteker
Paul Warner
William Warren
Eyal Warshavsky
Todd Warshaw
Lannis Waters
Susan Watts
Billy Weeks
Mary Wentz
Matthew West
John H. White
Kimberley White
Patrick Whittemore
Jeff Widener
Rick T. Wilking
Geraldine Wilkins
Anne Williams
Clarence Williams
J. Conrad Williams
Michael S. Williamson
Bill Willox
Jamal A. Wilson
Don Winters
Michael S. Wirtz
Scott Wiseman
Michael Wolf
Darrell Wong
Barry Wong
Ron Wurzer
Roger Wyan
Ira Wyman
Boris Yaro
David Yee
Bob Yen
Young-Joon Ahn
Mark Zaleski
Barry L. Zecher
Sherman Zent
Tim Zielenbach
Charlyn Zlotnik

UZBEKISTAN
Ruslan Zamilev

VENEZUELA
Carlos José Fuguet
Guillermo de Javorsky
Jacinto Jose Oliveros
Carlos Andrés Sanchez
Luis Vallenilla

VIETNAM
Ahn Hong
Ba Thinh
Bai Nguyen Duc
Bao Hoai Rham
Bui Xuan Luong
Cao Duc Minh
Chu Quang Phuc
Dang Thanh
Dang Tuan Binh
Dao Hoa Nu
Do Hieu Liem
Do Kha
Doan Anh Huy
Doan Duc
Doan Duc Minh
Dong Duc Thanh
Duong Quang Hai
Duong Thanh Tung
Duong Van Nhan
Ha Vy Chang
Hai Ha
Ho Canh
Ho Si Trung
Hoang Huli Tu

Hoang Kim Quy
Hoang Luat
Hoang Minh
Hoang Ngoc Hai
Hoang Zuan Hao
Huy Do
Huy Kha Le
Huynh Man
Huynh Minh Nhut
Huynh Ngoc Dan
Huynh Tan Tri
Khac Huong
Khanh Lai
Khau Hong Nho
Kiet Hoang Dinh
Kim Vu
Lai Dien Dam
Lan Nguyen Duc
Le Boi
Le Cong Mai
Le Dinh Canh
Le Kinh Thang
Le Ngoc Can
Le Ngoc Huy
Le Ngoc Tuan
Le Nguyen
Le Quang Hoang
Le Quy Trong
Le Van Truc
Linh Nguyen Hoang
Luong Chinh Huu
Luu Quang Pho
Luu Thuan Thoi
Ly Chi Hung
Ly Truong Xuan
Ngo Huong
Ngo Quang Nhon
Ngo Van Nhon
Ngo Viet Ngan
Ngoc Quang
Ngoc Thai Dang
Nguyen Anh Tuan
Nguyen Dan
Nguyen Dinh Hai
Nguyen Dinh Lac
Nguyen Duc Sinh
Nguyen Duy Thang
Nguyen Hong Tam
Nguyen Hy
Nguyen Kim Quan
Nguyen Kinh Luan
Nguyen Nan An
Nguyen Phi Hai
Nguyen Phuoc Loc
Nguyen Quang Truong
Nguyen Qui Hoai
Nguyen The Dinh
Nguyen The Ky
Nguyen Trong Thanh
Nguyen Tuyet Minh
Nguyen Van Dung
Nguyen Viet Thao
Nguyen Xuan Mai
Nong Tu Tuong
Pham Duc Thang
Pham Tti Thu
Pham Van Ty
Pham Vu Dung
Phan Dinh Loi
Phan Gong Thuc
Phan Loi
Phan Ngoc Kha
Phan Sang
Phue Nguyen Tren
Quang Hanh
Quang Huy Vu
Quoc Tuan Hoang
Si So Ho
Son Ngoc Ho
Ta Hoang Nguyen
Tang Canh
Thach Van Hoang
Thang Le Xuan
Thanh Ha
Ton That Duyet
Tran Cu
Tran Dat
Tran Duc Cong
Tran Duc Suu
Tran Duc Tai
Tran Huu Cuong
Tran Nam Son
Tran Ngoc Nam
Tran Quang Tuan
Tran The Long
Tran Thi Tuyet Mai
Tran Tuan
Tri Huynh Minh

Truong Cong Anh
Truong Hoang Them
Tu Bach Ngoc
Tu Thanh
Tu Tien
Van Bao
Van Tho
Van Xuan Nguyen
Vanthanh Chau
Vo Minh Hoan
Vo Dong Bay
Vu Anh Tuan
Vu Nhat
Vu Tin

YUGOSLAVIA
Jelena Djordjevic
Aleksandar Djorovic
Predrag Djurovic
A. Dragutinovic
Nikola Fific
Tomasevic Goran
Aleksandar Kelic
Petar Kujundzic
Aleksandar Lukic
Pavle Marjanovic
Ivan Mihajlovic
Vladimir Milivojevic
Zoran Milovanovic
Bratislav Nadezdic
Budimir Ostojic
Slobodan Pikula
Nikola Solaja
Aleksa Stankovic

ZAIRE
Guy Likaka

ZAMBIA
Asiah Nebart Mwanza
Chatowa Ngambi
Patrick Ngoma
John Ngoma
Timothy Nyirenda
Hendrix Pola

ZIMBABWE
Alexander Joe
Lovemore Mhaka
Augustine Mulambilila
George Muzimba

I CANNOT PREDICT THE OUTCOME OF THE CONTEST.
THE WEATHER IS A COMPLETE MYSTERY. AND THE LIGHT IS ANYONE'S GUESS.
THE ONLY CERTAINTY IS THAT I WILL GET THE PICTURE.

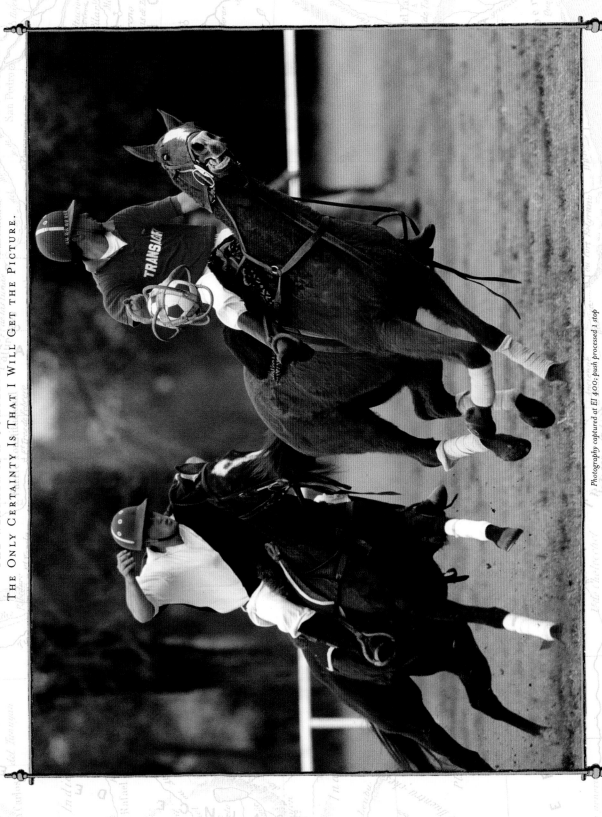

Photography captured at EI 400; push processed 1 stop

Capturing true colour under disparaging conditions is the essence of KODAK PROFESSIONAL EKTACHROME Film E200. It's the first high-speed chrome film with the colour, contrast, and image structure traditionally associated with lower speed films. E200 delivers excellent push-processing performance. This is a true 200-speed film you can push all the way to 1000.

Kodak, Kodak Professional, Ektachrome, and Take Pictures. Further. are trademarks. Kodak Professional. A division of Eastman Kodak Company. Photo © Heinz Kluetmeier, 1997

The Canon EOS IX, the perfect balance between form and function.

The EOS IX is more than a camera, it's a thing of beauty, an object of desire. The SLR camera that combines the simplicity of the Advanced Photo System with the legendary professional features of the EOS range. The camera designed for people for whom sophistication isn't simply a word, it's a way of life. **EOS IX**

THE EOS IX, CREATED BY CANON TO PLEASE ALL YOUR SENSES.

Canon Europa N.V., P.O. Box 2262, 1180 EG Amstelveen, the Netherlands http://www.europe.canon.com

The world's finest books on photography and photographers from Thames and Hudson

Berenice Abbott *Bailey*
Blumenfeld *Bischof* Bill Brandt
Brassaï Cartier-Bresson
Walker Evans Lois Greenfield
Horst Hoyningen-Huene
Duane Michals Tim Page
Man Ray Riboud *Daniel Schwartz*
Cindy Sherman

For details of our new and forthcoming publications, please write to:

(UK) Thames and Hudson Ltd., 30 Bloomsbury Street, London WC1B 3QP
(USA) Thames and Hudson Inc., 500 Fifth Avenue, New York, NY 10110

Copyright © 1998
Stichting World Press Photo Holland,
Amsterdam
Sdu Publishers,
The Hague
© Photography Copyright
held by the photographers

First published in Great Britain in 1998
by Thames and Hudson Ltd, London

First published in the United States of
America in 1998 by Thames and Hudson
Inc., 500 Fifth Avenue, New York,
New York 10110

Art director
Teun van der Heijden
Design
Heijdens Karwei
Picture coordinators
Marieke Wiegel
Katinka Canté
Interview and captions
Terri J. Kester
Production assistant
Marie-Luce Bree
Editor
Kari Lundelin

Lithography
Snoeck-Ducaju & Zoon, Ghent, Belgium
Paper
Royal Impression silk 135 g
Cover Royal Impression silk 300 g
KNP Leykam Maastricht
Proost en Brandt, Diemen
Printing
Binding
Snoeck-Ducaju & Zoon, Ghent, Belgium
Production supervisor
Rob van Zweden,
Sdu Publishers,
The Hague

Office:
World Press Photo
Jacob Obrechtstraat 26
1071 KM Amsterdam
The Netherlands
Telephone: +31 (20) 6766 096
Fax: +31 (20) 6764 471
E-mail: office@worldpressphoto.nl or
 100277,3402 (compuserve)
Website: http://www.worldpressphoto.nl

Managing Director: Marloes Krijnen
Deputy Managing Director: Árpád Gerecsey

British Library Cataloguing-in-Publication
Data
A catalogue record for this book is available
from the British Library

ISBN 0-500-97464-0

Printed in Belgium

Cover picture (detail)
World Press Photo of the Year
Hocine, Algeria, Agence France Presse
Woman Grieves after Massacre in Bentalha,
Algeria, 23 September